THE LIFE & TIMES OF
JERSEY CITY MAYOR
"I AM THE LAW"

Leonard F. Vernon

Charleston · London

THE
History
PRESS

Published by The History Press
Charleston, SC 29403
www.historypress.net

First published 2011

Manufactured in the United States

ISBN 978.1.60949.468.1

Vernon, Leonard F.
The life and times of Jersey City mayor Frank Hague : "I am the law" / Leonard F. Vernon.
p. cm.
Includes bibliographical references.
ISBN 978-1-60949-468-1
1. Hague, Frank, 1876-1956. 2. Mayors--New Jersey--Jersey City--Biography. 3. Jersey
City (N.J.)--Politics and government--20th century. I. Title.
F144.J553H348 2011
974.9'2704092--dc23
[B]
2011042755

CONTENTS

INTRODUCTION

For Frank Hague, the mayor of Jersey City for thirty years, the end came on New Year's Day 1956—not in the downtown Jersey City slum of his birth, but rather in his Park Avenue apartment in New York City. His body was removed to the historic Lawrence Quinn Funeral Home. Located on a hill overlooking the Hudson River, the house provided an ideal vantage point for military reconnaissance during the war for independence, and it is believed to have been where Washington met Lafayette to plan military strategy against the British.

Upon arrival at Quinn's, Frank Hague's body was prepared for public viewing. In death as in life, Frank Hague would be the best-dressed man in the room. His body was attired in a morning suit and a crisp white shirt with the high collar that he preferred in life, believing that it would help prevent him from catching a cold. The shirt was adorned with a plain gray silk tie. For more than twenty years, people would stand in line for an hour or more in city hall on New Year's Day just so they could meet the mayor. Frank Hague was now ready to meet the public for the last time.

The viewing began on Tuesday, January 4. Hague's son, Frank Jr., represented the family, greeting those who had come to pay their respects. It was an eclectic group of mourners who filed past the open casket—political friends and protégés, as well as housewives and salesmen. There was John Milton, then serving as the United States senator from New Jersey, who was Hague's personal attorney and one of only two men to ever gain the mayor's complete trust. Others in attendance at the viewing included Thomas Brogan, the former chief justice of the state Supreme Court; the infamous New York State Democratic leader Carmine De Sapio; and the then current mayor of

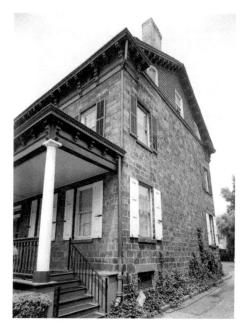

The Quinn Funeral Home, one of the oldest buildings in Jersey City. It was used by General Washington in the war for American independence.

Jersey City, Bernard Berry, along with numerous city commissioners. Those without titles, the ordinary citizens of Jersey City, like the wife and mother whose husband had been out of work for almost a year, came to thank the mayor for allowing her to receive the finest medical care in the country and deliver her baby free of charge. There were the police officers and the firefighters who owed their jobs to Frank Hague. Others who came to pay their respects included the grown children from families who remembered how the mayor had taken care of them during Thanksgiving by providing them with free turkeys, while others remembered his Christmas visits when, accompanied by Santa Claus, he would deliver toys to the city's hospitalized children. They had all come to say thank you.

However, this outpouring of love was not universal, causing Hague's undertaker concern regarding the embarrassingly few flowers that had been sent. Asked about the scarcity of floral arrangements, he could only reply, "When the Big Boy goes, it means he can no longer do anything for anybody."[1]

As the seven-hundred-pound hammered copper casket was being loaded into the hearse, the seventy-five white-gloved honor guards from the Jersey City Police Department, the department that Frank Hague had built into one of the finest in the nation, snapped a salute. In the background, the solemn voice of the funeral director called out to the pressing crowd, "Hats, men." Of the hundreds on the sidewalk, *Time* magazine reported that only four men were seen to lift their hats as a final gesture of respect toward Frank Hague. The solemnity was suddenly disrupted when a woman carrying an American flag and a sign attempted to hoist them onto a utility pole in front of the funeral home. The sign read, "God have mercy on his sinful, greedy soul." The sign quickly got the attention of Police Chief Michael Cusack, who pushed his way through the crowd,

removed the sign and, with anger visible on his face, proceeded to rip the sign to pieces, which he threw to the ground.[2]

By the time the casket left the funeral home, carried on the shoulders of eight professional pallbearers and accompanied by Hague's widow, their son, Frank Jr., and Hague's adopted daughter, Margaret, more than three thousand people had viewed the body of Frank Hague. Thousands of Jersey City residents lined up along Bergen Avenue and nearby Academy Street that cold Thursday in January; most did so out of respect and to say goodbye, while others—like

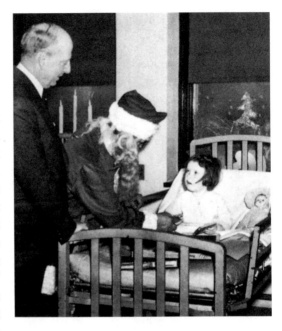

Mayor Frank Hague, accompanied by Santa Claus, pays a visit to a hospitalized child at the Jersey City Medical Center. This was an annual outing for Hague, who brought gifts for every hospitalized child. *Courtesy of Jersey City Public Library.*

the secretaries who peered out of the second-floor window of Jack Geddy Goldberg's law office located directly across the street from Quinn's—no doubt did so out of a sense of morbid curiosity. Still others, like the sign-carrying woman, just wanted to be sure that he was really dead.[3]

Frank Hague was both despised and loved, depending on what he did or didn't do for you—or to you. While some believed him a thief, others viewed him as a modern-day Robin Hood. He could put food on your table and coal in your furnace. He could give you a job on the police or fire department, or he could end your career (or that of your spouse or relative) just as easily. A visit from a city health department official could close down your restaurant, while a property reassessment could triple your real estate taxes. It was with this same ease and power that he could make you a federal judge, a congressman or even a United States senator.

The funeral procession, consisting of sixteen limousines but only three flower cars, was escorted by more than 200 uniformed policemen and firefighters as it made its way to Saint Aedan's Church, located only a

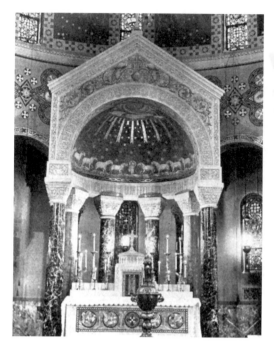

The altar at Saint Aedan's Church that was donated by Frank Hague in the 1930s at a cost of $50,000. *Courtesy of Jersey City Public Library.*

few short blocks from the funeral home.[4] More than 1,400 people crowded into the church for the solemn high requiem funeral mass scheduled to take place at noon and led by Monsignor Martin W. Stanton. Once inside the church, the casket was placed on the catafalque in front of the $50,000 marble altar that Hague had donated to the church in the 1930s.[5] It was at Saint Aedan's where the mayor and his wife had attended mass every Sunday when he was in Jersey City, something that in his later years would become more of a rarity than he would have admitted.

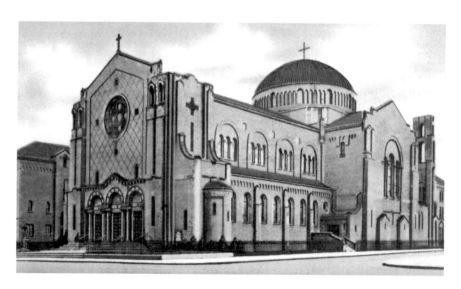

Saint Aedan's Roman Catholic Church. Located on Bergen Avenue in Jersey City, it was attended by Frank Hague and his wife every Sunday. It would also be the church where Hague's funeral would be held.

Although he was a devoted Catholic, Hague was not wholly altruistic or religious in his support for the church. Hague realized early on in his political career the strength, power and influence that the church held and the importance of obtaining its endorsement in political campaigns. This, of course, was during an era when the tax-exempt status of the church was not placed in jeopardy for such actions. Hague developed an extremely close friendship with the pastor of the mainly Irish Catholic St. Michael's Church, Monsignor John A. Sheppard. Sheppard was a good friend to Hague, standing by him even in the wake of allegations of his illegal activities. Hague would frequently turn Catholic social functions into political affairs, but this was not a one-way street. Hague and the church developed a symbiotic relationship that blossomed, and in later years the church would use Hague to curtail the building of public schools in Jersey City in order to bolster attendance at the church-run schools. Other than John Milton, Sheppard was the only person to have Hague's 100 percent trust to the day of his death.[6]

Following the three-hour church service, Hague's casket was once again placed in the hearse for the trip to the Holy Name Cemetery, which was to be Hague's final resting place. The procession proceeded along Bergen Avenue, a main street located in Jersey City's business district, and passed a large contingent of people standing in front of the iconic Goodman's Furniture Store. At the cemetery, located about three miles east of the mainly Irish immigrant neighborhood where Hague grew up and where he witnessed and experienced poverty firsthand, a mausoleum with the inscription

Hague's friend and lifelong confidant, Monsignor Sheppard. *Courtesy of Seton Hall University Archives.*

"FRANK HAGUE" over the doorway had been readied to receive him. The tarnished legacy of Frank Hague would, like his name at the top of the mausoleum, be forever etched in history.

The legacy of Frank Hague, who served as mayor of Jersey City from 1917 to 1947, can be summed up in a single statement: he "ran one of the most corrupt political machines in the country." Unfortunately and equally unfairly to Hague, it is nonetheless a reputation that continues to this day.[7] For anyone who has studied Hague as part of a course in political science or American history, Hague's negative legacy is a familiar one; for those who actually grew up in Jersey City under his rule, there is a mixed opinion. But even here the negative opinions are, for the most part, not based on actual experience with the mayor but rather have been formed by stories from others, in most cases political enemies of Hague. But how accurate is this portrayal? Have historians and others intentionally distorted the man to the point where accuracy and fact no longer matter? A perfect example of this negative reinforcement can been seen in the HBO series *Boardwalk Empire*, produced and written by Emmy Award winner Terence Winter, who wrote numerous episodes of *The Sopranos*.

The series, based on a book of the same title written by Nelson Johnson, is essentially a history of Atlantic City. The show focuses on Prohibition-era Atlantic City and the Republican boss of Atlantic County, Nucky Johnson. During one of the episodes, Chris Mulkey, the actor playing the role of Jersey City mayor Frank Hague, appears on the scene. Hague and Nucky are sitting down together in a brothel, Hague with a prostitute on his lap and an alcoholic drink in his hand.[8] Both friend and foe alike would agree that this is a total mischaracterization of the man. Frank Hague did not drink alcohol nor was he a womanizer, and while his abstention from these vices may have been for moral reasons, practical political reasons no doubt also prevented such behavior. Hague suffered from a throat and digestive problem that prevented his drinking of alcohol, and as far as women were concerned, Hague realized that his major support came from the Catholic Church and members of the church hierarchy. For Hague to be seen with another woman, especially a prostitute, would have ruined his career.[9] Although there were persistent rumors through the years of Hague having a mistress, there has never been one piece of evidence uncovered to confirm this. If there was any substance to the rumor, it most certainly would have appeared in Hague's Federal Bureau of Investigation (FBI) file, and it did not.

For some, the memory of Frank Hague is that of the "Little Hitler" of Hudson County, usurping the civil rights of the citizens of Jersey City and

ruling with unbridled authority. For others, he represented the absence of graffiti-painted walls and garbage-strewn streets and the ability to walk the streets of Jersey City at any hour day or night without fear. In the years following his death, when the crime rate of Jersey City increased, many of the city's older citizens would utter the words, "This wouldn't happen if Hague-y was around." As a matter of fact, whenever anything negative occurred, like an ambulance taking an unacceptable amount of time to reach an accident, it was always the same comment—"This wouldn't happen if Hague-y was around." And they would probably be right.

So who was Frank Hague? For sure, he was the stereotypical Irish political boss, the man people went to when there was a problem, like with the coal strike of 1922. After being informed by his police chief that people couldn't get coal to heat their homes and schools were shutting down because there was no heat in the classrooms, Hague ordered his police force to prevent a shipment of coal destined for New York City from leaving a Jersey City rail yard. He then had the coal distributed to Jersey City firehouses for pickup by local residents.[10] He was also the man who made sure that you had a turkey at Christmas and Thanksgiving, and if you or a family member were ill, you could be assured of receiving some of the finest medical care in the country, whether you could afford it or not. While many of these and similar actions were common among urban American political bosses of the time, the truth is that Frank Hague, as evidenced by his longevity in power, was much more than your typical American political boss.

For more than thirty years, Frank Hague dominated the political landscape of New Jersey's Hudson County, and while Jersey City and Hudson County remained his power base, his political reach extended throughout the entire state, eventually reaching the national level, where he was given control of more than $50 million (about $700 million in 2011 money) in federal funds.[11] What is often neglected when telling the story of Hague's rise to this position of power is how incredible the achievement was considering his lack of formal education, his absence of inherited wealth or familial influence and the absence of any ideological passion. In true Horatio Alger fashion, he was a self-made man whose grasp of political manipulation and the operation of city government allowed him to establish and keep an iron grip on his power. In the end, he would walk away from the post a multimillionaire. While most writers have assumed that this wealth was obtained via illegal activity, in actuality, this was probably not the case.

Frank Hague has been described as a political "boss" who operated in an era of "machine politics." Most current historians, perhaps because of the

mistaken belief that political machines are no longer worthy of study, have avoided the subject of machine politics, as well as political bosses such as Hague. Other reasons could be the paucity of primary resources available to researchers. New Jersey historian Matthew Raffety, who has written on Hague's early career, said that "little concrete information on Hague's early years survives, and much that is available bears the scars of the ideological and political agendas of its authors."[12] Raffety's observation can also be extended to Hague's later years in office, when author bias is actually responsible for creating a substantial amount of the negativity that affixed itself to Frank Hague.

To see how author bias plays a role in the shaping of historical opinion, especially that of political bosses, one just need read Jack Beatty's *The Rascal King: The Life and Times of James Michael Curley*. Beatty paints a portrait of a man that is much rosier than the facts reveal. With just a wink, Beatty passes over Curley's numerous questionable activities. For example, Curley's forced political contributions by city employees via kickbacks (a common political practice among political bosses; in the case of Louisiana governor Huey Long, it was the "deduct box," while in Jersey City, the practice under Hague was known as "Rice Pudding Day") or Curley's twenty-one-room stained-glass, marble and gold mansion, with its shamrock shutters, that was built with the unpaid labor of companies doing business with the city—firms that kicked back funds to Curley from material purchases.[13] In his more recently published *James Michael Curley: A Short Biography with Personal Reminiscences*, former Massachusetts Senate president William Bulger, himself a product of Boston machine politics, unashamedly dubs Curley—a man who served time in jail in his early life, as well as in a federal prison in his later career (and who was eventually pardoned by President Truman, himself a product of the Pendergast machine of Kansas City)—as "our hero." As unfortunate as it is unfair, historians have so tarnished the reputation of Frank Hague that it would be unimaginable for any current sitting or former New Jersey politician to refer to Frank Hague as "our hero."[14]

Beatty and Bulger were not alone in helping to shape the positive legacy of Curley. The city of Boston and its state historians have chosen to take the legacy of a man whose corrupt activities were well known and create a hero. If one travels to visit the sights of Boston, his trip would inevitably take him to the area of the city that contains Faneuil Hall, a historic marketplace that's part of the Boston National Historical Park and a well-known stop on the Freedom Trail. There the tourist will see not one but two statues honoring the former Boston mayor.

One reason for such contrasting Curley-Hague legacies may be linked to Curley's animated, colorful personality compared to Hague's steadily maintained look, dour and stiff. Perhaps it was the fact that Curley always looked happy while Hague always looked sour and angry. "Simply by presenting to the public eye his natural, unlovable self," wrote *Time* magazine, "Frank Hague helped destroy the dangerous American myth of the lovable and somehow admirable political boss."[15]

While it may be difficult to believe that traits such as these actually contribute to how legacies are shaped, it is true. Let's look at the legacy of Richard Nixon, who will always be remembered as the disgraced president forced to resign, while Bill Clinton, who narrowly escaped impeachment, is regarded as a hero, commanding speaking fees of $100,000 or more for an appearance. It has been widely reported that during the 1960 presidential debates between Nixon and Kennedy, those who listened to the debates on the radio, and thus were unable to assess personality, believed that Nixon won the debate, while those who watched on television believed that Kennedy won. Clearly, facial expression and demeanor can shape public perception.[16]

James Curley is not alone when it comes to politicians of dubious repute who have enjoyed popular acclaim despite their tawdry activities. If one were to take a tour of the nation's capital and travel down Pennsylvania Avenue, he no doubt would learn the history of Alexander Robey "Boss" Shepherd, one of the most controversial, influential and powerful big city political bosses in the history of the Gilded Age. Standing on a pedestal outside the building that houses the offices of the council and the mayor of the District of Columbia is a statue of Shepherd. Additional recognition has come in the form of a park that bears his name, and this same D.C. neighborhood where he once lived is also home to the Alexander Shepherd Elementary School.

The Nation magazine commented on the level of corruption that surrounded the Shepherd administration, which was investigated for misappropriation of funds. Congress found that Shepherd had given preference to neighborhoods and areas of D.C. in which he or his political cronies held financial interests. Although never convicted of anything illegal, Shepherd was removed from office. But because later generations have decided to focus on the positive aspect of the man and his accomplishments in office, his legacy has been rehabilitated, and he is now known as "the Father of Modern Washington."[17]

In the city of Chicago, what had previously been known as the Chicago Civic Center is now the Richard J. Daley Center, named after the man

many consider the last of the old-time bosses. Daley's early life, like Hague's, involved acts of what could be considered juvenile delinquency, and like Hague, Daley was a member of a local gang. Known as the Hamburg Athletic Club, the part political club but mainly gang was involved in the race riots of 1919, in which black youths were killed. Daley's exact role remains a matter of debate; what is known is that the Hamburg Athletic Club was involved in the murder of a young black high school student.[18]

Later in his career, accusations of election fraud became widespread, the most well publicized of these occurring in the presidential election of 1960, when Daley pulled rabbits, or in this case votes, out of a hat and helped win the election for John Kennedy.[19] However, what Daley will be most remembered for was the actions that his police force took on protestors during the 1968 Democratic Convention. The brutal beating of protestors on the orders of Daley has remained, as it should, a negative blot on American democracy. The actions ordered by Daley were a gross violation of civil liberties and a decision that should have sealed his legacy's fate. Daley's total disregard for civil liberties and the Constitution was visible to the world, as were his televised actions from the convention floor in response to comments made from the podium by Connecticut senator Abraham Ribicoff. As cameras focused on Daley, lip-readers throughout America claimed to have observed him shouting, "Fuck you, you Jew son of a bitch!" Defenders of the mayor would later claim that he was calling Ribicoff a faker.[20] Yet the angel of redemption has visited the mayor. The city of Chicago, instead of tarnishing him or trying to forget him, has decided to honor him with an arena.[21]

In contrast to his Boston, Chicago and D.C. counterparts, there are no buildings or schools named after Hague and no statues of the former mayor. In fact, schoolchildren in Jersey City, if they hear his name at all, continue to learn about the corrupt Frank Hague.

The majority of the published works on Frank Hague's early years concentrate on his quasi-criminal activities in his teen years. Likewise, most writings of Hague's later years are of a muckraking style and often miss or intentionally ignore many of the positive contributions made by Hague. One example can be seen in Melvin Holli's *The American Mayor: The Best and Worst Big City Leaders*. Holli rates Hague as the second-worst mayor in history, being topped only by Chicago's William Thompson. Authors such as Holli take great liberties when writing about Hague, apparently without worry that factual substantiation of their statements may be lacking. When examining Hague's early life, Holli described Hague as a "hoodlum." Later he wrote, "His early life was a far cry from the taxpayer-supported luxury

he later enjoyed in two different summer and winter palatial homes and in the private suite at the Waldorf Astoria, which he used when not sailing on his European vacations." There is no evidence that any of these items were ever paid for with taxpayer money, but it is this unchecked free-flowing dissemination of allegations that has allowed the myths surrounding Frank Hague to continue virtually unchallenged.[22]

Can anything good be said of a man who has been labeled by innumerable authors as a corrupt, money-stealing accepter of graft? Unfortunately for Frank Hague, the answer has been no, especially when the narrative is controlled by a lone author in a single piece of literature from which all other authors have derived their information. Dayton David McKean's 1940 published work on Hague, *The Boss: The Hague Machine in Action*, has done more damage to Hague's reputation than any other work. The text has become the Bible not only for Hague detractors but also for anyone who chooses to study the life of Frank Hague, and although fact-filled, it is extremely biased in its overall presentation. Information from the text has been extracted by numerous subsequent authors and cited as fact; these "facts" are then repeated over and over again. Thus, even where the material is incorrect, it has now, by the virtue of its longevity and repetition, become truth.[23]

Although McKean, who wrote *The Boss* while at the University of Colorado, was a widely known and respected political scientist, his portrayal as an independent objective news writer is far from the truth. An examination of the facts yields a far different story. McKean served as a member of the New Jersey State Assembly and was an aide to Charles Edison, one of the most anti-Hague governors to have ever held the position. Former New Jersey assemblyman Alan Karcher criticized McKean for underdocumenting most of his claims and for his use of transcripts from an investigation by a Republican-led committee as one of his major sources. Karcher described this committee's actions as nothing more than a witch hunt and as something that would not be tolerated today. It is Karcher's belief that the investigative committee from which a great deal of McKean's information was derived was instituted to retaliate against Hague for his involvement in circumventing the Republican Party's choice for governor.

In the 1928 gubernatorial primary, the handpicked candidate of the Republican Party was Robert Carey, a reformer who worried Hague. A victory by Carey could weaken Hague's status not only in Hudson County but in the entire state as well. Hague, believing that Carey's challenger in the Republican primary race, Morgan Larson, would be easier for the

Democrats to defeat in the general election, came up with a plan to enhance Larson's chances for victory. Hague found a loophole in the law. Under New Jersey's election law, a voter who had not voted in the previous year's primary could switch party affiliation without a penalty, and Frank Hague, exhibiting the political shrewdness that had helped him sustain his political longevity, had instructed twenty thousand of his loyal followers to skip the previous year's primary and to be on standby should he ever require them. On primary day 1928, he called on them: twenty thousand Republican votes were cast in Hudson County, thus assisting in obtaining the nomination for Larson. The *Jersey Journal* went on to note, "Who would have thought that there were 20,000 Republicans in Jersey City, let alone 1300 of them in the Horseshoe?" The paper then, only half facetiously, offered up a reward for anyone who could find them.[24]

Hague's attempts at altering election results were not limited to primary races; when he thought it politically expedient, he would have no qualms about consorting directly with Republicans to alter the outcome of a general election. In early 1916, Walter Edge announced his candidacy for governor, and while the evidence is circumstantial, it is widely believed that Hague had made a deal or an "arrangement" with Edge's campaign manager, the infamous Atlantic County Republican leader Enoch "Nucky" Johnson (of *Boardwalk Empire* fame).[25] It is widely believed that Johnson—fearing that the Democratic candidate H. Otto Wittpenn, a reformer, could threaten Johnson's control and power and certainly that of Hague as well if victorious—reached out to Hague.[26] The speculation is that Edge provided Hague with "a pledge of cooperation" or a "working arrangement" that, in essence, implied that if Edge and Johnson were left alone in South Jersey, Hague would be equally "protected" in Hudson.[27] Although there is no way of knowing the exact deal, this is what is known. When Democrat Woodrow Wilson ran for governor in 1910, he carried Hudson County by more than 26,000 votes. In the 1913 election, Democrat James Fiedler carried the county by roughly the same margin. However, in the election of 1916, former Jersey City mayor Wittpenn, the man who should have been the favorite son and should have scored the largest margin of victory, instead scored a meager 7,400-vote victory in Hudson and lost the election to Republican Walter Edge.[28] And while these maneuvers by Hague may raise ethical issues, they were nonetheless not illegal, nor were the tactics fraudulent; they were, instead, the survival skills of a very shrewd politician.

Another reason for the continuation of the "all-corrupt Hague" myth may be the result of a psychological phenomenon known as motivated reasoning.

This phenomenon involves processing and responding to information defensively and seeking out and accepting confirming information while ignoring and discrediting the source of or arguing against the substance of contrary information.[29] This confirmation bias means that people value evidence that confirms their previously held beliefs more highly than evidence that contradicts them, regardless of the source. In short, it is easier and less stressful to accept the Frank Hague as he has been portrayed, in other words the status quo, than to challenge it.

Most historians have viewed Hague as tyrannical and corrupt; however, for the most part, this "corruption" has been unfairly examined in the context of the rules and ethical standards that have been established for today's holders of public office. There is no approved, comprehensive, legal definition of corruption. It is a collective noun for practices encompassing both criminal offenses and civil wrongs, such as bribery, election tampering and exercising undue influence. The American Constitution makes no reference to "corruption" in setting the terms for a president's impeachment, although Article II expressly mentions bribery. The word "corrupt" has a strong moral implication, with one author describing it as "conduct which, though not criminal, a jury might find destructive of the very fabric of society."[30]

Judgment of what amounts to a corrupt act varies with societal norms from a given period in time. For example, infamous Tammany Hall boss George Washington Plunkitt distinguished between "honest graft" and "dishonest graft." Dishonest graft, he said, meant actual theft from the treasury or shaking down criminals for bribes. Honest graft, on the other hand, simply meant taking advantage of private deals that arose in the course of public office, and even if early Progressives might have frowned upon its ethics, it was legally acceptable well into the mid-1900s.[31] Today, "honest graft" would be termed "insider dealing," which is both a federal and state criminal offense. Certainly if society's leaders were opposed to conduct that they found morally offensive, they could have and should have legislated against it, but the fact was that certain transactions by politicians of larger-sized towns, as well as larger cities, were axiomatic, and there was no need for such legislation.

The historical interpretation of the urban boss has varied over time. From the late nineteenth century to the end of the Second World War, historians were harsh in their criticism of political machines and the bosses who ran them, stressing their moral failings and what they perceived as the inefficiency in such operations. From the postwar period to recent times, there has been a reassessment by academics who have attempted to stress the

positive aspects of bossism. It is their belief that historians need to look at the many complexities that were required in the operation of a city government and how these bosses were able to do it and, in most cases, do it very well.[32] It is this reevaluation of bossism that has allowed for the shortcomings of men like Chicago's Daley, Boston's Curley and D.C.'s Shepherd to be overlooked. By choosing instead to focus on the role they played in the area of social welfare services in an age when government and private business did not provide such services, while at the same time acknowledging their shortcomings, their legacies have been rehabilitated.

Because historians have chosen to continue focusing on Hague's violation of moral codes rather than on his pragmatic practices, his negative legacy has been frozen in time. Instead of receiving recognition for his vision and actions in the areas of social change, Frank Hague has become the quintessential poster child for political corruption and bossism in the 1900s. Rarely is he praised for governing the cleanest, safest city in the state.[33] Almost nonexistent in the historical literature are descriptions of Hague's actions as director of public safety following one of the earliest terrorist attacks on American soil, the Black Tom explosion.[34] Little recognition is given to Hague for his efforts in electing one of the first women to the United States Congress following the passage of the Nineteenth Amendment.[35] Few realize that, unlike other mayors, Frank Hague was proud to see the desegregation of baseball occur in his city. Hague was present when Jackie Robinson played his first game on an integrated baseball team in Jersey City's Roosevelt Stadium, and where other cities would have prevented such a game from occurring, Hague stood strong. The most glaring omission of recognition that Hague deserves is in the areas of public healthcare and juvenile justice reform. Despite the positive influences of Frank Hague, he remains a man that Jersey City would rather forget.

One frequent example of anti-Hague bias is the now famous "I am the law" quote, so indelibly attached to his name that the use of the quote has almost become a requirement when writing or discussing him. However, upon further examination, the context of the statement has been lost or, worse, intentionally ignored by most historians, who prefer to concentrate on the vilification of Hague rather than the origin of the statement. Ironically it was his efforts in the area of juvenile justice that led to his making that statement.

New York Times columnist William Safire described the criticism of Hague's statement as "a bum rap," because it had been taken out of context:

> *Two boys, both under sixteen…were apprehended by the authorities for truancy. The Mayor happened to be in one of his police-station hideouts*

when they were brought in. The boys told him that they preferred jail to school; so he took up their case with Doctor Hopkins, suggesting that jobs be found for them. Doctor Hopkins said that it could not be done because of the New Jersey Working Papers Law. Then the Mayor said to him: "Listen, here is the law! I am the law! These boys go to work!"[36]

While some might say that Safire's attempt at mitigation fails to demonstrate humility or in any way diminish the overt arrogance that was a Hague trait from the start of his political career, it does indicate an early concern for the youth of the city, a point lost on most Hague historians. The truth is that most writings on Hague fail to recognize the important social function that Hague and his organization filled during an era when there were no government-operated programs or food stamps or Medicaid for the poor to turn to when they required shelter, food, clothing or medical help.[37] Hague has been described as a progressive reformer, a working-class hero, a dictator and a demagogue. Who was the real Frank Hague? While it is easy to stereotype Hague as the typical Irish-American political boss, in reality his is a life that is significantly more complex and one that far surpasses any single label.

THE HORSESHOE

The social and geographical aspects of Jersey City during Hague's early childhood no doubt played a part in formulating his decisions in later life. A look at Jersey City politics in the 1850s, twenty years before Hague's birth, reveals that Jersey City was a residential suburb of New York. The native-born Protestant population that composed the city's economic elite governed the city's leadership, as well as most of its social organizations. The degree of Protestant influence in all aspects of Jersey City approached that of a government-endorsed religion.

The Protestants of Jersey City were, for the most part, members of the Republican Party, which contained a high percentage of former members of the Know-Nothing Party, which in turn held strong negative feeling toward immigrants. This xenophobia is evidenced in the election results of 1856, in which the American Party (an offshoot of the Know-Nothings) captured 28 percent of the vote in Jersey City, higher than the 24 percent received statewide.[38]

Jersey City's Protestants believed that it was their job, almost a spiritual calling, to bring Protestantism and middle-class morality to those who, they believed, brought neither to the city—the Catholic immigrant population, of which the Hague family were members. To accomplish this goal, two groups were created in the early 1850s: the Hudson County Bible Society and the Jersey City Mission and Tract Society. Although local in nature, these groups and others like them were part of a nationwide attempt at addressing the Catholic immigration issue.

Among the goals of the Hudson County Bible Society was to place a Protestant Bible in every Catholic home. Like the Hudson County Bible Society, the City Mission and Tract Society had as its mission to save souls;

however, it was also a mission rooted in politics. One tract issued by the society stated that the Irish "are crowding our cities, lining our railroads and canals, occupying our kitchens, driving our carriages, and *electing our rulers*" (emphasis added).

"They are priest-ridden and deluded, and, what is worse, [they] love to have it so," the tract continued. But if a "pure Gospel, with its restraining, elevating power," could be brought to them, "we would have nothing to fear from our civil institutions."[39]

So extensive was the influence of these groups within the city politic that in April 1854, the City Mission and Tract Society hired a full-time city missionary, Reverend William G. Verrinder. The position of city missionary became a quasi-official post in Jersey City, with Verrinder given access to address the mainly poor Irish Catholic boarders at the county almshouse. He was given unfettered access to prisons and public school students as well.[40] Verrinder believed that intemperance was the root of poverty among the Irish and was a strong supporter of prohibitionary legislation. To Verrinder, poverty was not a social or economic issue but rather a moral one.

There is no doubt that this attempt at temperance and conversion was spurred by the fact that by 1854 the increase in Irish immigration had become so significant that the previous virtually all-Protestant Jersey City now had a significant Catholic minority. This shift in population was of such concern to the Protestants of Jersey City that pressure was brought on the New Jersey State Assembly to pass a resolution urging Congress to increase the period of naturalization for citizenship from five to twenty-one years. Although this was defeated, one member of the State Assembly, John Roberts from the southern New Jersey town of Camden, another urban area in the state with an increasing immigrant population, said what many were no doubt thinking:

> *Foreign tongues are heard on every hand. Foreign newspapers flood the country. Districts of foreigners, townships of foreigners, counties of foreigners, with foreign hearts, and foreign manners, and foreign institutions, dot the whole country. Foreign quarters are found in our cities, and bands of armed foreigners parade our streets with foreign insignia. Foreign priests employ the thunders of foreign politico-religious power to force from the hands of the legal trustees the property of American citizens.*[41]

Over the next thirteen years (1854–67), although the city's population almost doubled, the proportion of Catholics rose from one-third to two-

fifths. The overall city population grew 88.7 percent, with the Protestant population increasing by only 72 percent, while the Catholic population increased by 115 percent. These were numbers that certainly posed a threat to the hegemony of the native-born Protestants of Jersey City and caused them to increase their attempts at proselytizing and other coercive attempts at assimilation and "de-Catholicization," which caused an even wider rift between the two groups, with the Irish defending both their identity and their Catholicism.[42] The *New York Irish World* in 1872 described the conflict thus: "Our lot is cast among a people who hate our nationality—a people who would absorb us if they cannot prevent our growth. How shall we preserve our identity? How shall we perpetuate our faith and nationality, through our posterity, and leave our impress on the civilization of this country as the puritans have?"[43]

The Jersey City newspaper, the *Daily Sentinel*, didn't help in calming matters when it said that "[n]o Irishman ever died of hard work in America," as well as claiming that the "average Yankee worked twice as hard as the average Irish man."

The article went on to note that Irish poverty "had three main causes. The Irish drank. The Irish herd and grovel in crowded cities where labor is always in excess and are bitterly competitive." The final and most damning anti-Catholic insult from the article was, "[T]he Catholic doctrine of Purgatory prevented them (the Irish-Catholics) from internalizing the Protestant ethic and raising themselves up through fear of the Devil's bootstraps." In essence, the Irish could rid themselves of all their problems simply by ceasing to be Catholic.[44]

This virulence toward Irish Catholics was not restricted to New Jersey. In middle America, the feeling was similar, as evidenced by this statement in the *Chicago Post*: "The Irish fill our prisons, our poor houses…Scratch a convict or a pauper, and the chances are that you tickle the skin of an Irish Catholic. Putting them on a boat and sending them home would end crime in this country."[45]

Between 1860 and 1868, the Irish gradually entered Jersey City politics. Fearing that the Republican Party, the Party of Lincoln, would end slavery and thus flood the North with ex-slaves they would have to compete with for jobs, the majority of Irish Catholics became members of the Democratic Party. Although the working-class Irish made up a majority of the Democratic Party in Jersey City, it should not be assumed that this was the party of the city's poor working-class Irishman—it was not, as they rarely if ever served in leadership roles.

By 1870, there was a comparatively large Irish middle class in Jersey City. These were mainly men who had prospered in New York City as merchants, manufacturers and brokers and who, like their native-born counterparts, had moved to Jersey City. However, even with achieving success, they quickly learned that affluence does not automatically gain the Irishman respect and rank; the stigma of their Catholicism prevented them from entering the world of the native-born, both socially and politically. Now, in an effort to gain respectability, something that they had achieved only within the Irish community, a group of the city's "respectable" Irish attempted to oust the leadership of the city's Democratic Party. Failing to do so and feeling that they had been underrepresented in the selection of candidates, this group of "respectable" Irishmen bolted from the Regular Democrats and organized their own party, the Young Democrats. It was this group's job to prevent the reelection of former mayor Orestes Cleveland, who had been nominated by the Regular Democrats to run for another term in the U.S. House of Representatives. Cleveland had been a member of the Know-Nothing Party from 1856 to 1859 and Jersey City mayor from 1863 to 1866, and he was then elected to Congress in 1868.

One week after leaving the Democrats, the new party had its own candidate for Congress: Aeneas Fitzpatrick, a forty-four-year-old Irish Catholic merchant. A successful businessman, Fitzpatrick did not reside in one of the tenement houses of Jersey City but rather in what the *New York Sun* called "a plain comfortable mansion" in one of the city's more elite districts.[46] Still, Fitzpatrick was in tune with the suffering of his countrymen. He had helped to organize the Irish Immigrant Aid and Land Colonization Society, a group that encouraged former Irish farmers to begin an agricultural life in the United States. Fitzpatrick urged successful "experienced" Irishmen to help finance a return to the soil for their poorer countrymen.

Meanwhile, similar defections from the Democratic Party were occurring in other districts of the city, such as in the third assembly district, where Alderman John Meehan led the revolt. The Meehan group nominated Michael Connolly, a successful, well-known contractor, to run for the third district seat in the assembly. To gauge the extent of anti-Irish fervor that existed, one just need read the anti-Irish *Evening Journal*, which, when describing the candidates chosen by the Meehan group, used the pejorative description of "bricklayer" to describe State Assembly candidate Connolly.[47]

In order to be successful, the Young Democrats would have to convince the working-class Irish who were members of the Democratic Party that they were being exploited, but how to get the workingmen, who made up

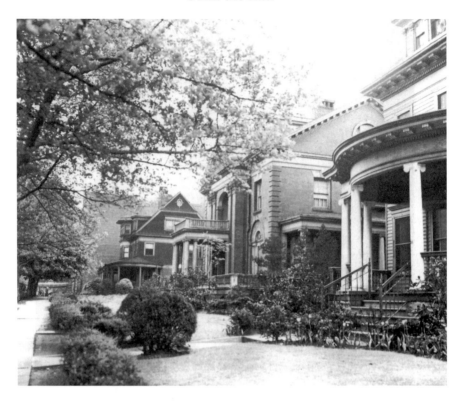

Gifford Avenue was located in the uptown part of Jersey City. There were many large, stately homes here, owned mainly by the Jersey City business elite, as well as lawyers and physicians. *Courtesy of Jersey City Public Library.*

the majority of the Democratic electorate, to understand this and act on it was a major problem. While most of the working class were not ignorant of the fact that their votes were taken for granted, they also realized that the Hudson County Democratic Organization, while not providing power to them as a group, did provide a great deal of patronage, and for this class of people a full belly and paid rent would always carry the day over power—and the Democrats were well aware of this.

In an effort to solidify its position with the working class, the Democrats used the fear tactic. They indicated that a vote for the Young Democrats was a vote taken away from the party and was, in essence, a vote to ensure a Republican victory, something that was of greater threat to the Irish working class than the lack of political clout within the Democratic Party. Patrick O'Beirne (a friend and a coworker of Young Democrat Congressional candidate Fitzpatrick, as well as many other of the Young Democrats candidates), in an effort to

try dissuade a mass exodus from the Democratic Party, issued the following statement, which was published in the *American Standard* and to which was appended the names of five Catholic aldermen who supported Cleveland:

> *I cannot forget that within the Radical Party at this moment is gathered all the essences of bigotry, intolerance, and proscription for which the old Know-Nothing Party became, at one and the same, notorious and odious, and who would proscribe me and my race, and deny us, if they could, the liberties accorded even to the negro.*[48]

Others addressed the possibility that victorious Republicans would abolish local government and substitute state-appointed commissions to run all aspects of the city, thus eliminating steady employment for the unskilled of the city. Still others made the point that there was not one Irishman on the Republican ticket. In the battle for the six assembly seats, the Republican candidates consisted of the city's business elite, while the regular Democratic Party slate was made up of a native-born, a German and (in an unsuccessful attempt to garner the city's Irish vote) four Irishmen. These were men chosen and acceptable to the old native-born Democratic elite, which meant that in essence they voted the way they were told.

The results of the election were not a surprise to anyone, and the Republicans, who had hardly campaigned, won in all assembly districts, as well as the Congressional seat. Fitzpatrick received just over 1 percent of the total vote, with no more than 10 percent coming from any of the usually Irish and Democratic Jersey City wards. In the end, the independent Irish movement failed to attract any significant numbers away from the Democratic Party or change the Republican voting patterns of the working-class Irish of Jersey City. This became even clearer when the votes were all counted and Cleveland had received almost 47 percent of the Jersey City vote and an astonishing 75 percent of the vote in the largely Irish seventh and eighth wards. It was clear that middle-class Irishmen were unable to gain the support of their working-class countrymen. Why this was is complex and would require an entirely separate study. A short answer would be that although the candidates of the Young Democrats were well known and respected by the lower-level Irish of the city, they were unable to disconnect the link that bound the Regular Democrats to that of Irish public employment. Unfortunately for these men, the Republican victory did as predicted and resulted in a wholesale removal of Irish from the public payroll, including the police force, which by 1866 had been dominated by the Irish.

With an ever increasing number of Irish immigrants of the city now becoming U.S. citizens and winning the right to vote, the now minority Protestant population, both Republicans and Democrats, began to fear immigrants ruling their city and closed ranks. They went on to convince the state legislature to change the form of government in Jersey City from an aldermanic form to a commission form. By 1871, citing the "lack of fitness" of the lower-class immigrants to govern an American city and although they were the minority, Jersey City was now ruled by a Protestant-dominated state-appointed commission.[49] As Jeff Greenfield stated, "The older 'respectable' citizens, secure in their status through birth, education and old-boy networks, found political machines so distasteful because they were the way 'the great unwashed' asserted the power of numbers."[50]

In addition to the change in Jersey City's charter dictating how the city government was to be run, the state legislature also set about redistricting the city. By deliberately gerrymandering the city's sixteen wards into six districts, the state legislature concentrated as many Irish into a single district as possible. The district encompassed the tenements and shanties along the

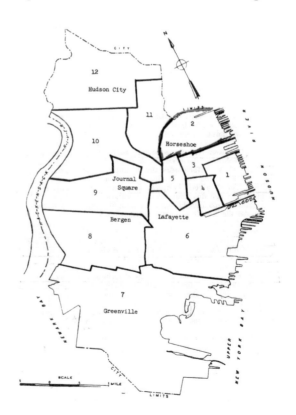

Election map of Jersey City, illustrating the "Horseshoe" district. *Courtesy of Jersey City Public Library.*

Hudson River docks and Erie right of way, as well as the swampland at the base of Bergen Hill. Not only did this consolidate the Democratic vote to a single district (the finished product yielded a voting district with fewer than one hundred Republicans), it simultaneously limited the Irish political power by ensuring Republican Protestant victory in the remaining districts. The resulting shape of the district on a map was that of a horseshoe.[51] It would be in the Horseshoe district of anti-immigrant, anti-Catholic Jersey City that Frank Hague was born.

Baptized as Francis, a name he would never again use in his public or private life, Frank Hague was the fourth of eight children. Born in 1871 to John D. and Margaret Hague, both immigrants from County Cavan, Ireland, Hague's birth, like that of most in this era, would occur at home on a kitchen table in a dilapidated frame house that, because of a stagnant pond that often swelled to surround the house after rainstorms, was dubbed "the Ark."[52] The house was located on Tenth Street in an area that today is the exit for the Holland Tunnel.

By the time Hague was ten years old, Jersey City had become an urban transportation center with heavy industrialization. Both the easily accessible railroads and its proximity to New York were the impetus for this increased industrialization. By 1876, the Lorillard Tobacco company had moved its entire operation from New York to Jersey City, where the newly completed factory employed more than three thousand people, albeit mainly women and children. Additionally, the 1870s saw the opening of the Mathiesson and Wiecher Sugar Works and the United States Watch factory, as well as the American Type Foundry.[53]

Frank Hague's neighborhood consisted of a cacophony of sounds and a plethora of odors from the garbage that was hauled by barge from nearby New York City to the piers in the Horseshoe, as well as to the landfills that were used to extend the area of the city into the river for the railroads. There was also the smell from the pigs and cattle that were often driven through the crowded neighborhood streets on their way to the nearby stockyards and slaughterhouses, where they would supply meat for the New York market.[54] In addition to the odors, there was the noise of railroad yards and the blackened air from the perfume, soap, graphite and snuff factories whose towering smokestacks spewed soot into the sky surrounding the Horseshoe.

It was a landscape of poverty, with a saloon on almost every corner where men could drown their sorrows in a cold beer or a stiff drink and where violence, including murder, was not an uncommon occurrence.[55] Although very similar in nature to the Bowery in New York, it lacked the high-rise

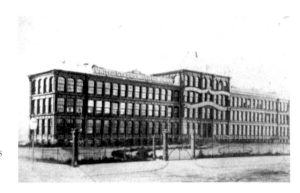

The United States Watch Company was one of Jersey City's many factories and was a large employer of Jersey City residents.

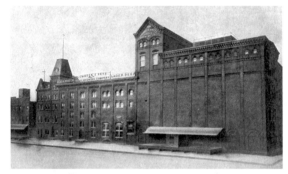

The Lembeck Brewery was another large employer of Jersey City residents.

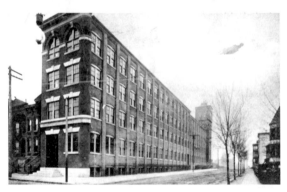

The New York Standard Watch Company.

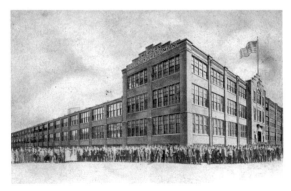

The American Type Founders, like other Jersey City factories, was a large employer and an important part of the city's economy.

tenements of its New York counterpart and was instead composed of four-to eight-family cold-water flats and run-down shanties. It was a rough, fend-for-yourself neighborhood where a youth had to grow up fast in order to survive. An 1870 *New York Times* reporter described what he viewed as he walked along the shore in Jersey City's downtown section:

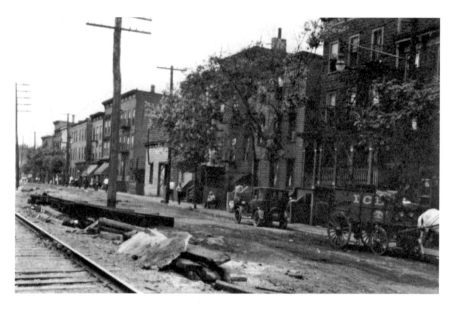

The Horseshoe section of Jersey City. *Courtesy of Jersey City Public Library.*

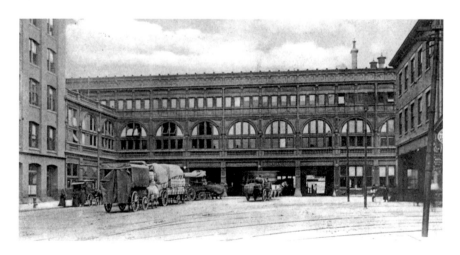

Railroad station.

STEERS ON THE RAMPAGE

TOSSING PEOPLE RIGHT AND LEFT IN JERSEY CITY.

TWO PERSONS DANGEROUSLY INJURED— THEY DEMOLISH A DRUG STORE WIN- DOW AND CREATE GREAT COMMOTION.

Two wild steers created the wildest com- motion in the north section of lower Jersey City yesterday. It is not an unusual thing for droves of cattle to be driven through crowded thor- oughfares in Jersey City to and from the Cen- tral Stock Yards. It was from such a drove, headed for Newark, that the two steers broke yesterday afternoon.

From Sixth-street, where the steers parted from the herd, they rushed wildly down Coles to Newark-avenue, and thence to Monmouth, to Third, and into Brunswick street. The crowd vanished before them, but a shouting party of men and boys made bedlam at their heels. They knocked down a young German and afterward an elderly gentleman who had his back turned to them, and one of them strode right over Annie Bentze, of No. 192 Sixth-street. She is only 5 years old, and probably was too small to be seen by the enraged beast, which saved her from at- tack with his horns.

Two ladies on Brunswick-street are said to have been knocked down by the animals, but their names could not be ascertained. On their way down through Grove-street one of the steers gazed for a second on the stock of drugs dis- played in Kennedy's store, at the corner of Seventh-street, and then plunged his horns through the plate glass window.

At Newark-avenue and Second-street one of them ran down Mrs. Perdie Van Tassel, of No. 34½ Fifth-street. She was thrown with such violence to the sidewalk that she became uncon- scious. She was carried into Cadmus's drug store, at the corner of Cole-street and Newark- avenue, and was restored to consciousness. She was in a delicate condition at the time of the as- sault and her condition is more critical now. She refused to go to the hospital and was carried home in a wagon.

The two beasts next encountered George Irie, a policy clerk, just as be stepped out of his office, and tossed him into the middle of the street. At Monmouth-street Matthew Clark, a laborer, liv- ing in Marion, took a stand in front of them and waved his coat at them. One of the animals charged on the coat and plunged one of his horns into Clark's chest. He was taken to the hallway of McDonald's grocery store and sub- sequently to the hospital. He may die.

Finally, a herd of cattle was driven from the slaughter house with a view of beguiling the two beasts. One of them mingled with the herd, but the other kept his distance. He was pursued to the meadows, where he was mired and killed. As is usually the case, no one knows who owned the animals, and it is hard to find out, therefore, who is responsible for the damage.

The New York Times

Published: October 7, 1884

Unknown to most people, Jersey City had a very active livestock industry, with a number of stockyards that held cattle and other animals on their way to slaughter in New York City.
Courtesy of Jersey City Public Library.

Downtown Jersey City. The Horseshoe district was a sharp contrast to the large homes of the uptown sections of the city.

[A] *walk up to the Long Dock discloses, after you pass large manufacturers and oil refineries that occupy nearly the entire space of dry land, the slimiest, dirtiest shore in this part of the country. When the tide is down, on a hot day, it is absolutely sickening. Old bits of carpet, clothing, ragged baskets, old tin kettles, bottles, and various articles of household crockery, all covered by green slime, are to be seen, suggestive of every nasty that lies or crawls in such a stench, including dead cats and dogs, and some other dread shapes whose mystery the rising and falling tides reveals. Decaying hulks of vessels are moored in the mud, where rats rush franticly through their gaping seams.*[56]

Jersey City, having only introduced grade school education in 1860 and having no public high school until 1872, made the completion of a grammar school education an uncommon event in the "Shoe," as it was affectionately known by its residents.[57] Basic survival was tested almost daily, and the ability to work, rather than obtaining an education, was of paramount importance to its inhabitants. Providing for the basic necessities such as food and shelter was the responsibility of all members no matter what their age, even if this meant quitting school.[58]

For Frank Hague, leaving school was not a voluntary decision or one made by need of family; he was asked to leave because of his unruly behavior. By the middle of the sixth grade at Public School No. 21, he had completed all of the formal education he would ever receive. Following his dismissal from the public school system of Jersey City, Hague, like his brothers John and Hugh, would join one of the many local gangs, and although violence perpetrated by such groups was common, there is no indication that Hague was ever involved in violent gang activity, choosing instead to become proficient in the art of robbing the freight cars that passed directly through his neighborhood.

Like many of the urban neighborhoods of the period, gangs in the Shoe were a mixed blessing; while often involved in violent activities that caused fear among the residents, they were at other times viewed as modern-day Robin Hoods.[59] The reselling of stolen merchandise known as "swag" was often overlooked by residents because, in the winter, these same gangs would shift their attention from items that could be resold to the robbing of local coal cars. The coal would then be given to the neighborhood residents who could not afford to purchase it to heat their homes. It is highly probable that it was from his experiences in the freight yards of Jersey City that Hague learned that most people really don't mind if you mingle in the gray area as long as they, too, are the beneficiaries.

This neighborhood of poverty, crime and disease, where even drinking the water could kill you, created a unity among the have-nots, who often blamed the "rich Protestant establishment" in the uptown regions of Jersey City for keeping them in poverty.[60] This feeling of collective poverty among the mainly Irish but not monolithic residents of the Shoe created a sense of camaraderie, as all were suffering the same economic plight and feelings of hopelessness. It would be from this feeling of collective disenfranchisement that ward leader "Denny" McLaughlin conceived the neighborhood slogan "Us Against the World." It would become Hague's mantra in both his youth and in his early political career.[61]

By the time Hague reached a level of political power, like most urban political bosses he would capitalize on this disenfranchisement by organizing a system of neighborhood patronage whereby both existing and new residents received benefits in the form of facilities, infrastructure, employment opportunities and policing in exchange for electoral support. This form of political organizational structure, the trading of services in return for votes, was typical in many large U.S. cities in the early twentieth century and is a method of politics that has commonly been referred to as "machine politics."[62]

According to University of California–Berkeley professor Raymond Wolfinger, machine politics and political machines are one and the same

and rely on each other: "'Machine politics' is the manipulation of certain incentives to ensure partisan political participation and a 'political machine' is an organization that practiced machine politics, attracting and directing its members primarily by means of incentives."[63] Yale University professor James Scott's definition offers the best description. It is his view that the two are not one and the same, stating that in machine politics there may be an ideology that is subscribed to, while a political machine is devoid of any such ideology. He described a political machine as "a non-ideological organization, interested less in political principle than in securing and holding office for its leaders and distributing income to those who run for it and work for it."[64]

University of Chicago political scientist Harold F. Gosnell suggested that the presence or absence of an ideology is of little importance and that longevity is the determinant of whether a political dynasty can be called a machine. It is his view that any political faction holding power for a considerable length of time is likely to be termed a "political machine" and will be "viewed negatively and as such can be portrayed in that light by opposing forces."[65] This explanation makes the important point that although a political machine may not be corrupt, solely by its longevity will it inherit the negative label of political machine nonetheless. The sheer inheritance of this label gives opposition forces the fodder to capitalize on the common belief that all political machines are inherently corrupt, a belief that is not necessarily true. By example, we can examine the political machine of "Boss Speer" of Denver. Although in all probability he was first elected mayor in 1904 with the help of ten thousand illegal votes, Robert W. Speer nonetheless is considered by most political scientists as operating one of the country's "honest" political machines.[66] Over several years, Speer cleaned up his act, and by the election of 1916, he was so popular in his own right that all parties admitted that he was honestly elected without any hint of corruption—he even received praise from the Progressive era's premier muckraker, Lincoln Steffens, who said, "He was Denver, that honest, able man; his eyes were Denver's eyes; his ambition was his city's."[67] Another example is the Byrd machine of Virginia, which has been reputed to be above corruption as well.[68] If we accept Gosnell's theory, corrupt or not, the mere fact that Frank Hague's dynasty lasted for thirty-two years classifies his organization as a machine, and with this label comes the implied belief that there must have been corruption.

While there remain conflicting views in academic circles as to the exact definition of "machine politics" and "political machines," there is general agreement that, once established, the most important core component of any

political machine was its ability to centralize power. Centralized power was essential for a machine to thrive. By taking advantage of the fragmentation that existed in American society in the late nineteenth century, with its absence of any form of social services, political organizations (machines) served not only as a pseudo-welfare system for the poor but also as "advisor, fixer, banker, social worker, bail bondsman and when required funeral director."[69]

Social scientist Robert Merton astutely observed that "[b]ecause of the fragmentation of American society and the diffusion of power in the late nineteenth century, political organizations served 'latent functions,' specifically the provision of welfare services for the poor, addressing the problems of the business community, serving as a vehicle for social mobility and defining limits for underworld activity."[70]

While much negative ink has been expended to describe Hague's patronage system, an objective eye, of which there appears to be a shortage when discussing the former Jersey City mayor, would acknowledge that, when properly used, patronage is a legitimate exercise of political power. Patronage also engendered loyalty in party workers, thus ensuring votes, not only from that individual but also on a group basis, where those who benefited from patronage, though they came from different classes and backgrounds, became united behind a political machine.[71] It was Hague's ability to exercise this political power during the Great Depression that allowed him to keep Jersey City's unemployment rate below that of other cities of comparable size and population. While the national unemployment rate approached 14.5 percent in 1940, New Jersey's rate during the same period (thanks mainly to the efforts of Hague's ability to keep Jersey City residents working) was about 11 percent.[72]

The ability to provide employment in exchange for political support was one of the more frequently used forms of patronage by most political machines operating at the time, and while a large city payroll ensured a large number of votes from city and party workers, this alone could not be counted on to win an election.[73] This quid pro quo system of politics was not used by the "machine" on a one-to-one ratio of exchange; an example can be seen in Daley's Chicago organization, where patronage was given with the belief that each jobholder would deliver ten additional votes, either through family or friends.[74] It has been pointed out that Hague's organization was somewhat more conservative, relying on four additional votes for each jobholder.[75]

While the term "patronage" has become synonymous with the crooked politician, it needs to be pointed out that political patronage, even that practiced by Hague in his early years, was not illegal. P.J. Madg
patronage as "power to award appointments, contracts and otl

is used to secure politically compatible political advisers and high executives, to reward party workers, to secure support and for personal profit," while noting that all but the last, personal profit, are acceptable elements in American politics.[76] In the 1976 case *Elrod v. Burns*, the U.S. Supreme Court recognized that the practice of patronage was within the law in given circumstances. The court accepted the definition of patronage as "generally, the allocation of discretionary favors of government in exchange for political support." While the court held that use of patronage for the discharge of non-policymaking, non-confidential public employees, solely on the grounds of political affiliation, violated First Amendment rights of association and expression of such an employee, the court noted that such rights did not extend to government contractors (i.e., municipalities).[77]

Historically, there have been attempts to limit political patronage; however, this has only been successful in the area of federal patronage—in 1883, the U.S. Congress, in an attempt to place federal employees on a merit system in their civil service jobs, passed the Pendleton Civil Service Reform Act. The act did not apply to state and municipal jobs, which remained in the hands of governors, mayors and, subsequently, political machine bosses, thus leaving the system open to abuse but not in and of itself illegal. The ruling noted that First Amendment rights did not protect policymaking or confidential public employees and that hiring and firing through the usual patronage dictum "to the victor go the spoils" was, in fact, lawful.[78] Thus one of the biggest misconceptions about Frank Hague—the idea that his trading jobs for votes was somehow an illegal activity—should be put to rest.

Not all patronage was Hague's to dole out, a fact of which Hague was acutely aware. He realized early on that a great deal of patronage power lay in the office of governor, especially when it came to appointing members of the judiciary and law enforcement. Thus it would be advantageous to have a governor in Trenton who owed his position to the boss. Of even greater advantage for a boss who was dependent on a patronage system for his political longevity would be access to federal money and jobs, as well as having influence in the appointment of such positions as federal court judges. Frank Hague would have multiple pocket governors and come close to having a pocket president, once remarking that "Franklin D. Roosevelt was the best precinct captain that he had."[79]

Hague's political history can only be described as a roller coaster ride that on more than one occasion looked like it would come to a complete stop. And while his political rise is nothing short of miraculous, it is an area that most historians have chosen to ignore.

FACT FROM FICTION

The story of Frank Hague, like that of other American political bosses, is steeped in both lore and fact. What we do know is that at age sixteen Hague took a job as a railroad blacksmith's apprentice. This was at the urging of his mother, who didn't want to see her son in trouble with the law like so many other Horseshoe boys, including his two brothers.[80] Hague held the position for about two years; it would be the only private industry job he would ever hold.[81] Two years later, he would go on to try his skill as a prizefighter. While training in McConville's gym in Jersey City, he met a lightweight fighter named Joe Craig, and upon deciding that it was better to watch someone else's face get cut than his own, he went on to manage the lightweight. Craig's career, despite an occasional victory, was short-lived, but it did allow Hague to earn enough money to purchase stylish clothing. Dressing in the latest-style clothing would remain a signature trait of Hague's for his entire life.[82]

Being a boxing manager elevated Hague's status in the Shoe, where many of the bouts were held. One of the frequent attendees at these matches was the leader of the second ward (which included the Horseshoe), Dennis "Denny" McLaughlin. The impeccably dressed, talkative, almost boisterous Hague caught the attention of McLaughlin. Having recently opened a number of social clubs in the ward, McLaughlin thought that Hague would be the perfect person to maintain order in these clubs. Hague immediately accepted; however, after only one year, the McLaughlin-Hague relationship soured when Hague failed to receive any monetary remuneration for his efforts. An angered Hague waited for an opportunity to exact revenge, and when the chance came, Hague did not hesitate.[83]

NO PRIZE FIGHTS AT ROCKAWAY.

District Attorney Fleming Taking Steps to Stop the Show.

LONG ISLAND CITY, L. I., Nov. 27.— Unless District Attorney John Fleming of Queens County changes his mind, there is a prospect that the three "boxing bouts" advertised to take place Thanksgiving Eve at Rockaway Beach will not come off.

The fights were arranged by the newly-organized Rockaway Beach Athletic Club, an organization that was forced into publicity during the recent political canvass in Queens County by friends of District Attorney Fleming, with the hope that it would make certain the defeat of his successful opponent, Daniel Noble. It was proclaimed that the proposed exhibition was to be a flagrant violation of the law, and was but the first of a series that would take place in the event of Mr. Noble's election.

The first move toward stopping the exhibition was made to-day, when a complaint was filed with the District Attorney by John A. Remsen and other residents of Rockaway Beach, alleging that a breach of the law was contemplated at that place. The matter was laid before County Judge Garretson, and subpoenas were issued for Miss Stella Murray, the reputed owner of the building where the bouts are to take place; Samuel Murray, and John A. Remsen, to appear before the Judge to-morrow morning. A subpoena was also issued for "Billy" Madden, the well-known sporting man, who is manager of the show.

District Attorney Fleming held a conference with Sheriff Norton. The Sheriff said he was aware of the proposed fights, and considered them all right, and that he had arranged to have fourteen deputies present to preserve order. The Sheriff's attitude, it is said, did not please the District Attorney, and he arranged to make application to-morrow for warrants for the principals, and also for an injunction restraining the club from holding the exhibition.

The "bouts" scheduled are two of twenty rounds each between "Joe" Ellingsworth and "Fred" Morris, and "Con" Riordon and Frank Craig, and another of six rounds between Martin Flaherty and "Joe" Craig.

A special train has been engaged to leave this city on the evening of the show.

The New York Times
Published: November 28, 1893
Copyright © The New York Times

Boxing was illegal in many jurisdictions. This article not only talks about the cancellation of a boxing match but also mentions "Joe" Craig, the boxer managed by Hague in his years prior to politics.

Hague, now in his early twenties, would, like other males in the Shoe, pass time in the local saloon. The fact that Frank Hague's career would begin in a saloon was not unusual. The pub served as the center of the social, cultural and political life of the working class.[84] Jules Zanger, when discussing immigrant communities, noted that "after their churches, the centers of their communities in the new land were to be their neighborhood bakeries,

butcher shops, and saloons."[85] Jersey City had no shortage of saloons; by one count, the number exceed one thousand.[86]

In addition to the saloons, there were local ward clubs set up by the ward leaders and funded by the political machine that was led by county political boss Robert "Little Bob" Davis. Davis, born on March 6, 1848, was one of eleven children of Irish immigrant parents William Davis and Eliza Kinling. The family moved to Jersey City when Davis was an infant and lived on Bright Street. Davis attended Public School No. 3 and St. Peter's R.C. Elementary School, but by age eleven, he, like so many immigrant children, was working to help supplement the family finances. In 1868, he started to work as a gas meter reader and became an inspector for the Jersey City Gas Company. Through his job as a meter reader, Davis became a familiar and well-liked figure in his community and began to build his local power base by starting a civic organization, the (Robert) Davis Association. He would use his club to aid the local Democratic Party, and his efforts and loyalty did not go unnoticed. Davis was twice elected a Jersey City alderman (1885–88) and sheriff of Hudson County (1887–90). New Jersey governor Leon Abbett appointed Davis a police justice (1891–93), and in 1893, he was appointed warden (then called jailer) of the Hudson County Jail, a position described as a "big job," one of the political plums of Jersey City, and it significantly helped Davis's power as a politician. His last political appointment was as city collector from 1898 to his death in 1911.[87]

To some degree, the ward clubs such as those set up by Davis were in direct competition with the neighborhood saloons, which were in effect,

Hudson County political boss Robert "Little Bob" Davis.
Courtesy of Jersey City Public Library.

according to Connors, "little islands of power." Each saloonkeeper had his own following of supporters, and the one particular saloon where Hague, a lifelong nondrinker (most probably for medical rather than religious or moral reasons), spent a good deal of time was the Greenwood Social Club, owned by Ned Kenny. Kenny was a well-known figure in the Shoe and was often referred to as the "Mayor of Cork Row"; like most saloonkeepers in the urban ethnic neighborhoods of America's cities, Kenny served as "sage, an arbiter of small disputes and an interpreter of the mysteries of politics."[88] Kenny understood the influence and power that politics brought; however, he had no political aspirations of his own. Instead, he very much wanted to be the power behind the candidate. In an effort to gain control of the second ward, Kenny broke his political allegiance to second ward leader McLaughlin. McLaughlin, who, according to an 1893 *New York Times* article, had a net worth estimated to be in excess of $1 million (about $20 million in today's dollars), did not take kindly to the challenge.[89] Kenny was not intimidated by McLaughlin's power or money and relished the day for an opportunity to challenge McLaughlin for supremacy of the ward. That day arrived in 1896 in the form of an upcoming race for constable.

Needing a candidate to challenge the McLaughlin candidate Jack Harnett, Kenny asked Hague to run for the position. Although a nonpaying, mostly ceremonial position, it allowed Hague to extract the revenge he had sought against McLaughlin. Hague was reported to be a great campaigner, going door to door in every flat in the second ward. Although most sources attribute his victory to these efforts, others have reported that it was Kenny's stealing of the ballot box in his saloon, which served as a polling station, and then altering the ballots.[90] This account may very well be factual, as it was not uncommon for those who had a vested interest in an election (this was usually a neighborhood saloon owner) to have polling places located right inside their saloons or in the saloon of a trusted lieutenant.[91]

Not long after this victory, the Hague-Kenny friendship, like the Hague-McLaughlin friendship, soured. Hague had become disgruntled with a position that had no salary and only paid a fee when he arrested or served papers on someone, that someone usually being a friend from his Horseshoe neighborhood. Hague decided that it was time for him to take control of his own political life and set out to undermine both McLaughlin and Kenny.

Realizing that there was strength in numbers, he immediately began the process of organizing his close Horseshoe friends into a tightly knit Hague faction. With this group in place, Hague went on to commit an act of supreme defiance, especially in the hierarchal system of political machines.

Instead of going up the chain of command, Hague bypassed the official ward leader, McLaughlin, as well as his rival Ned Kenny, and went directly to the boss of the Hudson County Democratic machine, Robert Davis, offering the services of his newly organized group.[92] Davis, however, was reluctant to make any waves in the Horseshoe and rejected Hague's offer, but this would soon change. In 1899, it was clear that Davis's candidate for Hudson County sheriff, Bill Heller, was in trouble and was likely to be defeated by his Republican challenger in the 1890 election. Davis blamed McLaughlin for not working hard enough and asked Hague to mobilize his followers to help secure a reelection victory for Heller. When Heller won, Davis rewarded Hague with the position of deputy sheriff at a salary of twenty-five dollars per week, three times his earning while he was at the railroad.[93]

Because of his ability to secure votes, Davis remained more tolerant of Hague's use of strong-arm tactics and his abuse of his power as a deputy sheriff. The most egregious of these abuses came when, in an attempt at voter intimidation, Hague arrested a group of black Republican voters for voter fraud.[94] For the Davis organization, this incident would become an embarrassment, but the fallout from the event was minimal as this was still a period when African Americans were considered second-class citizens. The incident, however, would become a problem for Frank Hague at a later date, when he would fail to appear at a hearing regarding the arrested voters. On the day the hearing was scheduled in a Hudson County courtroom, Frank Hague was in a Boston courtroom.[95] Hague's actions in this Boston courtroom in 1904 should have rendered him an untouchable commodity by any political organization and permanently ended his political career.[96]

Thomas "Red" Dugan, one of Hague's childhood buddies from the Horseshoe, was arrested in Boston for forgery and passing a bad check. In what one author has described as "a legendary impassioned plea," Dugan's mother prevailed on Hague, who had developed a fairly large following in the second ward, to go to Boston and help her son.[97] This help would come in the form of providing an alibi for Dugan. Hague, knowing full well that he was lying under oath and could be jailed for perjury, testified that, although he could not be certain, he believed he had seen Dugan in a park in Jersey City on the day of the crime. Dugan would later confess to the crime, and Massachusetts authorities would lobby to have Hague extradited to their state to stand trial for perjury.[98] What the people of the commonwealth of Massachusetts didn't realize was that in the world where Frank Hague came from, the values of loyalty and neighborhood reigned supreme over the law; they were not familiar with the Horseshoe's mantra of "Us Against

the World." Hague's willingness to lie under oath to save a friend did not diminish his popularity; to the contrary, consistent with the ethos of his environment, his actions actually increased his status with his Horseshoe neighbors. Frank Hague was a hero. Rather than bury the scandal, Hague used it to his full advantage, dragging Dugan's mother to appear at his side at campaign rallies.[99]

There was still the outstanding matter of Hague's arrest of the black Republican voters; however, Boss Davis intervened on Hague's behalf. Following a verbal lashing from Judge John A. Blair, a $100 fine and forfeiture of his post as deputy sheriff, the matter was closed with Hague not having to serve any jail time. Despite continued pleas for Hague's extradition to Massachusetts, the request fell on silent ears.[100]

Bob Davis's kindness to Hague was not purely altruistic; the fact is that he desperately needed Hague's help. There was a change occurring on the political landscape of New Jersey with a rise in the movement known as Progressivism. This backlash against big business and its control of the New Jersey legislature, which was under Republican control from 1894 through 1910 (save 1907), was being led by Republican Mark Fagan, a Jersey City undertaker. Fagan had stunned the Davis organization by winning the 1901

Mayor Mark Fagan.

election for mayor by running as a Republican on a platform that included ending the tax breaks given to large corporations and the railroads.[101] The railroads, while continuing to increase their presence in Jersey City, had remained exempt from paying millions in local taxes. Some of Jersey City's most valuable property (worth $19,934,546, or about $500 million in 2011) was owned by the railroads, yet they paid taxes at a rate of only two-thirds that of other commercial real estate owners. Connors estimated that the railroads owed up to 30 percent of Jersey City real estate.[102] While the railroads continued to benefit, the treasury of Jersey City went begging, causing a severe curtailment in the delivery of essential services. Even with this decrease in services and the struggling city treasury, Fagan, who during his tenure as mayor of Jersey City was responsible for the building of a number of public schools, as well as a new high school where working adults could attend in the evening, easily won reelection over the Davis candidate in both 1903 and 1905.[103]

The Progressive movement of Mark Fagan was not embraced by all Republicans and was beginning to cause a crack in the unity of the party, which threatened its monopoly in Trenton. By the time the 1907 election rolled around, the Davis organization had reinvented itself, having stolen Fagan's reform program and adopted it as its own, simultaneously dropping its aging candidates and filling the slate with young progressives. Among these reformers in the newly oiled Davis machine was Joseph P. Tumulty, a Jersey City lawyer who would later go on to become President Woodrow Wilson's personal secretary. Davis, now cloaked in his newly knitted reformer cape, recognized political talent and loyalty, and although (or perhaps because) he still carried the baggage of the Red Dugan affair, he selected young Frank Hague as the new leader of the second ward.[104]

In another surprise move, Davis selected H. Otto Wittpenn to challenge the popular Fagan. Wittpenn had become a persona non grata among members of the Davis organization because of his refusal to go along with their suggestions for patronage positions. It was this refusal that increased his appeal with the public and gave him an independent thinker image among voters, an image that allowed him to be elected Hudson County supervisor by an overwhelming majority. Davis, recognizing Wittpenn's voter appeal, was convinced that he could beat Fagan in the upcoming mayoral election, but as in most Davis transactions, there was quid pro quo involved. He offered the slot to Wittpenn in exchange for a promise to allow him (Davis) to control all patronage positions, as well as having the city enter into a contract worth in excess of $1 million with his company, the Jersey City Supply Company,

Above: James Tumulty, a Jersey City lawyer who would later become the personal secretary to President Woodrow Wilson. *Courtesy Library of Congress.*

Left: President Woodrow Wilson. *Courtesy Library of Congress.*

to supply the city's water. The offer was too great for Wittpenn to pass up, and he agreed.[105]

Despite his two consecutive victories as a Republican, Mayor Fagan was having great difficulty obtaining support from the state Republican Party in his reelection bid. His strong reformer message, as well as his support of the "New Idea" Republican faction of President Theodore Roosevelt, so enraged the old-line Republicans that they now vowed to destroy Fagan in his bid for reelection as Jersey City mayor.[106] The state Republican Party was heavily influenced by the railroads, especially the Pennsylvania Railroad, a major financial supporter of the New Jersey Republican Party.[107] It was this financial support that allowed the Pennsylvania Railroad to exercise influence over the Republican-controlled legislature, and the company was in no mood to lose its tax benefits and end its cartel because some members of the Republican Party wanted to take up the mantle of reformer. Likewise, the party was not going to jeopardize its funding source.[108] In an all-out effort to defeat Fagan, the local Republican organization did the unthinkable: it backed the Democrat Wittpenn for the office of mayor. Wittpenn's margin of victory, even with the backing of a revitalized Davis organization as well as the opposition party, was a mere 9,500 votes.[109] On the state level, the split in the Republican Party was sufficient enough to cause it to lose control of the State Assembly for the first time in thirteen years. Davis would now name Hague to the Democratic executive committee of Hudson County, and despite editorial complaints from newspapers statewide, he named Hague as sergeant-at-arms for the New Jersey State Assembly.[110]

Among the wards that went heavily for Wittpenn was the second ward, which had been managed by Hague, and although he was given the position of sergeant-at-arms in the assembly, he was seeking a more substantial reward: the post of city hall custodian. It was a job that paid $2,000 per year, and despite its title, the appointment involved a great deal more than pushing a broom; it was a position that controlled a number of jobs, and Hague knew that by controlling these jobs he could increase loyalty to him and thus increase his own political strength.[111]

County boss Davis refused Hague's request for the position. The reason for the refusal was due in some part to the use of violence by young Hague supporters, who were quick to fight and had used intimidation tactics on Fagan supporters in line at polling places. But it was not the use of violence that was the problem; both violence and voter intimidation were well-accepted parts of the election day scene in Jersey City. The problem was that of perceived disrespect. Hague's offering of his "boys" to other

ward leaders without first consulting Davis was viewed as a lack of respect, and Davis felt that by denying Hague the position he could teach him a lesson.[112] While others would have accepted this decision and let the issue die, this was not Frank Hague's style. Hague immediately presented himself to the office of the newly elected mayor, Otto Wittpenn. Wittpenn had already been having second thoughts about his promise to Davis regarding control of all patronage positions, and seizing the opportunity to show his independence he immediately appointed Hague to the position of city hall custodian.[113]

Upon hearing the news, Davis immediately removed Hague as second ward leader and replaced him with John Sheehy. Hague's removal as ward leader was so contentious that violence erupted between a Hague supporter, James Connolly, and Joseph Maucha, a supporter of new ward boss Sheehy. The brawl between the two was so violent that Maucha died as a result of the altercation.[114] Davis then sent an order to the board of aldermen to pass an ordinance giving them, instead of Hague, control of the custodian position. Hague realized that the aldermen were all yes men for Davis and that the passage of this bill, if brought up for a vote, was a foregone conclusion, so Hague set about to prevent the bill from being posted. This was done through the now common Hague practice of intimidation. Hague's "boys" roughed up the aide to John Sheehy, the new leader of the second ward, and made sure that word reached the aldermen—it did. The bill was never brought to a vote, and Frank Hague had given more than a minor jolt to the Davis machine. In the 1909 election, Wittpenn was again pitted against Fagan, and again the Republican organization opposed its own party's candidate, thus ensuring Wittpenn's reelection. Although there is no way to confirm it, there must have been a four-leaf clover in Frank Hague's pocket because his next move, like that of the Red Dugan perjury charge, should have ended Frank Hague's political ambitions.

Wittpenn, now in his second term as mayor, was being urged by Hague to announce his candidacy to be the Democratic Party's nominee in the upcoming governor's race. Already at odds with the county Democratic leadership over the Hague appointment as city hall custodian, Hague suggested that Wittpenn could forever end his indebtedness to Bob Davis. Wittpenn, who was planning to run as a reformer on an anti-boss platform, had reservations about publicly attacking Davis. These fears, however, must have been only minimal, as he allowed Hague to organize Wittpenn for Governor Clubs in all of the city's wards. Hague viewed Wittpenn's fear of offending Davis as a hindrance to the campaign and instructed Wittpenn to

ask Davis to publicly state his support for his candidacy, but Davis demurred, instead saying that he would wait. The reason for Davis's hesitation was not an objection to Wittpenn's candidacy, to which he was ambivalent; his greater concern was the possibility that Frank Hague would become a kingmaker, the proverbial power behind the throne.

Having paid the customary courtesy of first asking Davis for his endorsement, Hague now urged Wittpenn to publicly announce his candidacy and to besmirch Davis and his group as machine politicians who put their own interests, both political and financial, before those of the people of Jersey City. Wittpenn dutifully obliged, saying, "I have endured the machine as long as possible, but patience is no longer a virtue."[115]

Wittpenn's announcement caught Davis by surprise, and he immediately set the wheels in motion to prevent Wittpenn from receiving the nomination. Davis and the state committeemen from the Hudson County delegation were ready to support former Trenton mayor and the party's gubernatorial candidate in the 1907 election, Frank Katzenbach. In addition to stopping Wittpenn, Davis may have felt some obligation to Katzenbach, who had lost the 1907 election by a mere eight thousand votes, having only received about half the number of votes from Hudson County compared to what other Democratic candidates had received in previous elections. Although he denied it, Katzenbach believed that Davis had intentionally sabotaged his 1907 gubernatorial campaign, believing him to be the candidate of his archrival, James Smith, the Democratic boss of Essex County.

The third candidate being considered was Princeton University president Woodrow Wilson. Wilson's name had been bandied about for a U.S. Senate seat, and it was no secret that he was tiring of his position at Princeton and was actually seeking a career in politics. When the name of Wilson was presented to Essex County boss Smith, he was at first reluctant to support the idea. Eventually, after giving some thought to the matter, he realized that a man like Wilson had larger aspirations and that he would probably only be a one-term governor. Additionally and more importantly, Smith mistakenly believed that Wilson, a political novice, would be easily controlled.[116]

At the state convention, Smith was somewhat surprised at the groundswell of support for Katzenbach. Even James Nugent, the state Democratic boss and Smith's son-in-law, was strongly opposed to Wilson and told his father-in-law that he believed he was making a mistake in supporting Wilson. Smith, upon realizing that there was not enough support for Wilson to win the nomination, exercised the art of political practicality, a tactic that was practiced only by the most skillful and successful of the machine bosses.

In a last-minute effort to save the Wilson nomination, Smith approached his archenemy, Robert Davis, and asked him to have the Hudson delegation switch its support from Katzenbach to Wilson. Under this agreement, Davis was promised a role in running the state government should Wilson be elected. Davis agreed. In addition to the power-sharing deal made to Davis by Smith, Davis's compliance with the request was no doubt influenced by his realization that if he withheld his support of Wilson, Smith could turn his Essex delegation to support Davis's new political opponent, Jersey City mayor Otto Wittpenn.

Neither Davis nor Smith had any interest in seeing the reform movement take hold, as each was heavily entrenched in the companies that shaped New Jersey legislation. As alluded to earlier, ideology seldom played a role in lives of political bosses and their machines. Although chairman of the Essex County Democratic Organization, Smith was a leading financier and banker in the state and, as such, had very close relations with a number of Republicans. Davis controlled four of the largest utilities in the state: the Northern Street Railway Company, Jersey-Hoboken Railroad, the Hudson County Gas Company and the U.S. Electric Company.[117] Both Smith and Davis saw in Wilson someone who understood big business and could protect their financial as well as political interests.

Once Frank Katzenbach heard of this union between Smith and Davis, he realized that it would be impossible for him to attain the nomination and instead withdrew his name and joined the Wilson bandwagon. This virtually cleared the way for Wilson's nomination, and the only matter left was the formality of receiving the official nomination at the state convention in 1910.[118]

On July 14, 1910, an infuriated Wittpenn confronted Wilson at his Lyme, Connecticut home. Wittpenn tried to convince Wilson that he, in fact, was the anti-boss candidate and that the public would perceive Wilson as a puppet of the bosses.[119] The attempt to sway Wilson fell on deaf ears. He not only refused to withdraw from the contest but also would not distance himself from the Davis-Smith alliance. For the sake of party unity, Wittpenn was asked to withdraw his name from consideration before the convention but refused.

Wittpenn's only hope (as well as Hague's) was the upcoming Democratic state convention, where the nominee of the party would be officially selected. Hague's plan was to stack the convention with Horseshoe buddies who would raise the noise level for Wittpenn, believing that this appearance of support would cause delegates to rethink their vote and throw their support

to Wittpenn. However, Davis and Smith were far from novices, and both bosses poured bundles of money into Jersey City so that city employees could be bussed to the convention in Trenton in order to present boisterous enthusiasm for the nomination of Wilson. Wilson won the nomination with over 66 percent of the delegates.[120]

Wilson went on to ask Wittpenn for his help in the general election, but more important was his request for Wittpenn to refrain from running a competing ticket against the Davis slate in Jersey City. Hague urged Wittpenn to refuse; however, being the loyal Democrat he was, Wittpenn consented to the request. For Frank Hague, there was no turning back, and Hague decided to run his own citywide slate of candidates to challenge Davis. Shortly before election day, the pressure of the Davis machine succeeded in having every candidate on Hague's sponsored slate, except those in the second ward, withdraw from the race.[121] In the end, even Hague's remaining candidates for city council and alderman in the second ward were soundly defeated, and Woodrow Wilson was elected governor. Most political watchers viewed the defeat as the nail in Hague's political coffin. But Hague, unlike many of his contemporaries, had an uncanny ability to maximize opportunities on the political landscape when they presented themselves—it was an ability that would help him throughout his political life.

During Wilson's gubernatorial campaign, Essex County boss James Smith had publicly announced that he would not seek to return to the U.S. Senate, where he had previously served as the representative from New Jersey. Shortly after Wilson's election, Smith had a change of heart, deciding that he would seek reelection. When Wilson learned of this, he confronted Smith and asked him not to run because he (Wilson) believed that if Smith ran it would make the new governor appear as nothing more than the typical disingenuous politician. Smith refused to back down. Wilson now took his fight to the people, and in this Wilson-Smith feud, Hague spotted his opening.[122]

Having realized that it was Davis who was responsible for denying Wittpenn the nomination, Hague and Wittpenn were now in an all-out war with Davis. The two began to publicly support the Wilson anti-boss position. Both Wittpenn's and Hague's speeches in support of Wilson received statewide newspaper coverage, and in the end, Smith would relent and withdraw from the senatorial race. Hague and Wittpenn were not shy in publicly taking credit for helping Wilson defeat Smith, and it was a move that revived Hague's almost lifeless political career. Hague's career would receive additional breaths of life when Hudson County Democratic boss Bob Davis died shortly thereafter from intestinal cancer.[123] Wittpenn, who had earlier

WITTPENN WRESTING CONTROL FROM DAVIS

Hudson County, N. J., Democratic Boss in a Desperate Fight to Stay in Power.

PRIMARIES THE REAL TEST

Jersey City's Mayor Out for the Governorship, but Is Expected to Swing to Woodrow Wilson.

Hudson County will be the most furious political storm centre in all of New Jersey all this week. The Wittpenn forces and the "Bob" Davis forces are to be lined up between this and Saturday night for the most desperate battle at the primaries of Tuesday of next week in all the history of the State. If Mayor Wittpenn should win out, as the disinterested political prophets predict he will, the sceptre of power will have been wrested from Davis's hands, and the twenty-year rule of one of the most noted and one of the most absolute of Jersey bosses will end forever.

For nearly forty years Hudson County has lived under the rule of a political boss. In the early seventies it was "Bill" Bumsted, then it was "Billy" McAvoy, after him came "Denny" McLaughlin. Now it is "Bob" Davis. Mayor Wittpenn is the first man in political, business, or social life who has dared to seriously challenge the supremacy of any of them.

The local situation makes the challenge by the Jersey City Mayor of the Davis autocracy a serious and a dangerous one—for Davis. There are four political divisions in Bob Davis's local empire. In the early days of his power they were all under his heel. But they have gradually drifted away from him, till Jersey City is the last of his citadels left to him. Bayonne is in the control of a machine that is against him. North Hudson has cut loose from his domination. The election of a Republican Mayor in Hoboken destroyed his power there. Davis has managed to overpower them all in conventions by his supremacy in Jersey City—the equal in population and political importance of all of them combined. The loss of Jersey City will take the last of his strongholds from him.

Nominally, the bone of contention between the two well organized armies of political workers is the Governorship of the State. Without probably ever expecting to reach the nomination, but with the idea of achieving other advancement, Mayor Wittpenn, early in the campaign, announced his candidacy for the office, and was immediately met with the ultimatum from the Davis camp that he could not have even his home delegation from Hudson at his back in the convention—the prerequisite, as a rule, in Jersey State Conventions, of a successful campaign for a State office. The Mayor sent back word to the Democratic chieftain that he proposed to elect a delegation to the State Convention that would support him for the nomination over Davis's head. And the war was on at once.

In the earlier days, H. Otto Wittpenn and Robert Davis were friendly. Davis's chief political possession has been his absolute mastership over the Board of Freeholders, which manages the affairs of the county. Over the board the county

has a Supervisor, from whose veto of the board's work no appeal lies. Davis made a Supervisor of Wittpenn. When Wittpenn looked upon the board's acts that he was expected to approve, he found much to criticise, and felt forced to stand in the way of a lot of the board's schemes of extravagance or worse. Davis would have liked to throw him out of office for his contumacy, at the end of his first term, but circumstances forced him to consent to a renomination, and Wittpenn, who had been first elected by a majority of less than 4,000, went into office for the second time with a majority of more than 20,000 at his back.

During his second term there was even more friction than there had been during his first term between the Davis board and the Supervisor. But Wittpenn kept right at his independent work, and when he thought he would like to be Mayor of Jersey City, Davis was glad to help him get the nomination for that office; it would take him out of the other office, where he was so much in the way. Mark M. Fagan, then a sort of a popular idol in Jersey City, was its Mayor at the time. He had been elected three times by swinging majorities, all the more remarkable because he was a Republican and Jersey City is a Democratic stronghold, when Wittpenn threw down the glove to him. In a notable struggle, Wittpenn made his canvass on his record in the Supervisor's office, which the Davis crowd had so much disliked, and drove Fagan from the Mayoralty. He carried every ward—almost every precinct—in the city, and became Mayor with the unprecedented majority of 9,324.

It was not long before Wittpenn, in the Mayoralty, and Boss Davis came to the parting of the ways. The Mayor made a City Collector of Davis, but declined to accept the boss's advice as to the filling of the other city places; and during the four years his two terms have covered he has busied himself in building up, all over Davis in his city collectorship offices and all around it, the machine of anti-Davis local officialdom with which he now hopes to crush him.

Those who know best say that in the rearing of the anti-Davis machine Mayor Wittpenn has paid a politician's regard to its personnel and that it presents a compact front of practiced, effective, and efficient workers; while Davis will go forth to combat with a reduced and scattered and disheartened army, wholly unequal to the new force of enthusiastic dependents at the Mayor's command, and that the end of it must be the taking from Davis the last foothold of his bossship in the county.

Davis's friends do not, of course, admit that the end is so near, but the Wittpenn workers say Davis's followers are only whistling to keep up their courage when they boast that all but thirty of the hundred-odd delegates to the convention from Hudson will be followers of the beleaguered chieftain.

Whatever the outcome of the contest, it will have no effect on the vote of the convention in the choice of the Democratic candidate for Governor. Either delegation is expected to swing into line for Dr. Woodrow Wilson at the psychological moment, as it is generally believed that Wittpenn cannot get enough delegates outside of Jersey City to give him the place.

The New York Times

Published: September 5, 1910
Copyright © The New York Times

The battle for control of Hudson County.

feared that he would lose his mayoral contest to the Davis-backed candidate, watched the infighting for supremacy within the Davis organization with delight, confident now of his reelection success.

One of the first pieces of legislation that newly elected Governor Wilson proposed and passed was known as the Walsh Act. The legislation was part of the reforms that Wilson was attempting to institute and was strongly opposed by the machine bosses. The law authorized, by referendum, municipalities to form a commission structure of government. The commission would take over "all administrative, judicial and legislative powers and duties now possessed by the mayor and city council and all other executive or legislative bodies."[124]

Connors described the governmental structure of Jersey City in the early twentieth century as "a patchwork quilt" of charters and legislative acts. Elected posts included a mayor, a president of the board of aldermen, a board of aldermen (each ward selecting two), a five-member Street and Water Commission (selected at large) and a three-member police commission, as well as two police magistrates who administered local justice. It was a system that was cumbersome and extremely complex.[125] Despite a personal appearance by Wilson, as well as an endorsement from Wittpenn, the political machine in Jersey City went to work and was successful in defeating the referendum. Wittpenn, however, was successful in his reelection bid for a third term as mayor.[126] The issue of charter change would have to wait another two years before its reappearance on the ballot in Jersey City.

With Wittpenn's victory, Hague's political ascent continued as well. Hague was elected to the patronage-rich five-member Street and Water Commission, and while Wittpenn supported his candidacy, Hague was still determined to develop his own identity and reputation exclusive of Wittpenn. He began by enforcing the city's anti-littering ordinance and requiring the streets to be cleaned every night by hosing them with water from the fire hydrants. At one point, Hague sent a letter to Police Chief Benjamin Murphy demanding that his men arrest anyone who violated the anti-litter law. Murphy balked, believing that it was a waste of time and manpower. However, Wittpenn was starting to feel some backlash from members of the press, who were asking why he wasn't forcing police to enforce the law, and he ordered Murphy to arrest violators. For one month, Murphy followed through with the request and then stopped, but it didn't matter. Hague had achieved his goal—he was the city's clean streets man. Additional public accolades were heaped on Hague from the local press for his instituting cost-cutting measures and for decreasing the number of employees in his department from 218 to 116. Eventually, Hague quietly

increased the number of employees, most of whom were his friends from the second ward, to a higher figure than previous.[127]

While Frank Hague was increasing his visibility in Jersey City, Mayor Wittpenn would again focus his eyes on the statehouse. Hoping to succeed Wilson if the latter was successful in his current bid for the White House, Wittpenn continued to support Wilson. However, support for Wilson was not unanimous among state Democrats. The main opposition came from Essex County Democratic boss Jim Smith, who felt that he had been betrayed and used by Wilson and headed up the "Stop Wilson" movement. In this movement Frank Hague again saw opportunity. Hague, the great chameleon who had previously supported Wilson, would now shed his reformer skin, abandon Wittpenn and other Hudson Democrats and join Essex County boss James Smith by becoming the Hudson County representative in the "Stop Wilson" movement. Hague would also join with former members of the now fragmented Davis organization in an effort to challenge Wittpenn, the heir apparent to replace the late Bob Davis as the leader of the Hudson County Democratic organization.

In the end, Wilson would win the presidency, and Wittpenn would have one of his assistants named as head of the Hudson County Democratic organization. With Wilson's victory, Wittpenn now saw clear sailing to the statehouse, while Frank Hague, although still a member of the city's Street and Water Commission, had all of his patronage stripped by Wittpenn, a retaliatory move by the mayor. For all intents and purposes, Frank Hague's political career was over, yet within six months Hague would achieve what has been described as nothing short of a political miracle, becoming the dominant voice in governing Jersey City for the next thirty years.

THE DIRECTOR OF
PUBLIC SAFETY

When looking at the early political life of Frank Hague, one cannot help but notice that the seeds of political genius existed very early. Although luck and timing played a role to some degree, Hague's real talent was his uncanny ability to turn adversity to advantage. The other aspect of Hague that was not evident in most of his competitors was his willingness to take risks. This can be attributed to his youthful environment in the Horseshoe, where risk-taking was an everyday event. A perfect example of this can be seen in 1913, when the issue of charter reform was once again on the ballot in Jersey City.

The *Jersey Journal*, widely regarded as a progressive Republican paper, and its editor, Joseph Dear, were on a mission to have the reform measure passed, and Dear gladly allowed his paper to be used by anyone promoting the passage of the legislation. In essence, a candidate could obtain massive amounts of free advertising, and while Wittpenn failed to take advantage of this, Hague did not.[128]

Having already gone on record as supporting charter change and realizing the strong support for the change by the city's newspaper, Hague began issuing press releases touting himself as a reformer and proponent of change, which garnered him columns of free publicity in the local daily. Hague's rise coincided with that of the penny press. With his name constantly appearing in the press, Hague was able to establish credibility as a reformer and began campaigning hard against Wittpenn's gubernatorial bid. Meanwhile, Jersey City native James Fielder, an attorney who served as a state assemblyman and state senator, had announced his candidacy for the Democratic nomination for governor; he would seek and obtain Hague's endorsement.

Hague was able to develop a symbiotic relationship with the press, and taking full advantage of this, he was successful in reinventing his image as a reformer while simultaneously diminishing Wittpenn's reformer image, the very image that Wittpenn had hoped would carry him into Trenton. And while Hague's use of the newspapers to tear down the reformer image of Otto Wittpenn was successful, one cannot help but believe that to a great degree it was Wittpenn himself whose inability to take risk and make decisions was the real cause of destroying his reformer image. A perfect example of this can be seen when it was clearly obvious that the drive for a commission government was gaining public support even among the hard-line political bosses. Wittpenn, fearing that he was being scrutinized by the few of the old line of political supporters who were still in opposition to charter change, continued to straddle the fence on the issue. When it became clear that the referendum would pass, in a classic case of "too little, too late," Wittpenn issued a statement stating his support of the charter change with just four days left before the vote.[129]

In a continuing series of blunders by Wittpenn, his next one should have been fatal. In 1913, an interparty battle was shaping up for the position of state treasurer between Jersey City banker Edward I. Edwards and state party chairman Edward Grosscup. The position was filled by joint resolution of the state legislature, and since Democrats controlled both houses for the first time since 1893, party lines were not an issue. It was a matter of which man could gather the most votes in the chambers.[130] Mayor Wittpenn, who was eager for Wilson's endorsement in his gubernatorial run and was keenly aware of Wilson's strong support of Grosscup, ordered the Hudson County Assembly delegation in Trenton to back Grosscup's bid. The move angered Edwards and his other banker friends, who proceeded to line themselves up behind Frank Hague, who had orchestrated the Hudson County Democratic Committee to rescind its previous endorsement of Wittpenn's candidacy and now came out in support of his candidate for Governor James Fielder.[131]

In what had been originally viewed to be an uncontested primary with the naming of Wittpenn as the Democratic candidate, the race was now shaping up as a major political contest between Otto Wittpenn and James Fielder, the senate president and the acting governor. On election day on April 15, 1913, the citizens of Jersey City approved charter reform, and James Fielder won the nomination.[132] Frank Hague was aboard a rocket that was about to launch him into a three-decade career.

Now that the citizens of Jersey City had passed the reform act, it needed to be implemented. Under the change, the rules called for a preliminary

election to be held, with all candidates being listed alphabetically. The top ten vote getters would then compete in a runoff election for the five new commission seats. Interest for one of the seats was extremely high, with ninety-one names listed. Among the entries was a slate of candidates backed by Wittpenn. Wittpenn himself was not on the ballot, choosing instead to concentrate on his rapidly evaporating statewide campaign. Also among the lengthy roster of candidates was a three-man slate put together by Frank Hague, which included himself.

When the counting was finished on election day, all five candidates of the Wittpenn ticket, as well as Hague and his running mates, were survivors. The top vote getter was former mayor Mark Fagan, with the last spot going to Jersey City businessman and Republican Thomas Stewart.[133]

The race for the five available seats began almost immediately, and it became an all-out battle, with the "Hague Three," Fagan and Stewart forming an alliance against the "Wittpenn machine government." This alliance with Republicans caused Hague to be labeled as a traitor to the Democratic Party. Hague, in an early version of what today would be called spin doctoring, responded that it was true that he was disloyal to Wittpenn—however, he said, in his disloyalty to Wittpenn he was being loyal to the people of Jersey City. His criticism of Wittpenn was painted in a way that portrayed Wittpenn as selling out to big business, while he (Hague) had always stood with the people and against big business; in what would become a hallmark of Hague politicking in the future, he enlisted the aid of the Catholic Church, specifically his local priest, Monsignor Sheppard, who took to the pulpit to endorse Hague and openly criticized the "boss" candidates.[134]

On June 10, 1913, the voters again would give former mayor and Republican Mark Fagan a 2,500-vote plurality over the second-place finisher George Brensinger (a Wittpenn candidate), with another Wittpenn man, James Ferris, finishing in the third slot. The fourth position went to Hague, with Wittpenn secretary A. Harry Moore, who was surreptitiously supporting Hague, winning the remaining seat. As was the custom, the top vote getter, in this case Mark Fagan, was assigned the position of mayor, with the other commissioners being named department heads. Hague was appointed director of public safety, which gave him control of the police and fire departments.[135]

The police forces of major urban America in the late 1800s and into the 1930s were nothing like the modern police departments that we are familiar with today. It was an era when police had very little effect on the crime rate.

FIRST COMMISSION VOTE.

Jersey City Chooses To-day 10 Candidates for New Government.

Citizens of Jersey City will register to-day at the polls their choice of candidates to make the race for places as City Fathers under the new commission form of government. Each voter will pick five candidates from among ninety-three willing applicants who have filed with John H. Morris, city Clerk, petitions bearing the requisite 165 names each. The ten who receive the greatest number of votes will be the nominees for a special election to be held on June 10, when the voters will make their final selection of five out of the ten. The five Commissioners thus elected will choose from their number a President of the board, who will act as Mayor.

The ninety-three candidates who have filed petitions represent every kind of political opinion. There are Socialists, Democrats, Republicans, Independents, Prohibitionists, and Bull Moosers. The new commission will assume office one week after the general municipal election, or on June 17, when Mayor H. Otto Wittpen will have completed his six-year term as Mayor.

Every tree, post, fence, and billboard in Jersey City bears placards with the name and lithograph of some aspirant for office under the caption "For Commissioner." Henry Byrne is one of the most prominent candidates in the field. He owns 125 buildings, houses, factories, and office buildings, and is a believer in non-partisan municipal politics. He favors the development of the city's water front and the encouragement of manufacturers to locate on the border of the city. Mark M. Fagan, an undertaker, who was Mayor of the city for six years before the defeat of the Republicans by the Democrats under Mayor Wittpen, has a strong following and is expected to qualify for the final election. In addition to Mr. Fagan the strongest Republican candidates are said to be John H. Weastell, John C. Kaiser, Andrew Knox, and John Rotherham.

The faction of the Democratic organization which is supporting Mayor Wittpenn's policies is expected to vote for A. Harry Moore, John H. Morris, Joseph F. Farmer, and Charles P. Colwell.

COHALAN BACK AT WORK.

Supreme Court Justice Has Recovered from Operation.

Supreme Court Justice Daniel F. Cohalan, who was operated on for appendicitis at Roosevelt Hospital five weeks ago, is now taking up judicial matters which had been awaiting his attention. There were no complications to the operation, and after three weeks in the hospital Justice Cohalan went to his home, where he has been for a fortnight.

He plans to sail for Europe with his children on May 29.

The New York Times
Published: May 13, 1913
Copyright © The New York Times

Eric Monokkonen, when speaking of the police of this period, noted: "If the appearance of a uniform deterred any potential criminals, their non-behavior left little or no mark in the historical record."[136] Police in this period were mainly used for removing drunks from the streets, reporting open sewers and shooting stray dogs. Hague recognized the underutilization of manpower in this area of essential public service and took upon himself a complete restructuring of the force. Hague has been grossly less recognized in this area, and although he has been given some credit, scant mention is made of the magnitude of Hague's undertaking and his accomplishments in restructuring and reforming the Jersey City Police Department.

One of the first problems that Hague encountered was widespread police corruption, a problem that was not isolated to Jersey City. Sherman argued that police corruption existed in "virtually every urban police department in the United States." Most of this corruption revolved around vices such as prostitution, drugs (which included alcohol during prohibition) and gambling.[137] Although in theory they were engaged in law enforcement, most police departments in America's cities systematically ignored these violations. Additionally, even when they wanted to make an

Ninety-three candidates, including Frank Hague, ran for the ten available spots on the newly created commission. *Courtesy of Jersey City Public Library.*

arrest, there wasn't a high probability of success, since most cities either did not have the funds or choose not to spend the money to properly train their officers. This can be seen in an August 27, 1899 incident in Jersey City when a homeless man carrying a parcel on the street was ordered to stop by a man who had failed in identifying himself as a police offer. The suspect ran, and the officer fired two shots; the man's parcel contained a loaf of bread that he thought was going to be stolen from him.[138] As late as 1900, large cities such as Chicago, which had more than three thousand police officers, still lacked organized training. Not only did they lack policing skills, but they were also completely ignorant of legal procedure.[139] In Jersey City, like in most other cities, there was a local police court, where those arrested were brought before police justices who did not always possess legal training.[140]

The role of the patrolman was an evolutionary process that began with sheriffs, constables and night watchmen. Because these men were appointed and not elected, with wide latitude of discretion given to those in power, corruption was very common. The citizens and local businesses regarded most police departments as corrupt and ineffective, subservient to local politics and totally incapable of providing the level of protection they felt they required.[141] This was especially true when one examines the lackadaisical and undisciplined attitude of the police department inherited by Frank Hague.[142]

In about the middle of the nineteenth century, police and fire departments were the most valuable groups to the political organizations in power. This was a period when there was no civil service to protect their jobs, and they could be fired and hired at the whim of the local political leader. Promotions were determined by the amount of money that an individual could pay and thus became a lucrative source of income for the political organization in power. Once in the position of police or fire officer, one needed to retain his position, which was done through heeding the dictates of the ward leaders. It was a system that caused total demoralization of both the fire and police personnel. It was a system that, because of the insecurity of the job, created widespread police graft.

Police in Jersey City, as well as in other large cities, were protecting, directing and sharing in the profits of gambling halls, brothels and other illegal activities. Attempts by church leaders and citizen groups to root out bad cops or suppress vice were met with constant failure. In 1905, in an all-out effort to stem corruption within the force, a civil service act was put into effect. This change had little effect, since the policemen on the beat, civil service or not, couldn't resist the temptation of a few extra dollars. When

attempts were made to fix the problem by changing the top officers of the force, this failed as well. In fact, every known attempt to curb the graft by police officers and the violence in and outside Jersey City's saloons, which totally ignored closing laws, continued to fail. Jersey City was a city out of control; author Steven Hart described it as "the East Coast equivalent of a brawling Wild West city…where the police were only slightly less frightening than the criminals."[143]

Hague began a makeover of the Jersey City police force with the fervor of a new CEO of a major corporation who wanted everyone to know from the start that he didn't care how things were done in the past, he was now the boss and things were going to be done his way. To start, there would need to be a change in the culture of the department; offenses that had gone unpunished for years would now have repercussions. Hague quickly found that his ability to punish officers was extremely limited; the rules under the newly passed charter hampered his ability to fire members of the force. This inability to act as judge and jury caused two problems for Hague. The first was incompetent members of the force (and there was an abundance of them) who could not be terminated. This, of course, led to a second problem: his inability to exercise the patronage available to him, the lifeblood of every machine politician. Hague's only recourse was to go to the state legislature and ask for a change in the law, which he did. In his presentation to the legislature, he indicated that he needed these powers because the current force consisted of "a lot of drunken bullies swaggering around with a pistol in their pockets and a nightstick in their hands."[144] It was no secret that patrolmen, because they walked their beats with only minimal supervision from superiors, spent much of their time in saloons, barbershops and other neighborhood centers.

The effort to change the law began with Hague having a member of the Hudson County Assembly delegation introduce a bill that would in essence give the director of public safety the power to dismiss any member of the police or fire department for violating any of the department's rules. It was at this point that Frank Hague would encounter his first of many run-ins with labor unions. The police union that represented the rank and file patrolman in the various municipalities throughout New Jersey, the Patrolman's Benevolent Association (PBA), put up strong opposition to the bill—when the bill came up for a vote, it was defeated.[145] While it could be argued that it was his lust for power that drove Hague to continue this battle, the alternative argument is that his desire for an efficient, professional police force, with officers performing their jobs with pride, was in all probability the greater motivator.

In a move of legal genius by city attorney John Milton, Hague was given the power he sought. Milton—who was in the process of preparing a proposed amendment to the city commission government statute that would permit voters to approve or disapprove of salary increases for commissioners—added one more change that went unnoticed until after it was passed by the legislature. The original statute's language gave the commissioners power of an executive, administrative and legislative nature—to this Milton added the word "judicial."[146] The simple addition of this one word now gave Frank Hague the power to act as judge and jury in the disciplining of the city's police force. Although the PBA filed suit to overturn the legislation, it was upheld. Now, with his newly found power, Frank Hague wasted no time in going to work.

Among the moves that Hague immediately made was to move high-ranking desk officers to outlying beats, as well as demoting desk brass to patrolmen.[147] Hague once put 125 policemen on trial for various charges in a single day, while hundreds of others were ordered to summarily turn in their badges without the benefit of a trial.[148]

Realizing that people were tired of witnessing cops taking bribe money or failing to respond to emergency calls in a timely fashion, he instituted what is best described as an early version of an internal affairs unit, called the Zeppelin Squad or "Zeps." The squad was an inner circle of officers whose loyalty was solely to Hague and whose job it was to spy on and report back to Hague about other members of the department. Some authors have unfairly compared them, mainly because of uniform style (especially the high spit-polished jack-style boots), to the Nazi Gestapo.[149] The fact is that the Gestapo and their jackboots weren't in existence at the time of Hague's formation of the "Zeps" (1913), and the design of the boot was similar to those worn by New Jersey state troopers then as well as today. This was just one more example of unfairly trying to portray Hague as Hitleresque.

Especially irritating to Hague was the slow or, even worse, lack of police response to a call for help. To remedy this, Hague himself used to go for walks at night, place emergency calls to the police and fire department and time the response. If the police, firemen or an ambulance were slow in responding, Hague would punish them, usually verbally though he had been known to occasionally get physical.[150] A story reported in the *New York Times* noted that once, when an ambulance took forty-five minutes to reach an accident scene, Hague asked the young physician what had taken him so long. The response from the doctor—"I had to put my clothes on, didn't I?"—brought the doctor "a swift punch in the face."[151]

JRSDAY, OCTOBER 22, 1925.

Hague Punched Doctor's Face And Then Built New Hospital; Reforms Won Mothers' Vote

Jersey City's "Violent, Passionate Master" Has Removed Fire Menace and Raised Schools to Model Standards—Spurred to Establish Baby Hospital by Death of Own Child

HUMANITARIAN, BUT YET SHREWD POLITICIAN; MAYOR'S MACHINE IS THREAT TO DEMOCRACY

This is the second of a series of four articles Mr. Gilbert has written on the influence of "Hagueism" on New Jersey politics. The third article will appear tomorrow.

By CLINTON W. GILBERT
Staff Correspondent of Evening Post
Copyright, 1925, by N. Y. Evening Post, Inc.

Washington, Oct. 22.—Babies are born into the Hague machine. You may see them, long baskets full, in the lying-in ward of the excellent hospital in Jersey City, which the Mayor is responsible for.

You may see hundreds more of them taken by their mothers to the infant welfare stations all over the city, and the most pathetic ones, those who seem to have been born only to die, at the sick baby clinic in the Mothers' Institute, a "city school for mothers," unique so far as my knowledge of city institutions goes.

You cannot talk long with Mayor Hague without having him tell you with great feeling how, when he was young and poor, he lost a baby of his own who might have been saved had the old, badly governed city been interested in lessening infant mortality. He and his physician in charge of the sick baby clinic, Dr. M. W. O'Gorman, will give you figures to show how the sale of little white coffins has fallen

had set his will against the fate that besets the children of the poor and ignorant in cities.

You do not go far with Hague before you realize that you cannot explain him by any simple formula, such as the typical city boss of the Tammany sort, "catering to the people," as he calls it, for the sake of the votes there are in it. He has known of the sufferings of the poor, the dying of the baby in the home.

There is the passionate pride of a creator in his work. The Jersey City of today is his handiwork, the Mothers' Institute is his creation, the hospital is his hospital, the schools are his schools, the police force is his police force.

"I inspected every nail that was driven into this hospital," he said as he showed me about it with all the pride of authorship.

Then there is in him an inordinate love of power. He is ruthless. He was born to be a dictator. He tolerates no obstacles. I have no doubt the end with him inevitably justifies the means. It is breath in his nostrils to look out upon everything that is his in Jersey City.

And lastly, the politician is always in plain sight. There is no pretense about it. "Of course," he will say to you, "I have the women of the city with me, with the

Frank Hague was not intimidated by many people and was not shy about using physical force when he thought it was necessary.

Newspaper reporter George Creel, writing in the national weekly magazine *Collier's*, said this of Hague: "Every home in Jersey City is supposed to have officers on hand within three minutes after a call…and there are few failures, for a cop never knows whether the telephone is from a frightened householder or from the boss himself, a menacing figure with eyes on his watch."[152]

The combination of Hague's somewhat unorthodox methods to punish inept officers, methods that did not exclude violence, along with his ability to

restore pride in the Jersey City police and its officers, was extremely effective, causing the city's once astronomical crime rate to decline significantly. Eventually, through the efforts of Hague, Jersey City would have one patrolman for every three thousand residents.[153]

Hague also inherited a fire department that was on the verge of collapse, with alarm boxes that failed to signal alarms and frozen hydrants (even though there were public works employees paid to keep them free of ice) and whose equipment included rotting water hoses that leaked so much that it was impossible to have the stream reach a second-floor fire.[154] At the time of Hague's takeover of the department, fire insurance rates in Jersey City were among the highest in the nation, with the poor reputation of the city's department as the main reason.[155] Increased inspections of movie houses that were deemed unsafe, literal firetraps, were closed by Hague, and while these activities gave him additional recognition as a "doer," it was his anti-vice reputation—with increasing support from the Catholic Church, as well as from Protestant denominations and synagogues throughout Jersey City—that got him the most press coverage.[156] That was, until the morning of July 30, 1916.

Following the outbreak of World War I in July 1914, it wasn't long before Britain joined France and Russia in their battle against Germany and Austria. The British Royal Navy was quick to act by forming a blockade of German ports and then pursuing German ships on the high seas. Looking for cover, many of these ships ended up in the harbors of the United States, which was still neutral at the time. Even if Germany wanted to purchase products from the United States, and it did, the blockade of German ports made it almost impossible to import anything, while the Allies were able to purchase products like food and ammunition at will from the United States. Although there was some loss of revenue to U.S. businesses as a result of the inability to sell to Germany, this was more than made up by the large, usually cash purchases from the Allies.

While President Wilson was sympathetic to Britain, he still advised America to remain neutral. When German government officials protested to Wilson about the United States allowing sales to the Allies, his administration's reply was that the United States was willing to sell to anyone who could pay. This response so infuriated the kaiser that on February 4, 1915, he ordered German submarines to sink any vessel, even those from neutral countries, that sailed within an area of exclusion around Britain. This action was simultaneous with orders to Germany's military attaché in Washington, D.C., to begin a sabotage operation

to "destroy every kind of factory that was supplying munitions for the war."[157]

To begin the operation, they needed to build explosive devices, and they had just the place: a converted workshop aboard one of the about eighty German vessels in quarantine in New York and New Jersey ports. The efforts of these saboteurs were successful in blowing up numerous ships and factories. While Jersey City was the terminus for many trains that were shipping munitions, these would usually be emptied and quickly shipped abroad. The city fire code forbade the storage of such munitions for any length of time, and the fact that they lingered on the shores of Jersey City at all was a concern to the city's director of public safety, Frank Hague.

In early 1916, when Hague discovered that millions of pounds of munitions were being stockpiled on the Jersey City waterfront, he traveled to Washington to register concerns for the safety of his constituents. His meetings with congressmen resulted in no action, Congress having decided that Jersey City was an "appropriate port for the munitions."[158] At 2:08 a.m. on July 30, 1916, Hague's concerns proved valid when, in an apparent act of sabotage, German agents attempting to prevent ammunition and other war matériel from being sent to the Allies ignited an explosive device, causing war supplies stored in a warehouse pier on Black Tom Island just off the foot of Jersey City to explode in flames. Damage from the explosion was estimated at $20 million[159] ($377 million in today's dollars). Shrapnel from the explosion traveled long distances, with some pieces becoming lodged in the Statue of Liberty's skirt and torch. The damage to the Statue of Liberty was valued at $100,000 ($1.9 million in today's dollars), and the arm has been closed to visitors ever since. Damage even reached the clock tower of the *Jersey Journal* building in Journal Square, over a mile away, stopping the clock at 2:12 a.m. The explosion was the equivalent of an earthquake measuring between 5.0 and 5.5 on the Richter scale and was felt as far away as Philadelphia. Windows broke as far as twenty-five miles away, including thousands in Lower Manhattan. Some windowpanes in Times Square were completely shattered. The outer wall of Jersey City's city hall was cracked, and the Brooklyn Bridge was shaken. In a tone eerily reminiscent of the 9/11 attacks, author Jules Witcover described the scene:

> [A] *blast like a thundering cannon turned night into day as "flaming rockets and screeching shells" pierced the sky over the Hudson River, skyscraper windows shattered by the thousands and shrapnel tore into the Statue of*

Frank Hague with President Roosevelt. *Courtesy of Jersey City Public Library.*

Liberty and ripped at buildings on adjacent Ellis Island, where newly arrived immigrants wondered if they had truly escaped the Great War.

Twenty minutes later, a second gigantic explosion rocked both shores of the river, "unleashing," Witcover wrote, "yet another tremendous fusillade into the sky."[160]

The *Jersey Journal*, which at 5:00 a.m. that Sunday published one of its rare extra editions, noted: "The population became so fearful of further similar occurrences and the danger of their habitations falling on them that they dressed and walked the streets for fully two hours. Women with children in their arms sat all night upon the gutters; the public parks were filled with refugees. Open spaces everywhere were sought by men, women and children, who feared to stay anywhere within falling distance of brick or timber walls."[161]

The return to order and the investigation into the explosion fell at the feet of Commissioner of Public Safety Frank Hague. The lack of reported looting or violence in the aftermath of the explosion is testament to the effectiveness

of a police force now run by Frank Hague. The *New York Times* on the day of the explosion indicated in a headline that there were two men arrested; however, if one did not read the entire story, he would not have known that the two individuals arrested were not suspected terrorists but were, in fact, railroad executives who were "ordered arrested by Director of Public Safety, Frank Hague." Hague believed that regardless of whether the explosion was a result of German terrorists, these individuals and their companies were liable for the explosion because they had not taken the necessary precautions or provided the proper security for such a large amount of explosives.[162]

Hague would now use his reputation as the man who cleaned up the Jersey City police force and maintained order during chaos in his bid for reelection. Taking advantage of the recently changed law that allowed for bracketing of candidates, as well as the use of nonpartisan slogans on the ballot, Hague put together a commission ticket called "The Unbossed." The ticket consisted of himself, Parks Commissioner A. Harry Moore, a former Wittpenn supporter; Revenue Commissioner George Brensinger; ex-judge Charles F.X. O'Brien; and City Clerk Michael I. Fagan[163] (no relation to mayor Mark Fagan).

Hague's ticket swept all five spots on the commission. Although Moore was the top vote getter, with Hague finishing third, the group broke with the traditional practice of naming him as mayor, and when the commission met for the first time on May 15, 1917, Frank Hague was chosen as the new mayor, a position that he would hold for almost thirty years.[164]

As a strong believer in the maxim "keep your friends close, but keep your enemies closer," Hague gained support from former political rivals, especially those who had some political clout. One example can be seen in his having the Hudson County Board of Freeholders create the job of general purchasing agent for John H. Morris, who had served as Wittpenn's chief lieutenant.[165]

Hague's early tenure as mayor saw a man who was very much hands-on. Hague involved himself in a number of issues, some of them bordering on the bizarre. Such was the case in October 1922 when Hague intervened on behalf of Horseshoe residents Mr. and Mrs. Edward Rich. The *New York Times* reported the story of Mr. and Mrs. Edward Rich, who had hired a lawyer because they believed that their baby had been switched. Mrs. Rich stated that she was told that she had delivered a baby boy on August 12; however, when it was time for discharge from the Bergen Sanitarium, where the baby was born, she was given a baby girl. Both Mrs. Rich and her husband testified that they had been told by the attending doctor and nurse

that they had, in fact, had a boy. Because the parents failed to take the baby home, they were charged by the "poormaster" with child abandonment and ordered to appear in criminal court for a hearing. However, in a strange twist, the hearing was postponed when Hague agreed to talk to the Riches, who agreed that they would allow Hague to hear the testimony and would abide by his decision.

At a hearing held before Hague on October 9, 1922, Hague ruled that the baby born was, in fact, a female, and the Riches then embraced their baby girl. How and why Hague became involved in this controversy is pure speculation; it most probably was at the request of a relative of the Riches who was worried that the couple faced a jail term. Aside from the involvement of Hague in his role as Solomon, this story on its face raises a number of issues. The fact that there was testimony from a number of people, including Mrs. Rich's roommate, that the doctor attending Mrs. Rich had indeed stated that she had delivered a baby boy has to make one wonder what really happened.[166] Perhaps it was all a result of the anesthesia given to Mrs. Rich during her delivery. Whatever the case, it demonstrated the lengths that Hague would go to in helping a fellow resident of the Shoe, as well as the degree of respect he commanded among its residents.

No doubt because of his own experience as a child, Hague became almost obsessed with the issue of juvenile delinquency, yet absent in any of the major writings on Hague or in the scholarly journals dealing with punishment of juvenile criminals is any mention of Hague's establishment of an alternative to the revolving door of the reform school of the 1930s:

> *I realized long ago that you cannot protect the boys and girls of a city from the dangers of entering a life of vice or crime if you send them to the reformatories and penitentiaries, which are actually in my opinion, schools of crime. So I prevent any police officer from arresting any boy in a juvenile delinquency case and taking him to a police station, a court or a penal institution. We settle these cases quietly and send them home without a mark on them to live better lives. We have saved thousands of young boys from being destroyed for minor infractions of the law and when they grow up they appreciate it as do their parents and relatives and become our friends.*[167]

Hague's establishing of the Bureau of Special Services, which put delinquent youth to work rather than in jail, was a decade before most cities would implement similar plans.

In the early part of 1931, the Jersey City Board of Education and Frank Hague, as well as representatives of the Jersey City Police Department, held a joint meeting to discuss ways of improving an already enviable record of a city relatively free from crime. Their overall goal was to address the problem of truancy and juvenile delinquency. The main problem was that of cost, since habitual truants and young delinquents were costing the city many thousands of dollars not only by repetition of grades but also through frequent institutionalization. They also realized that the cost to society of the continued recidivism of young offenders was unacceptable.

Unlike other juvenile programs, which focused on punishment, this group, realizing that the idea of prevention was hardly ever addressed, appointed two members to spend their entire time over a number of months studying the inmates of the various state institutions that housed juvenile criminals. The goal of these officers was "to secure information regarding the character, training, offenses, and handling of the young people of the State of New Jersey who had finally been lost to society through the gradual development of antisocial thought and conduct."[168]

In preparation for their work, Frank Hague issued orders that the police department, the courts, the city hospital and the board of education were to combine in an exhaustive study of the causal factors of juvenile delinquency, possible remedial activities and carrying out a coordinated program of crime prevention. The unanimous opinion of the group was that there existed very little information regarding the amount, causes, nature or proper treatment of juvenile delinquency. There were a great many opinions by various workers in the field of criminology, including genetic consideration (what was then called physical heredity), environmental factors (called social heredity), native intelligence, emotional disturbances, glandular deficiencies and a host of other factors, both in isolation and in a variety of combinations, none of which proved to be conclusive, according to Lemert.

It was due to this lack of existing factual materials about the prevention of juvenile delinquency that the committee decided that there seemed to be only one way of approaching the problem intelligently, namely by setting up an experimental program that would combine and coordinate all available public agencies in Jersey City for the study and treatment of all its "maladjusted" children. This combination of talent from multiple public agencies into a single department whose only charge would be to work for the prevention and treatment of "difficult children" marked a very definite departure in the field of social work. Considering the paucity of information on the subject, for Jersey City to take on this project, especially in the 1930s, was astounding.

Based on the logical reasoning that it was the only agency that dealt with "every" child in Jersey City during their formative years of development and where they could be observed, it would be the school system that would be coordinating the program. It was believed that the classroom would be the best place to detect a problem, and a preventive program began. Although many of the necessary services were already in existence in the school system, a teacher reorientation program was instituted, along with the addition of psychiatrists, social workers and other professionals, resulting in the formation of the Bureau of Special Service on February 1, 1931, within the Jersey City public school system, according to Hopkins.

Immediately after the organization plans for the new bureau had been completed, Hague called together all the public school officials, including classroom teachers, all superior officers of the police department, judges from the juvenile and police courts, heads of all public agencies who had up to that time dealt in any way with juvenile offenders and reporters from the various local newspapers. Through the latter group, the purpose of the meeting and the functions of the new organization were conveyed to the public in detail, garnering wide public support.

In addition to the issue of juvenile delinquency, Hague faced another problem involving the education of children. The polio epidemic that raged from 1917 until late in the 1920s had left large numbers of children in Jersey City with some form of paralysis. Since most of the public schools in the city were without elevators and lacked even the most basic accommodation for such students, many students who were intellectually but not physically able were denied an education.[169]

Even before the polio epidemic, there were many other children handicapped by other diseases, such as cerebral palsy, who although mentally able to attend school could not do so because of the lack of the special equipment and facilities required to attend to their special needs. As early as 1915, Hague and then Jersey City superintendent of schools Dr. Henry Snyder sought to found an elementary school for children with physical challenges. In 1917, in an effort to meet the needs of these children, construction was begun on the Clifton Place School for Crippled Children in Jersey City. However, design problems delayed its completion until April 1921, when the school finally opened with fifty-three students.[170]

The school was considered the "first of its kind in the United States" and enjoyed rapid growth, which led to the need for more specialized services, at which point Hague enlisted the services of architect John Rowland to design a new, much larger school.[171] The school was to

provide physical therapy and all essential services, including specialized teachers to handicapped children from all of Hudson County, and would be located on Hudson Boulevard (now Kennedy Boulevard) in Jersey City. Construction of the school began in October 1930. Governor A. Harry Moore, who had been instrumental in obtaining the funding for the school and for whom the school is named, was present when the school opened in September 1931. In 1939, Moore, then a U.S. senator, and Hague were once again instrumental in obtaining WPA funding for additions to the school, which included treatment rooms and a solarium, as well as the building of one of the most modern indoor swimming pools in the country (the natatorium).[172]

Often unrecognized in the development of the A. Harry Moore School is Margaret Sullivan Herbermann, a Jersey City physician who was responsible for the passage of legislation in 1919 that required municipalities with fifteen or more handicapped children to provide transportation and to make every effort to accommodate such children. The legislation also required the state to furnish each municipality with $100 per student. In a posthumous tribute to Herbermann, the Jersey City Redevelopment Agency announced in January 2009 that the forty-four-unit workforce housing project known as Summit Heights—on Summit Avenue between Hague Street and Secaucus Road—would be named in her honor.[173]

Connors, in a more objective analysis of Hague, stated that "it is clear that he recognized the limits of the city he governed and tried to make it better and greater." The areas of juvenile justice and the education of children with special needs are clear examples.

THE ORGANIZATION

Accusations of ballot stuffing in Hudson County occurred well before Frank Hague became active in Jersey City politics.[174] And although some attribute Hague's popularity at the polls to alleged electoral fraud, and while reports of ballot stuffing and graveyard votes actually did occur, the extent of the frauds needs to be examined in context. The famous "voting from the graveyard" story has taken on a life of its own, even to the point of former New Jersey governor Brendan Byrne using it as a joke while making public appearances. Byrne would quip that "when I die I want to be buried in Hudson County, so I can remain active in politics."[175]

The genesis of the graveyard vote myth is a 1927 *New York Times* article. The details revealed that, after an investigation, out of the 1,100 ballots examined, there were 27 votes (about 2 percent) cast by persons who had died. That Hague himself orchestrated such an event is unlikely, and in all probability the guilt lay at the feet of one of the district workers or ward lieutenants.[176] The only evidence that has strongly hinted of Hague's direct involvement in ballot fraud occurred in September 1917, when Commissioner Brensinger was killed in an automobile accident and Hague didn't want to risk losing the vacant seat to ex-magistrate John Warren. The *Jersey Journal* head, who was annoyed by Hague's increased spending, orchestrated a write-in campaign for Warren. Although Warren carried four of the six uptown wards, his lopsided loss in the second ward, as well as the disqualification of 10 percent of the ballots cast, allowed Hague's candidate, James Gannon, to win the election. Connors indicated that this occurred as a result of a conspiracy between Hague and the city clerk. In 1918, the Hudson County assistant prosecutor obtained fifty-six indictments against

Second Ward Election Board workers. After obtaining three convictions, juries began returning not guilty verdicts, even for those who had publicly admitted their guilt. Attempts to prosecute fourth ward election workers also became an exercise in futility, and after two acquittals the remaining prosecutions were abandoned.[177]

Although the activities of Hague and his supporters were far from angelic, when Hague's repeat victories are examined, it would be hard to conceive of such a mass conspiracy not becoming public. A great deal of the accusations of fraud were legal, albeit in the gray area of the term. An often-cited example is that of patronage. The mere ability to offer patronage or buy a vote here or there was not enough to win elections; organizational skill was the essential tool required to obtain multiple victories, and the Hague machine was very well organized. So skilled was this organization that it was the envy of other political bosses, and Hague was sure that it was superior to New York's Tammany Hall.[178] This well-oiled machine was one of two main reasons for Frank Hague's political longevity, the other being that when Frank Hague ran for office, he liked campaigning and was constantly testing his popularity with the voters.[179] While his contemporaries—Pendergast in Kansas City, Cox in Cincinnati and the leaders of Tammany—held minor offices or none at all and stayed out of the limelight, running city government through their iron control of the party organization, Frank Hague was out shaking hands.

While there is much made of his lack of formal education and his use (or, more precisely, *misuse*) of the English language, which would frequently be the brunt of jokes and editorial comment, Hague's ability to analyze election data was unmatched.[180] In an age before the computer, Frank Hague was able to view voting statistics and results and make comparisons so adjustments in strategy could be made almost in real time. At election time, hanging in Hague's city hall office could be found a large chart that included copious amounts of data. Jersey City was divided into twelve wards; these wards were further divided into 306 districts, which were further subdivided into precincts. Each precinct had its own captain; the names were listed on the chart, along with the hour-by-hour vote from these precincts in previous elections. It was this data that allowed Hague to determine the course of the current election.

The hierarchy of the organization was structured in such a way that almost no citizen was not under the watchful eye of the Hague machine. Every house in every precinct was under the supervision of a precinct worker who, in return, reported to a precinct captain, who reported to a ward lieutenant,

who reported to the ward boss, who would ultimately report to Hague. Acting more as ombudsmen than spies, these workers took care of problems such as trash pickups, arranged outings for residents of the ward, helped find jobs for unemployed residents and even acted as intermediaries with police if the child of a ward resident got in trouble with the law. If it were known that a resident was having an extramarital affair, knowledge of this information would be brought to the attention of the person involved by a precinct captain; no threat was made, but the implication was clear. Among the other problems that would be brought to a precinct captain might be that he or she or a family member had been fired from a job through no fault of their own—perhaps business was slow and there was no longer a need for the employee. In an effort to have the employee rehired, someone from the organization would go to the employer and offer the employer additional city work to make up for the salary of the fired worker so he could be rehired.[181] This method of using city contracts was but one way the organization helped its loyal constituents. Other methods included the use of city labor and materials to build additions to employers' homes or stores. Practices such as these were used much more frequently than the threat of violence.

The full scope of this organizational masterpiece would be visible on election day through the use of voter canvassing, a campaign tactic perfected by Hague.[182] As the name implies, a Hague election worker canvassed every voter in every district. Every voter in every district was personally asked to come out and vote on election day. Carefully compiled lists of those who were homebound or very old were created, and fleets of automobiles were made available to every ward leader to transport these voters to the polls. Historian Thomas Fleming, whose father was a major operative in the Hague organization, noted, "Even the dying were taken to the polls."[183] Names were carefully checked off as people entered the polling booths, and if by the final hour of election day you had not voted, you received either a telephone call or a personal visit from one of the precinct captains asking why you had not yet voted. Ward and district leaders were rewarded—or punished—strictly on the basis of their turnouts.[184]

The absence of today's technology did not diminish Orwellian behavior. Come election time, precinct workers could examine files kept on residents that indicated if they were "friendly, "okay" "Republican but friendly" or "Republican, no good," in order to know how to handle the individual. One of the worst marks a citizen could have next to his name was that of "Received favor but proved ingrate." So sophisticated was this organization that in 1937 it drew the attention of the FBI. In a letter to FBI director

J. Edgar Hoover, dated October 2, 1937, Special Agent in Charge P.E. Foxworth outlined how the Hague organization operated. Claiming to have received all of his information from Sam Flex of the Essex County Sheriff's Office, as well as from Miles W. Beemer, a employee of the WPA and the originator of the Miss America contest in Atlantic City, Foxworth went on to tell Hoover that Hague's payroll consisted of "about 40,000 persons and that each of these persons is supposed to count for four votes." Next there was a detailed description of the card index that the organization kept on each voter in every district. Where it had previously been believed that this information was limited to political affiliation and possible needs due to sudden unemployment, apparently a form of blackmail could also be used if necessary. Agent Foxworth's letter stated that in addition to the routine information, there was damaging information: "For instance, some married man was running around with some women, a notation of this was made on the card index, and, as a result, if one of the members should attempt to 'kick over the traces' he was called in and his record was related to him, after which he usually changed his mind."[185]

It was not fraud that allowed Hague to survive but rather the less-recognized organizational skill that would allow him to control and thus cast Hudson County's 600,000 voting residents as essentially one voting bloc. Fleming noted that

> *a political machine was a meaningless misnomer. There was no such thing in Jersey City…or any city where the Irish-Americans organized things politically…For anyone who saw how things worked from the inside, the opposite was the case. A political organization was a churning mix of ambition and resentment and inertia over which leaders presided only by constant effort.*[186]

It was this ability to corral large numbers of votes, transforming the "churning mix" into a cohesive voting bloc, that would soon give Hague control over just about the entire governing apparatus of the state of New Jersey, including the judiciary, and eventually gain him direct access to the White House.[187]

As we noted earlier, although patronage without organization could not win an election, likewise organization skill without patronage was just as ineffective; the two operated in a purely symbiotic relationship. For Frank Hague, as well as for most of the political bosses of the period, their power lay in their ability to form and maintain a political patronage system, with

the biggest challenge being the continuous funding of these systems, whose operational expenses were enormous. However, here again we see a potential bias in the calculating of the city payroll under Hague.

McKean attacked the Hague city payroll, saying that "the per capita payrolls of Jersey City and Hudson County topped those of any city or county in the United States where the population exceeded 100,000."[188] Alternatively, former New Jersey state senator Alan Karcher in his book *New Jersey's Multiple Municipal Madness* noted that Jersey City's payroll under Hague never exceed a ratio of 1 employee for every 700 residents and that at the height of the Depression, Jersey City had only 3,600 employees in a city with a population well in excess of 300,000, a significant contrast to McKeon's numbers.[189] Nonetheless, whether McKean or Karcher is correct, it must still be acknowledged that the payrolls of Jersey City, Hudson County, were certainly padded. There were the usual police, fire and teacher positions, all of which were fertile ground for employing of thousands of machine faithful. This was followed by the next tier of supervisory personnel and the top positions such as that of county sheriff, a position usually reserved for a top vote getter or ward boss. While police, firefighters and teachers would have to actually perform a service, the job requirements for the next tier employees were somewhat vague. Take the case of fourth ward boss and County Sheriff John Coppinger, who testified in an investigation of Hague that he did not know the duties of the thirty deputies under him, or the testimony of Hague aide Alfred Mansfield, who headed up the office of city health inspector and could not remember a single place he had ever inspected.[190]

Of all the patronage jobs, the one that was most coveted was the "no show" job. Hudson County had seventy men listed on the county payroll as "county mechanics." However, there was no record of their work. Others were listed as "ballot box repairmen," and dozens were listed simply as "park employees." The most egregious of these appointments can be seen in the naming of a large vote getter to the city payroll, where he received a weekly check as "foreman of vacuum cleaners." Even members of Hague's singing quartet were paid as policemen.

Along with no show jobs there were the double dippers, Hague lieutenants who received two paychecks. An example was John Saturniewicz, a judge of the Second Criminal Court, who apparently had time to also serve as the mayor's "senior clerk-stenographer." The head of the state civil service commission in Jersey City, Theodore Smith, was lucky enough to pick up an extra $10,000 annually as condemnation commissioner.[191]

While many of the lower-level patronage beneficiaries would remain in their jobs for years, those in the upper-level positions were frequently shuffled from one position to another and from city payroll to county payroll—not, as most believed, to camouflage their presence on the payroll, but to prevent them from developing a following among those under them or to give the public the perception of them having a hold on the office. An example cited by Connors is that of eighth ward boss Joseph Colford, who served as superintendent of bus transportation for Jersey City from 1923 to 1929. From 1929 to 1939, he served as undersheriff of Hudson County. In 1939, he was made city clerk, a position he held until 1940, when he became city commissioner, where he served until he became a member of the board of county freeholders in 1949.[192]

Hague was well aware that it was the city and county payroll that gave him control over his domain. He knew that when you controlled a man's livelihood, you controlled the man, but funding all of this was beginning to become problematic, and Hague began to seek alternative funding sources.

While legitimate criticism can be leveled at Hague for his use of city and county funds as his organization's piggy bank, the truth is that if there were an equitable tax system in place, money would have been a minimal issue, and it could be argued that more people could have been put to work. The argument of patronage aside, what Frank Hague did next would again fall under the category of underrecognized achievement. As he witnessed industry after industry in Jersey City grow rich on orders that continued to increase as a result of World War I, Hague reasoned that industry and the railroads should share the weight of funding his organization, not by simply burdening these entities with unreasonable or excessive taxes but by having them pay a fair and equitable share. His first target would be the railroads.

While commercial real estate in Jersey City was assessed at $17,000 per acre, the railroads were paying only $3,000 per acre. Also paying below the standard rate was the Public Service Electric Company and the Standard Oil Corporation. Hague saw these as potential gold mines and an end to his problem of funding his machine. Railroad taxes were abruptly increased from $67 million to $160 million, while Standard Oil went from paying $1.5 million to $14 million and the Public Service Corporation was given a tenfold increase from $3 million annually to $30 million, all of which resulted in an almost $150 million increase for the city coffers. Realizing that they could not just get up and leave Jersey City, and upset with the increases, all three groups appealed to the state board of tax assessments, and the Hague increases were rescinded.[193] It was at this point that Frank

Hague decided that in order to maintain and increase his power, he would need to have control not only of Jersey City and Hudson County but also of the entire state of New Jersey. To do this, he would need to have a pocket governor, and so he proceeded to obtain one.

President Wilson's personal secretary and Jersey Cityite Joseph Tumulty had his eyes on the statehouse. This dream would soon end for Tumulty when he learned that Hague was going to run the president of the First National Bank in Jersey City, Edward Irving "Teddy" Edwards, for governor. Edwards was the product of the Jersey City public school system and would later go on to study law at New York University. From 1911 to 1917, he served as state comptroller, a position for which he is well remembered when he withheld then governor Wilson's $880 paycheck while he was campaigning for the presidency.[194] In 1918, he was elected a state senator from Hudson County. A very wealthy individual, Edwards had announced that he was going to spend a large portion of his own money to fund the campaign. When Tumulty heard this, as well as the fact that the liquor lobby was also was going to be made available to Hague and Edwards, he retreated to the security of his White House job.[195]

Meanwhile, Essex County boss Jim Nugent was becoming very concerned with Hague's increased influence not only in Hudson County but also on his home turf of Essex. In an effort to thwart this threat, Nugent approached a number of potential candidates to run against Edwards and offered them the full support of the Essex County machine. When no one accepted, Nugent decided to run himself.[196] When the ballots from the September 1919 primary were counted, Edwards had the nomination, and Frank Hague was on his way to creating a political dynasty. But Hague, being the genius that he was, knew that the Edwards election was not a shoe-in. Although he was not worried about his own county of Hudson, he was concerned about the nationwide trend of voting Republican, as evidenced in the 1918 election, when that party regained control of Congress. Hague knew that for Edwards to secure the governorship he needed an issue that would spilt the Republican vote for their nominee, Newton A.K. Bugbee, and he found this in the Eighteenth Amendment, commonly known as prohibition, which was scheduled to go into effect in January 1920.

While the bill had passed in Congress, Frank Hague was betting that the legislation was not as popular with the common folk and ordered Edwards to tell every audience he appeared before on the campaign trail that if elected governor he would make New Jersey "wetter than the Atlantic Ocean."[197] The other whipping boy for Edwards was the Public Service Electric and Gas

Company (PSE&G), which had a monopoly on supplying utility services to New Jersey residents and businesses. He vowed that the unpopular PSE&G was owned "body, boots and breeches" by the Republican Party, this despite his own large stockholdings in the company and the fact that his bank had financed the PSE&G.[198] In the end, the tactic of cutting into the Republican vote was a help; however, the real help came in the counting of the votes from Hudson County.

On election day 1919, the Hague machine and its police force swung into action. At several polling places throughout Jersey City, police barred Republican poll watchers from observing the vote count. The late evening returns had the Republican Bugbee with a statewide 21,000-vote lead over Edwards, but when the final ballots from Hudson County were announced, the result indicated that Edwards was so popular that he had received a 36,000-vote plurality over Bugbee and thus a 14,500-vote victory statewide.[199] Frank Hague now had his governor, and it would not take long for him to start to derive the benefits of the office. In fact, almost immediately following his inauguration, Governor Edwards dismissed every commissioner on the state board of tax assessments. With a newly appointed Hague-controlled board, the mayor's previously denied tax increases on the railroads, Standard Oil and PSE&G were unanimously approved.[200]

Hague, through his new governor, was now able to appoint the state attorney general and the Hudson County prosecutor, as well as make numerous judicial appointments. Feeling insulated from any criminal accusations and with his position as statewide boss firmly established, Hague now focused his sights on the national stage.[201]

With President Wilson's recent stroke causing paralysis and no other candidates on the horizon, Hague believed the 1920 primary race to be wide open and filed petitions for Edwards to run in a number of state primaries. When the New Jersey delegation headed by Hague arrived at the Democratic National Convention in San Francisco, it was solidly behind Edwards, who on the first ballot finished fifth among the twenty-three nominees. When it became clear that Ohio governor James Ox was going to get the nomination, Hague, who wanted to be associated with the winner, swung the New Jersey delegation and supported Cox, who became the party's nominee.[202] But not even Hague could counter the anti-Wilsonian mood of the country, and the Harding-Coolidge team was swept to victory, winning not only New Jersey but also Hague's Hudson County. With this defeat, Jersey City reformers sensed that Hague might be vulnerable, and in the 1921 election, they put together a five-man slate to oppose Hague's reelection bid.

The 1921 election in Jersey City was a heated battle that included a mass distribution of the state senate report stating that the Hague machine had violated state election law with impunity.[203] Despite these accusations, Hague's victory was substantial, and in his home ward, his margin of victory was 4,620 to his opponents' 120 votes. Although his margin of victory was not as significant in other wards in the city, it was more than enough for a reelection victory. But the celebratory atmosphere would be limited, as Hague's next battle was just around the corner.

Because the New Jersey Constitution forbade governors from running for successive terms, Hague needed a new candidate for the upcoming election if he were to maintain his stronghold on the statehouse. This would require some shuffling. The first move made by Hague was to extend his reach to the United States Senate. This was accomplished by running outgoing governor Edwards against Republican incumbent Theodore Frelinghuysen, while selecting circuit court judge George S. Silzer of New Brunswick as his candidate for governor. Both men won their respective contests; however, it didn't always look like this would be the case. Silzer, like his predecessor, was thirty-four thousand votes behind his Republican opponent as the early returns came in. However, when all the votes from Hudson County were counted, Silzer had a forty-six-thousand-vote margin over his Republican opponent.[204] Now with a United States senator and a governor in his pocket, Hague turned his attention to gaining the support of the up-and-coming new bloc of voters.

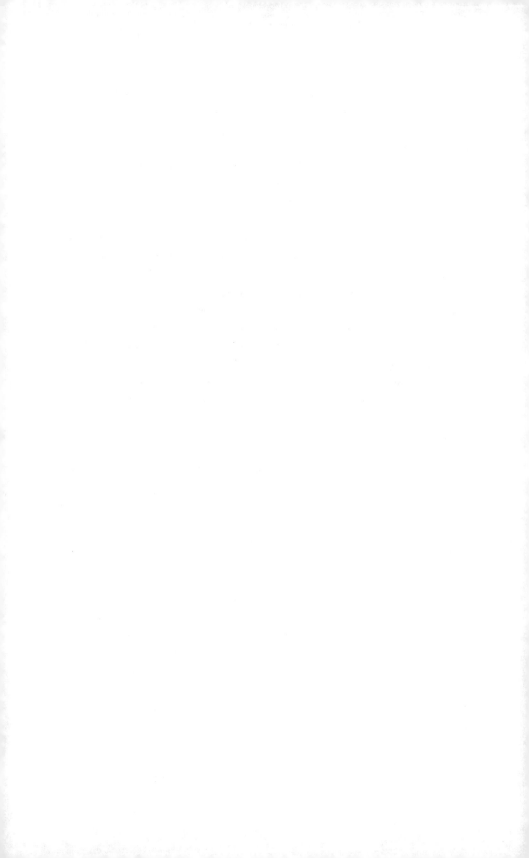

MRS. NORTON GOES TO WASHINGTON

Historically, New Jersey was an early granter of women's right to vote as long as they owned more than $250, about $7,500 in modern money. However, by 1807, this law had been repealed, and women were again relegated to second-class citizens in New Jersey, where they would remain until the passage of the Nineteenth Amendment.

On January 9, 1918, President Woodrow Wilson announced his support of the Nineteenth Amendment to the Constitution. Although the House of Representatives narrowly passed the amendment (mainly because a number of senators were up for reelection in 1918 midterm elections and wanted to avoid the suffrage movement as an issue), the measure was tabled in the Senate until October of that year. Following the elections, the majority of Congress had come out in support of the amendment, and on May 21, 1919, it passed in the House of Representatives by a vote of 304 to 89, with the upper chamber passing the amendment on June 4 by a vote of 56 to 25.[205] On August 26, 1920, the Nineteenth Amendment to the United States Constitution became law, and millions of new voters appeared at the polls in the presidential election of that year.[206] There can be little doubt that Hague realized that an entirely new bloc of voters was going to be available for the taking, and he intended to see to it that they voted as Democrats.

Although Hague can be criticized as someone who saw the opportunity and grabbed it solely for his own benefit (in this case, to ingratiate himself with female voters), it does not minimize his efforts on behalf of women and the suffrage movement. In 1921, his Hudson County slate included Irene Brown as a candidate for the New Jersey State Assembly, an election that she won thanks to Frank Hague. Brown became one of the earliest, if not the

first, female state legislators. She was followed two years later by May Carty and Catherine M. Finn, both elected to office because of Hague. Hague made sure that in every election the Hudson County Assembly delegation always had at least one woman, and at times it included as many as three.[207]

In 1912, Mary Norton—a young Catholic social worker and an early advocate for working mothers who had no safe, inexpensive place to leave their children—began Queen's Daughter's Day Nursery, a nonsectarian day-care center that operated out of the basement of St. Joseph's Roman Catholic Church in Jersey City. As part of her duties, she lobbied Frank Hague for city funds for the center. Her efforts left a lasting impression on Hague, and in 1920 he urged her to become a member of the New Jersey State Committee representing Hudson County, a position she held until 1944. In 1923, again through Hague's efforts, Norton was elected to the Hudson County Board of Chosen Freeholders.

In 1924, Mary Norton resigned as a county freeholder after she was tapped by Hague to run for Congress from New Jersey's District 12 (Bayonne and Jersey City). The elections that year were slated to be a Republican sweep nationally, but Norton believed that the women she had met throughout the community would come out to support her. She won the election by a plurality of seventeen thousand votes over her opponent. Historically, this has been viewed as an astounding victory. For a woman to win a Congressional seat in this time period in male-dominated urban America was virtually unthinkable, and many credit Hague as being a visionary, albeit an opportunistic one. Yet the truth is that there was really no political motive for Hague naming and supporting Norton; in fact, had she lost (a real potential even with the backing of Hague's machine), he would not only have suffered from the humiliation attached to the loss, but the loss of a House seat would also cost him valuable federal patronage. History has failed to record and has underappreciated the vital role that Hague's support of Mary Norton played in society's future.

Although Mary Norton stated that the newly available female voters would rally to her support and help her attain victory, that was probably not the case. The fact is that many new female voters objected to being urged into a women's bloc to vote only for women or to vote strictly on the basis of women's issues.[208] Grace Abbott, who evaluated the voting record from the passage of the Nineteenth Amendment until 1924, found that unlike other special interest groups such as manufacturers, women consciously avoided voting as a bloc.[209] Another problem in trying to determine what role women had or didn't have in Norton's victory is that no state, save Illinois, separated the ballots of males from females.[210] Additionally, although this is still a matter

of some debate, it has been argued that female voter apathy was extremely high in the election of 1920 and failed to improve significantly over the subsequent five years.[211] The result was that without a women's bloc, female candidates were at a disadvantage, and because major political party leaders did not view women as an influential voting bloc, their candidacy was by and large ignored.[212] Keeping this fact in mind, the magnitude of Hague's decision to back Ms. Norton is even more astounding and again points to an area—women's rights—where Hague was in the forefront.

There was absolutely no need to nominate a woman. Hague was still very much in charge of a large political organization, and in all probability any candidate on the ticket would have won the election. The myth that his actions were his way of securing the female vote is somewhat flawed when one considers that he could have done this without nominating Norton. Hague's control of his political army extended beyond the men that his organization employed: the women in these households realized that their husbands' and sons' livelihood depended on voting the "right" way. In addition, even those men who were not employed in patronage positions still wielded significant influence over their wives in the 1920s, especially in the area of politics. In 1927, Frank Kent concluded that women's politics merely reflected those of their husbands or male relatives.[213] Although this belief has been challenged by the research of Willey and Rice, who found evidence of "sex cleavage" in the 1920 presidential election, the problem with the research is that it is extremely limited since data was only available from Illinois.[214] If Kent is indeed accurate, then it could certainly be argued that Hague's risk was even greater, since there was a great deal of opposition to female candidates among males and urban politicians in New Jersey.[215] Proper evaluation of the impact of this decision by Hague requires additional insight into Mary Norton.

By the time Norton had reached the House, she was the first woman elected to Congress who was not initially preceded by her husband and the first female Democrat elected to Congress. In the House session of 1925, she was the only woman.[216] During her first term, she was assigned to the World War Veterans Legislation Committee. The all-male bastion of the halls of Congress did not intimidate Norton, who was more than able to hold her own. On one occasion, when a colleague deferred to her as a "lady," Norton retorted, "I am no lady. I'm a Member of Congress, and I'll proceed on that basis."[217] She would later serve on and eventually chair four committees: Labor, District of Columbia, Memorials and House Administration.

Norton introduced legislation that was in line with that of someone from an urban, working-class constituency, and there can be little doubt that Frank

Hague influenced her legislative agenda. Among the legislation introduced by Norton was a bill to exempt the first $5,000 of a family's income from taxation, creating mechanisms to mediate labor-management disputes in the coal mining industry, raising survivor benefits for women whose sons were killed in World War I and opposing the Smoot-Hawley Tariff in the late 1920s.[218] Norton was the first legislator to introduce bills to investigate and, later, repeal prohibition as codified in the Eighteenth Amendment. (It was repealed in 1933.) In 1929, in keeping with Hague's strong Catholic beliefs, as well as her own, she opposed the Gillett Bill, which would have eased restrictions on the dissemination of birth control information.[219]

Although she pushed hard for a bill that would have provided the District of Columbia with self-government, the legislation failed. She was, however, successful in gaining passage of a number of pieces of legislation that benefited residents of the District of Columbia. These included obtaining Public Works Administration funds to build a hospital for tuberculosis patients, securing the first old-age pension bill for District residents and legalizing liquor sales and boxing. Norton's (and thus, indirectly, Frank Hague's) most significant contribution to the working-class population of this country began in 1937, when Labor Committee chairman William P. Connery Jr. died. Norton resigned her chairmanship of the District Committee to succeed him as head of the powerful Labor Committee, with which she had been the second-ranking Democrat since 1929.[220] When the Democrats took control of Congress in 1931, Norton exercised her rapidly increasing influence to shepherd major pieces of legislation through Congress. By the time she became chair in June 1937, the second phase of the New Deal was in full swing. This focused on programs that sought to alleviate poverty and provide a social safety net, programs that included Social Security benefits and unemployment insurance. It was during in this period that Norton's underrated political career reached its pinnacle.

In 1938, the Fair Labor Standards Act, the only significant New Deal reform to pass in President Franklin Roosevelt's second term, was a result of Mary Norton personally shepherding the legislation through committee and onto the House floor. Included in the act were provisions for a forty-hour workweek and the outlawing of child labor, as well as setting the minimum wage of twenty-five cents per hour. Her efforts to get the highly controversial bill out of the Rules Committee, which determined what legislation was to be debated on the floor and which was controlled by "anti–New Deal" conservative Democrats, utilized a little-known parliamentary procedure known as the discharge petition. The procedure, which required her to obtain 218 of her colleagues' signatures

(half the total House membership plus one) on a petition, was successful, and she was able to bring the bill to the floor for a vote, where the bill as drafted failed to pass. Norton, who refused to be defeated, revised the legislation and managed to get the revised measure to the floor, where it then passed.[221] Upon its passage, Norton said, "I'm prouder of getting that bill through the House than anything else I've done in my life."[222] In 1940, when attempts were made to water down the act, Norton teamed up with majority leader John McCormack of Massachusetts to fight off revisions. From the House floor, she scolded her colleagues for attempting to reduce the benefits to working-class Americans (a $12.60 weekly minimum wage). That, Norton declared, was "a pittance for any family to live on...I think that when Members get their monthly checks for $833 they cannot look at the check and face their conscience if they refuse to vote for American workers who are getting only $12.60 a week."

Norton would serve thirteen successive terms, from 1925 to 1951. Although it is quite possible that Norton could have survived reelection on her own, she nonetheless remained fearlessly loyal to Hague. When the son of inventor Thomas Edison, Charles Edison, was elected governor of New Jersey and broke with the Hague organization, Norton came to her mentor's defense, calling Edison "the most arrogant hypocrite that ever walked." The following day, Norton received a handwritten note from President Roosevelt that simply said, "You are a grand girl!"[223]

Frank Hague, in addition to a representative in the House, had now elected the last two governors and was primed and ready to reelect a United States senator, Edward I. Edwards. Following his six years in the Senate, Edwards ran for reelection against Republican Hamilton Kean in 1928. Unlike Edwards's previous opponents, Kean came out against prohibition. This, along with the "Coolidge Prosperity" that was sweeping the country, cost Edwards the election. He lost by more than 230,000 votes, having 41.8 percent of the vote to Kean's 57.8 percent.[224]

Believing that even with this loss he would again be Hague's choice for governor in the 1929 election, Edwards was shocked when instead Hague chose A. Harry Moore, a decision that forever ended Edwards's friendship with Hague. This disappointment, along with the death of his wife and the loss of his substantial monetary holdings in the market crash of 1929, culminated in Edwards's shooting himself in his Jersey City home.[225]

Hague's choice of Moore wasn't surprising, since they had been friends for a number of years. The friendship began in the early days when they served on the Jersey City Board of Commissioners, and with the exception

of one disagreement, the relationship lasted without incident throughout Moore's three terms as governor. Moore was everything that Hague wasn't. While Hague had a sixth-grade education, Moore was a graduate of Cooper Union College and had received a law degree from New Jersey Law School. Hague was a solid Irish Catholic, while Moore was a Presbyterian and Sunday school teacher. In all likelihood, Moore was the first Protestant that Hague ever knew intimately.

Arthur Harry Moore would be challenged by New Jersey senator Arthur Whitney, an independently wealthy man who spared no expense in the election and made Hague, rather than Moore, the issue, explaining to voters that their choice was "Hagueism" or "Coolidge's." This campaign slogan resonated in most of the state, and on election night Whitney had a 65,000-vote lead, which quickly evaporated once the numbers from Hudson County started to come in. With his new bloc of female voters added to his already loyal contingent of organization voters, Hague was able to deliver a whopping 103,000 votes for Moore, giving the Democrat a 38,000-vote victory—and Frank Hague his third governor in row.[226] Although Republicans as well as the *Newark Evening News* would level charges of voter fraud and present the Hudson County prosecutor with some convincing evidence (such as a Hudson County district that delivered more votes than there were registered voters), they knew that the chances of the information ever reaching a grand jury were nonexistent. The reason was that the Hudson County prosecutor was Hague's personal attorney and his business associate, John Milton.[227]

Hague had also begun his move to become a national powerbroker starting at the 1920 Democratic convention, where he had met New York governor Alfred "Al" E. Smith. The two men hit it off immediately, recounting their similar backgrounds growing up in the ghetto and being subjected to the anti-Irish, anti-Catholic prejudices of the era. The Hague and Smith families soon became good friends and would vacation and attend boxing matches in New York City together. This relationship grew so close that when the 1924 Democratic Convention rolled around, Hague became an enthusiastic supporter of Smith's presidential nomination.

To Frank Hague, loyalty was everything, so when early in his tenure Governor Silzer fired the entire state highway board while Hague was on vacation, announcing that he did so because he believed that there was graft taking place in the awarding of paving contracts in the state, Frank Hague was left seething. This action by Silzer caused Hague to fear that Silzer had turned on him—in fact, Silzer was simply demonstrating to Hague that he wanted some degree of independence. Even with this slight to his

ego, Hague still went to the 1924 Democratic convention and supported Silzer's bid for the nomination by dutifully voting all thirty-eight of New Jersey's delegates for him on the first ballot, but he subsequently switched the delegation's votes for Al Smith. Smith's challenger was Woodrow Wilson's son-in-law, William McAdoo, and after 103 ballots and with neither Smith nor McAdoo willing to concede, the party instead settled on a compromise candidate: J.P. Morgan's lawyer, John W. Davis. Although this was a loss for Smith, Frank Hague emerged from the convention a winner, a man elevated to vice-chairman of the Democratic National Committee. Frank Hague was now a national figure within the Democratic Party.

While the stock market crash of 1929 was a disaster for most, it was a blessing for Frank Hague. Although it has been reported that Hague, in fact, lost a large portion of his personal wealth in the crash, from a political standpoint it was a deliverance from heaven. A country that had been solidly behind the Republican Party and its leader, Herbert Hoover, had now turned Democratic. In the statewide election of 1937, Hague would again deliver for Moore with a 130,000-vote plurality over his opponent, Reverend Lester H. Clee, who had an 80,000-vote lead over Moore before the ballots from Hudson were counted. Moore was sworn in for his second term of governor in 1931.[228] With confidence in Moore's ability, as well as loyalty, Hague did not micromanage the governor; he had more important things to do in his new role as the campaign manager for his good friend Al Smith, who was seeking the Democratic nomination for the presidency.

Smith's challenger was the very popular New York State governor Franklin Roosevelt, and one week before the convention, Hague set out for Chicago to head up the "Stop Roosevelt" movement. There he met with other big city bosses in an attempt to get them to switch their states' delegations to Smith. His efforts were in vain, and Hague left Chicago feeling beaten and nervous. His anxiety revolved around a statement that he had made to the press during the convention in which he said that "Governor Franklin D. Roosevelt, if nominated, has no chance of winning the election in November...He cannot carry a single state east of the Mississippi and very few in the far West. Why consider the one man who is the weakest in the eyes of the rank and file."[229] Frank Hague immediately knew that he had made a serious error and that if he wanted to maintain his power as a national figure within the party, he would have to remedy the situation, even at the cost of losing his friend of twelve years, Al Smith.

Hague realized that it would take more than just an apology to gain the loyalty of the nominee and keep his position as vice-chair of the national

committee. Moreover, he understood the potential monetary and patronage benefits of having a solid political ally in White House. With that in mind, Hague began to plot his move. Shortly after his return from Chicago, Hague telephoned Roosevelt campaign manager James Farley and offered up the governor's summer executive mansion in Sea Girt, where—if Roosevelt agreed to come to launch his campaign—they would be greeted by the largest crowd ever assembled for a political event. Farley and Roosevelt, with some reluctance, agreed. On August 27, 1932, Roosevelt entered the grounds of what James Farley described as "an endless crowd." In fact, some political observers have called it the largest political rally in history up to that time, with more than 100,000 people in attendance.[230] In typical Frank Hague fashion, he commandeered multiple trains and transported his minions from Jersey City to the shore for a day of fun, free lunch, music and fireworks, all of which culminated in the arrival of the nominee Franklin D. Roosevelt.[231] Roosevelt was so impressed with the showing that in his speech he said, "There is no general who could have assembled such a host as my old friend, the mayor of Jersey City," comments that were viewed by Hague and others as a public acknowledgement that FDR had, in fact, forgiven Hague.[232]

Hague took this new lease on his political life and ran with it. In addition to raising large sums of cash for the campaign, Hague did what he did best, delivering New Jersey's sixteen electoral votes. Although the Democrats had carried the state by more than 31,000 votes, Hoover would have won the state had it not been for the 118,000 votes that Hague delivered for Roosevelt from Hudson County, a favor that would not be forgotten by FDR.

HAPPY DAYS ARE
HERE AGAIN

On September 4, 1929, U.S. stock prices began a precipitous fall. Despite occasional rallies during the next six weeks, the market came to a crashing halt on what has become known as "Black Tuesday." On October 29, 1929 (the date that most economic historians usually attribute the start of the Great Depression), a record 12.9 million shares were traded. The economic fallout was incomprehensible to the average citizen; however, it would not be long before they would understand what it meant. During the next three years, stock prices in the United States continued to fall, until by late 1932 they had dropped to only about 20 percent of their value in 1929. This began to strain many of the banks, most of which had large stockholdings in their portfolios, and by 1933, eleven thousand of the United States' twenty-five thousand banks had failed.

The failure of so many banks increased the country's loss of confidence in the economy, which led to decreased spending, which in turn caused a decrease in demand and brought production to a virtual standstill. By 1932, U.S. manufacturing output had fallen to 54 percent of its 1929 level, causing between 12 and 15 million workers, or 25–30 percent of the workforce, to become unemployed.[233] Bread lines and soup kitchens were common sights, and unemployment, especially in the construction and mining trades, was extremely high. Families lost their homes because they could not pay their mortgages and had no choice but to seek alternative forms of shelter, such as the shantytowns called Hoovervilles, named after President Hoover, whom many blamed for the problems that led to the Depression.

As the Depression grew deeper and deeper, it started to have an effect on many American big city bosses as well. Their ability to provide patronage

became increasingly difficult as more and more people became unemployed. This high unemployment caused a lack of funds, and with consumers no longer having money to pay their real estate taxes, the well began to run dry. What also became clear was that no relief would be forthcoming from Washington, as President Herbert Hoover opposed any form of government intervention to ease the mounting economic distress, save the creation (in 1932) of the Reconstruction Finance Corporation, which lent money to ailing corporations but was viewed as woefully inadequate.

With the mounting despair in the country, it was no surprise when Hoover lost the 1932 election to Franklin D. Roosevelt, with Roosevelt garnering 22,821,277 votes to Hoover's 15,761,254 while capturing 472 electoral votes to Hoover's 59. Getting the nation back to work was the number one priority of the new Roosevelt administration, and getting his citizens gainfully employed was the priority of the mayor of Jersey City.

Almost immediately after his inauguration, FDR began to implement his legislative agenda (known as the New Deal, a term that was coined during Roosevelt's 1932 Democratic presidential nomination acceptance speech) for rescuing the United States from the Great Depression. Among the measures enacted during the first one hundred days were:

- The Emergency Banking Act (March 9), which provided the president with the means to reopen viable banks and regulate banking.

- The Economy Act (March 20), which cut federal costs through reorganization of and cuts in salaries and veterans' pensions.

- The Beer-Wine Revenue Act (March 22), which legalized and taxed wine and beer.

- The formation of the Civilian Conservation Corps (March 31). Three million young men between the ages of eighteen and twenty-five found work in road building, forestry labor and flood control through the organization.

- The establishment of the Federal Emergency Relief Administration to distribute $500 million to states and localities for relief. Administered by Harry Hopkins for relief or for wages on public works, the federal agency would eventually pay out about $3 billion.

- The establishment of the Agricultural Adjustment Administration to decrease crop surpluses by subsidizing farmers who voluntarily cut back on production.

- The passage of the Thomas Amendment to the Agricultural Adjustment Act, which permitted the president to inflate the currency in various ways.

- The passage of the Tennessee Valley Authority Act (May 18), which allowed the federal government to build dams and power plants in the Tennessee Valley, coupled with agricultural and industrial planning, to generate and sell the power and to engage in area development. The TVA was given the assignment of improving the economic and social circumstances of the people living in the river basin.

- The passage of the Federal Securities Act (May 27), which stiffened regulation of the securities business.

It was widely believed that the New Deal social welfare programs would undermine the old-style political machine. This belief was known as the Last Hurrah thesis. In reality, the New Deal work relief programs actually strengthened political machines. Local political bosses like Hague were able to trade jobs with the Civil Works Administration and Works Progress Administration for votes for their machines.[234]

Recent scholarship appears to challenge the benefits of Roosevelt's New Deal, with some authors suggesting that his actions may have actually lengthened the Great Depression.[235] For Frank Hague, the Great Depression was more like the "Great Sustainer," a literal reversal of fortune. With the establishment of the New Deal, federal funds began flowing to the states. Searle stated that "Roosevelt used the WPA as a national political machine. Men on relief could get WPA jobs regardless of their politics, but hundreds of thousands of well-paid supervisory jobs were given to the local Democratic machines."[236]

While allocation of funding to states was to be based on greatest need, the data makes this difficult to support. There was, in fact, a pattern of political motivation and WPA expenditures.[237] This distribution was done via each state's governor or its two U.S. senators who, if they were Republicans, would now have some difficulty in obtaining funds and thus have less patronage to funnel to the political bosses of their party. This essentially

put an end to Republican boss rule in cities such as Philadelphia.[238] In states with Democratic governors, funds flowed more readily, and opposition from political reformers ceased, mainly because they needed work or feared that they might need assistance and thus could not afford to oppose the machine. As John T. Flynn said of FDR, "It was always easy to interest him in a plan which would confer some special benefit upon some special class in the population in exchange for their votes," and eventually "no political boss could compete with him in any county in America in the distribution of money and jobs."[239]

The one exception to this procedure was New Jersey, where instead of the governor controlling the purse strings, it was Jersey City mayor Frank Hague whom the Roosevelt administration placed in charge of the distribution of these federal funds. When solicited for jobs or other federal patronage, Governor A. Harry Moore of New Jersey responded, "I do not have the power to appoint to these Federal positions. They are made upon the recommendation of the local organizations to Frank Hague...I would suggest that you get in touch with the mayor."[240] And while the priority of the Roosevelt administration was getting the nation back to work, getting his citizens gainfully employed became the priority of the mayor of Jersey City.

WPA administrator Harry Hopkins began the federal flow by giving Hague $500,000 per month for relief in 1933 and '34; during the five years Hopkins directed the WPA, $50 million poured into Jersey City. Harold Ickes, director of the Public Works Administration (PWA), an agency that made contracts with private firms for construction of public works, gave $17 million to Jersey City. By 1943, more than 8.5 million people had been put back to work on WPA-PWA projects, including a good portion of Jersey City residents. Among the projects for which Hague would use this federal money would be the construction of what many consider his legacy: the Jersey City Medical Center, which would eventually become the third-largest hospital in the world.[241]

During the nineteenth century, Jersey City operated a variety of public facilities for the health and welfare of the poor and sick. Among the earliest of these facilities was the pest house, which opened in 1805 in an isolated section of the Paulus Hook area of downtown Jersey City. Used to quarantine sufferers of contagious diseases, the building on the site known as the "Old Cabin" subsequently served as the county poorhouse. During the Civil War, it was once again turned into a facility to treat the sick when it was used for cholera cases. In 1868, the city aldermen voted to demolish the existing building on the site and establish the Jersey City Charity Hospital.[242] The

site was cleared, and the new building erected would house the institution for about a dozen years.

By 1881, factory development had taken over the Paulus Hook area of the city, and with this development came the large smokestacks that spewed their black soot into the skies and eventually into the lungs of the area's residents, including the hospital's patients. The city aldermen, aware of the situation, purchased a piece of land "up the hill" from the current downtown location at the corner of Baldwin Avenue and Montgomery Street. Because the health situation downtown had gotten so deplorable, a temporary building was established near the new site, and construction on a new facility commenced almost immediately.

In the interim during construction, the medical and surgical patients, as well as the alcoholics (of which there was no shortage), were housed in a mansion that was the former home of Orestes Cleveland, who served as mayor of Jersey City from 1864 to 1867 and again from 1886 to 1892, while obstetrical and pediatric patients were cared for in a smaller house on the property.[243]

In December 1882, the new building was complete and ready for occupancy. It was equipped to serve several thousand patients per year; however, it was quickly determined that the new facility would be outgrown in a very short time. By 1893, the facility had performed 4,095 surgical procedures, 1,972 medical dispensary cases (a term used to describe sick visits) and 691 ambulance calls, as well as had filled twenty-two thousand prescriptions.[244]

In 1905, under the direction of progressive mayor Mark Fagan, demolition of the existing facility occurred, and construction of a new hospital began. The building would not be completed until 1909, under the administration of Otto Wittpenn. In less than a decade, this new facility would require additional space to accommodate the ever increasing population of Jersey City. By 1919, an additional story was added to the existing structure, and a second building was constructed and attached to the original building. The now modern hospital consisted of two wards of twenty-five beds each on the first three floors (divided into male and female sections), and it was where most residents who required hospitalization were housed.[245] The exceptions were the wealthy residents of the city, who would obtain the very few private rooms. This was rare since most patients who could afford it would avoid the hospital, viewing it as an unclean house of death or a refuge for the poor, and instead remain at home under the care of a private physician.[246] The fourth floor of the facility housed two operating suites, complete with rooms for inducing anesthesia, an X-ray room, a sterilization room and a supply

room. The only patients not treated at the hospital were psychiatric patients, who were held in the county jail.[247]

In 1907, the hospital became a training school for nurses; admission requirements included the completion of at least two years of high school. The school graduated its first class in 1909, and within five years, Mayor Fagan had the city contract with architect John Rowland to build a facility to house nursing students. The cost of the project was $30,000, about $1 million in today's currency.[248]

The real development of the medical complex would occur under the auspices of Hague, and the man and the center would become inextricably linked. Unfortunately, the linking of Hague to the hospital has mainly been used as ammunition for attacking him. McKean, when describing the hospital in his book, sarcastically titled a chapter "Turning Hospital Beds into Votes: Socialized Medicine Under the Hague Machine." McKean's criticism continued, with statements such as, "It is practical to have children literally born into the organization, obligated to it from the first squalling moment."[249]

Additional criticism has been leveled at Hague regarding the poor planning and design of the hospital. The hospital at its peak had more than one thousand beds, too many to care for a citizenry the size of Jersey City. The number of elevators was far too small considering the enormity of the facility; additionally, there was no consideration for the parking of automobiles other than the street parking in front of the hospital, and while all of these are valid criticisms, to blame them on Hague is unfair.

Hague relied on the abilities of professional architects and designers, including the well-respected John T. Rowland, who designed most of the city's public schools, as well as many of the large private and public buildings that still dot the Jersey City skyline to this day—including the Public Service Building and the Jersey Journal Building, as well as the building known as 2600 Hudson Boulevard, a building in which both he and Hague resided.[250] Hague spared no expense in building the hospital facility and hiring the best physicians in the country, and there was neither economic reason nor personal benefit to be gained by Hague for allowing these deficiencies. And while there is no doubt that the grandeur of the facility caused the city to have an overbuilt hospital with some floors that were never used throughout its history, it was this same grandeur that enabled tradesmen and others to put food on the table for their families.[251]

The building of the medical complex that became known as the Jersey City Medical Center began in 1921 with the construction of a ten-story neoclassical building. The building was a separate specialty hospital for

obstetrical care located on the grounds of the hospital complex. In order to get the project started, Hague recruited members of the Hudson County Board of Freeholders, especially Mary Norton. With their assistance, a $1.6 million bond was issued by Hudson County for construction of the project.[252]

On October 12, 1931, the Margaret Hague Maternity Hospital opened its doors. Named after Hague's mother, the hospital would deliver more than 350,000 babies during its tenure. At its peak of operation in the late 1930s, more babies were born there than in any other hospital in the nation—the total for 1936 was 5,088. Of the 6,096 mothers admitted in that year, only 20 died—a maternal mortality of about 0.33 percent. The infant mortality was 2.50 percent. Both figures were well below the national average.[253]

The building accommodated four hundred mothers and babies and featured a stainless steel chandelier in the delivery room, as well as all-brass handles and a terrazzo floor. All of the public rooms were done in aluminum and bronze. Along with several penthouses, there was a movie theater on the top floor.

With the influx of federal funds via the WPA, Hague began to add to the complex, achieving the recognition of a man who brought first-rate healthcare to Jersey City, all while putting his supporters to work. On October 2, 1936, a public holiday was declared in Jersey City, and all schoolchildren and city employees were asked, or possibly "required," to attend the dedication of the new hospital. A crowd of more than 200,000 people was on hand to watch and hear President Franklin D. Roosevelt and Mayor Hague dedicate the new additions to the hospital. Author Marquis Child described the scene this way:

> Mayor Hague had turned out the town and half the state in an imitation of a Roman triumph. From the moment the procession of cars rolled out of the Holland Tunnel the thunder of bombs assaulted the ear, and the whole city under a cloudless blue sky seemed one mass of flag-waving humanity. Hague, an iron-jawed master of ceremonies, rode in the presidential car… to Hague's great public hospital and clinic in the center of the city.[254]

Frank Hague and Jersey City were the first experimenters in socialized medicine in the United States. During the Hague years, the annual cost to operate the hospital was estimated at $3 million. On the other hand, there was one year in which the hospital's revenue was less than $15,000. Although the revenues were not this meager in all years, in no year did revenue ever come close to the cost of operating the facility. Statistics from 1934 show a

complex that treated about 900 patients daily, and with its 750 employees, it became a great place to employ party loyalists.[255]

Hague, who was very fastidious about his dress and neatness, was known to walk the halls of the hospital unannounced, many times with his daughter, and check the cleanliness of the halls and rooms. If things were not up to snuff, there would be hell to pay.[256] Hague's insistence on extreme cleanliness for the hospital was the result of a little-known encounter that had occurred in early 1920. A city hall investigation of conditions at the Jersey City Hospital (the name prior to its change to the Jersey City Medical Center) resulted in the headline, "JERSEY CITY HOSPITAL PATIENTS FED FROM TROUGH. SPECIAL NURSE IN INSTITUTION TESTIFIES AT HEARING. THE FOOD NOT FIT FOR A SICK HORSE—MANY CASES OF ABUSE." Hague, who at the time was mayor, was incensed. "I will resign as mayor and close Jersey City Hospital rather than allow this condition to continue," he said. "I will not let these fellows stain me with their filth and corruption." This attack was against the hospital superintendent, John J. McDonald, and his staff. Hague filed charges against McDonald with the city commission to have him removed. What affected Hague most were the reports of mothers who had recently delivered their babies being moved into wards where there was rampant disease.[257]

When during a New Jersey state senate investigation a Republican senator accused Hague of allowing both the rich as well as the poor to deliver their babies and have their surgeries at no charge, and spending over $950,000 of city money, Hague shot back, proclaiming, "If they say they cannot pay, that is good enough for me…We do not argue with a sick person."

"Even if the patient is trying to get something for nothing?… notwithstanding his ability to pay?" asked the senator.

"My God, he is welcome to be restored to health!" answered Hague. When pressed further by the senator, "At the expense of the other taxpayers?" Hague responded, "Of anybody, of anybody!"

"When you give me a sick man I will restore him to health at anyone's cost," said Hague.[258] Most citizens of Jersey City, rich and poor alike, believed this, as is demonstrated by Dr. Dufay in his 2003 memoir about growing up in Jersey City:[259]

> It was true that I was skinny and more sickly than most…in my younger years. There was a remedy for most of my problems. Both Mom and Pop decided I needed Citrus of Magnesia for most of my ailments. I took it because it was real sour…and much, much better than castor oil (the ultimate remedy).

I tried to pull out most of my first teeth—when pulling was the best solution. I did that by tying a string to the tooth and then a doorknob, then dramatically slamming the door. It worked...most of the time.

But there were times when one of my teeth really ached, really. As the spoiled brat, I could have gone to a dentist...at least a dollar in cost. Nope.

Another one of my never told before secrets...I went to that huge hospital that was a product of Mayor Hague's generosity. It was a very tall white structure, a least a dozen stories high. I decided that I would go to that hospital one time. I would find out if people really were nice to even a poor kid. Vividly, I recall walking in one of their back doors. I was stopped by a person I now assume was receptionist.

"Hi, Sonny, can I help you?" (I wondered how she knew my name was Sonny).

With an almost scowl, I answered, "My tooth hurts."

There was only the briefest hesitation. Then that lady in white walked me down the hall.

She opened a door, peered inside, and introduced me to a puzzled lady in a white dress. She explained for me, "His tooth hurts."

Suddenly, there were smiles aplenty.

Within a short time, I was sitting in a dentist's chair.

"Open your moth. Hmm. Keep your mouth open."

Scrape, scrape, scrape, bzz, bzz, bzz.

"Rinse out your mouth. Spit here."

It was all over. I did get a pat on the head. Best of all, I had experienced socialized medicine, no paperwork, no numbers being recorded. And...my tooth didn't hurt anymore.

Thank you, Mayor Frank Hague.

When I got home, I was asked the usual question. "Where were you?"

Answer: "Nowhere. I just went for a walk."

Even Hague detractors acknowledge that he undertook one of the greatest relief and social programs of any city during the Great Depression; there is also no doubt that he was a social visionary in the area of healthcare.

Hudson County's largest funded project under the federal Works Progress Administration opened in April 1937. Jersey City's Roosevelt Stadium was built for $1.5 million. Originally to be called Veterans' Memorial Stadium, the 24,500-seat stadium was instead named for FDR by Mayor Frank Hague. The name change came about when Hague asked New Jersey WPA administrator Harry Hopkins to bend the rules and allow him to use funds

earmarked for construction for plumbing and seating in the new stadium instead, assuring Hopkins that the new stadium was going to be named after the president and that he would be invited to attend the opening.[260] The interesting point here is that much has been said about Hague allegedly pocketing WPA funds; this instance would seem to contradict such statements, as Hague went out of his way to ask permission to change the use of the funds.

Of all of the events held at Roosevelt Stadium, the most historic took place on April 18, 1946, when the home of the Jersey City Giants became the scene of the professional debut of Jackie Robinson, the African American player who broke the color barrier in baseball. In his five trips to the plate, Robinson had four hits (including a three-run home run), scored four runs and drove in three; to cap the day, he also stole two bases, allowing the Montreal Royals to beat Jersey City, 14–1.[261] (Hague was in attendance.) Other major events held at the stadium include the 1940 heavyweight fight between Max Baer and "Two Ton Tony" Galento, as well as many circuses and high school and college baseball and football games.

Federal funds would also help to build the A. Harry Moore School on Kennedy Boulevard. Designed as a school for children with special needs, Mayor Hague, who was not known for his command of the English language, used to refer to the school as "the Crippled School for Kiddies."[262] The school was named after Governor A. Harry Moore, a U.S. senator from New Jersey who was instrumental in obtaining funding for the building's construction. Both Moore and Hague were present when the cornerstone for the school was laid on May 5, 1931.[263]

As with everything with Hague, all of these social welfare programs were flush with questionable ethics. With his constant flaunting of the system, including the allegations of misuse of WPA funds and his overt kickback system by city employees, it is clear that if Frank Hague didn't have a friend in Washington, he must have had a guardian angel.

THAT MAN IS A RED

Although there have been many quotes attributed to Frank Hague, as seen earlier, they at times have been used out of context. One particular quote that has been credited to Hague and has been accurately quoted is: "As long as I am mayor of this city, the great industries of this city are secure. We hear about constitutional rights, free speech and the free press. Every time I hear those words, I say to myself, 'That man is a Red, that man is a Communist.' You never heard a real American talk in that manner."[264] Hague made this statement in a 1938 speech to the Jersey City Chamber of Commerce.

Based on this statement and what is known about his belief system, it's not hard to imagine how Mayor Hague would have reacted to the events that have been tied to Muslim extremists, such as the September 11 attack, the attempted bombing of the Detroit-bound Northwest Airlines jet on Christmas Day 2009 or the shooting by a Muslim army psychiatrist on an American military base in Fort Hood, Texas. Although we can only speculate, he no doubt would have called for an increase of racial profiling or even asked for more draconian measures, possibly the internment of all Muslims, an action that is not without precedent.[265]

We can make this assumption based on the fact that to Frank Hague it did not take an action against the United States to make you anti-American; just the verbalizing of anything anti-American was grounds to suspect that you were a communist, and there would be no anti-American speeches made in his 100 percent American Jersey City. It is because of Hague's limitation on free speech that he has been so vilified as to be compared with a dictator. Hague's challenging the rights of the Committee for Industrial Organization (CIO) to organize in Jersey City led to one of the more famous First Amendment

rights cases in the history of this country, *Hague v. CIO*, a case that was heard by the United States Supreme Court on February 27, 1939.[266]

The genesis of this case begins with Hague's on-again, off-again relationship with labor unions and their bosses. A September 23, 1919 *New York Times* article details a telegram that Hague had received from the president of the American Federation of Labor (AFL) asking him to meet with him. This telegram was in response to Hague's published reports in newspapers that he opposed the Jersey City police unionizing and affiliating with the AFL. The news story implies that there was a fear among Jersey City police to join the union since the 5 percent who were union members had resigned their memberships since Hague had become mayor (by 1917).[267]

While opposing unionization of the police force in Jersey City in 1917, Hague was a pragmatist and, like most politicians, did what was best for himself and his political career. Despite his actions against the police union in his early career, he actually became somewhat union-friendly and very accommodating to labor unions. This coziness with labor unions extended to the point of ordering his police department to turn back strikebreakers and protect union picketers, a very uncommon practice at the time. Some of this pro-union support by Hague no doubt was due to the influence of local labor czar Theodore Brandle, whom he had befriended.[268]

Brandle ran his own construction bond underwriting company, and Hague funneled millions of dollars worth of city and county work to Brandle's company. The friendship was so close that any strike that Brandle called had the full support and backing of the Hague police force. However, in 1931 this relationship turned bad.

Construction had begun on a project to build a powerhouse for Hague's pride and joy, the Jersey City Medical Center. The city had contracted with a construction company that was all union and had been approved by Hague. Not accustomed to first checking with others, Hague failed to clear the company through Brandle, who had a card filing system whereby he would select who would get the next construction project. Brandle was so annoyed that he ordered the union workers on the project to strike, and unlike previous Brandle-called strikes, this one did not receive police protection and even led to fighting between workers and police. Following the incident, Brandle, who was in charge of other union crews that were building the new hospital, threatened to halt all work on the hospital; Hague capitulated and fired the construction company building the powerhouse, allowing Brandle to run the project.[269] But Frank Hague would never forget or forgive Brandle for this humiliating episode.

The next large project in Jersey City was the construction of a large causeway between Jersey City and Newark, eventually named the Pulaski Skyway. The construction of this project was carried out by bridge companies belonging to the National Erectors Association, an "open shop" or nonunion organization. In addition to hiring nonunion workers, the construction bond was put up in cash, thus bypassing Brandle's company. Brandle threatened to "unionize the job or else" and began to organize picket lines of union men, which frequently broke out into violence in the streets around or directly in the work area. Brandle did eventually succeed in causing a five-day work stoppage in July 1931. But the 165 nonunion workers who had grown afraid of the fighting and would have liked increased wages in the end decided against joining Brandle's union. It was later determined in Congressional hearings that it would have cost National Erectors Association $50,000 in salaries had it chosen to pay union scale. Instead, the construction companies paid more than $300,000 for security measures to keep the job nonunion.[270]

Hague's war on labor was not over. Through his control of the state courts, he began foreclosing on labor and calling its leaders "racketeers," an assessment in which he was not alone. While there is a common belief that Hague's rhetoric was supported only in his city by those who were obligated to do so, this is not the case. The *Newark Evening News*, one of New Jersey's largest newspapers, backed Hague in his union-busting activities, reporting, "Hague's break with 'Czar' Brandle of the building trades was the signal for extending the fight being made here into the stronghold of Hudson. Mr. Hague knows how to fight these gentry, as has been shown by the fashion in which his police department cleared Jersey City of the gangsters who have found Newark to be such a comfortable place."[271] Author Steven Hart indicated that Hague's chief method of closing down or foreclosing on unions was to get locals declared corrupt and then placed under receiverships that drained their finances and scattered their membership. Hague also would ensure that these groups would be denied the use of rental space for their rallies.[272]

Hague now began the chant that unions were communist; in his mind, the two were synonymous. He also had Jersey City begin a campaign to lure industry to the city. The "Everything for Industry" slogan was advertised in newspapers and other outlets to let companies know that they could operate in Jersey City without fear of unionization, promising "perfect labor relations"—in other words, Jersey City was an "open shop."[273] What Frank Hague didn't know was that he had met his match in a new labor union called the Committee for Industrial Organization (CIO).

During the 1935 American Federation of Labor's convention, the issue of "craft-skill" (such as carpenters, lithographers and railroad engineers) versus "industry-workplace" became one of division. Craft unionists were opposed to organizing workers on an industry basis (i.e., into unions that represented all of the production workers in a particular enterprise, such as "auto workers"). Instead, they preferred separate units divided along the lines of individual craft. The battle at the convention became contentious, and a resolution proposing that union organization should be industry-based in order to support the explosion in the growth of mass production companies in the United States was defeated.[274] The defeat prompted a large defection of representatives from eight unions, who became the core group for the formation of the Committee for Industrial Organization.[275]

Some of the CIO's early victories in unionizing came in the auto industry and then the steel industry, but many of the early successes began to unravel, mainly because of decreasing membership, a result of the Great Depression.[276]

It was during the Great Depression that other labor groups would be formed. Many of these, such as the American Workers Party, had strong left-wing leanings and sought to find what they called "an American approach" for Marxism. However, it would be the Communist Party of the United States of America that would play a prominent role in the U.S. labor movement from the 1920s through the 1940s. However, it must be noted that the Communist Party of the United States never succeeded in bringing any large unions to endorse its agenda, nor was it able to increase its own membership from the rank and file of those unions with which it did wield a great deal of influence.[277]

The American Communist Party was well entrenched within the CIO, and although it was not a union organizer, its base within the CIO gave it clout. Even CIO leader John Lewis, who later would be the driving force to remove communists from the union, was in the earlier days willing to cooperate with the American Communist Party. When the Iron, Steel and Tin Workers expelled any member who was a member of the Communist Party, it was John Lewis who had them reinstated.[278]

One of the reasons for the lack of success in increasing its own membership roles was its overt use of the word "communist." It had been less then ten years since the height of the "Red Scare," which had begun following the Bolshevik Russian revolution of 1917 and during the First World War (1914–18).[279] Author and historian Murray B. Levin stated that the Red Scare was "a nation-wide anti-radical hysteria provoked by a mounting fear and anxiety that a Bolshevik revolution in America was imminent—a revolution that would destroy private

property, Church, home, marriage, civility, and the American way of Life."[280] Most leaders of these new groups, many of whom were preaching the political theory of anarchism, were mainly European immigrants, and xenophobia became widespread.

In some circles, the word "union" and particularly the CIO became synonymous with communist, and Frank Hague would latch onto this fear like a hungry fish on a fisherman's hook. The important thing to note (a fact that, like so many others, is ignored by Hague historians) is that this attitude and the actions that Hague eventually implemented were not his creation. Author David M. Kennedy noted that twenty-one states legislated "criminal syndication" laws. These laws had the effect of outlawing advocacy of violence in effecting and securing social change; however, some of the restrictions included limitations on free speech.[281] Whether or not Hague's anticommunist fervor was based on political ideology cannot be known for sure; it did, however, allow him to distract the attention of city residents, who were growing increasingly angry over the continuous tax increases that were required to feed the patronage machine.

Hague's political machine required ongoing patronage in order to survive. This patronage was paid for mainly by taxes, taxes that were becoming increasingly high in an effort to continue the ever growing patronage pool. In his twenty-year regime, Hague doubled the city's real estate assessments and tripled its tax rate. In a series about Hague, the *New York Post* cited the case of a small German tailor who in 1918 paid $126 in taxes on a shop-home assessed at $7,300. The following year, though, the neighborhood declined, the tailor's property was assessed at $16,200 and his taxes were $726. Hague also increased the city's debt 500 percent.[282]

Frank Hague at an anticommunist rally.

Additionally, and perhaps more importantly, those industries that did exist in Jersey City were getting tired of the constant tax increases. The last thing Hague needed was some union coming into the city and attempting to unionize these already fragile businesses, and he was determined to keep them out.

Hague went about doing so by telling the citizens of Jersey City that to join a union was the biggest mistake they could make and that they knowingly or unknowingly were supporting the "Reds." The utilization of the Red Scare technique by Hague also had the unwanted effect of bringing hundreds of sweatshops from across the river in New York City.[283]

Hague's control of the populace was mainly accomplished through a patronage system that was direct as well as indirect. The indirect control revolved around the fact that even if one were not directly employed by the city or the county, he certainly had a brother or a sister who was a teacher, a cousin who was a fireman or an uncle who was a cop, and so on. However, this indirect control was not as secure as direct control. It was because of the fear of losing this indirect control that Hague was cautious about using hardball tactics against union organizers without justification, so the Red Scare tactic and making Jersey City off limits to "Reds" (Hague's euphemism for unions) gave him the justification he need to attack union leaders.[284]

In all probability, Hague not only used the fear of communism as a way to keep unions out of the city, but he also no doubt felt, as did the majority of the country's other citizens, that communism (their Al-Qaeda) was a threat to all that was American. To Hague and his Jersey City residents, being American did not mean standing up for the rights of those who spoke against America; on the contrary, Hague believed in unconditional support of government policy, even if it resulted in the un-American tactic of limiting civil liberties.

Hague's linking of the CIO to the American Communist Party was not as off the mark as many believed, but even if it was a Communist organization, the CIO was not about to be intimidated. On November 29, 1937, several individuals gathered in the Jersey City headquarters of the CIO to initiate a recruitment drive and discussion of the National Labor Relations Act. When the CIO sent some forty circular-passers swarming into Jersey City, Hague immediately ordered his police force to seize the group's recruitment literature and refused to allow any outdoor meetings to take place by refusing to grant the required permits. Hague relied on a city ordinance that forbade gatherings of groups that advocated obstruction of the government by unlawful means.[285]

Since Hague's prime talking point in an effort to attract new industries was its freedom from labor troubles, and since as part of the publicity campaign the Jersey City Chamber of Commerce ran advertisement slogans like, "The industries of this city are more than 80 percent open shop," one could see how the actions of the CIO were beginning to upset the proverbial apple cart.[286]

So far reaching and powerful was Hague that the CIO could not find one Jersey City hall owner willing to take the risk of renting to the CIO for a mass meeting. The fear was not one of violence as much as economics, since any hall owner who rented out space would no doubt be visited the next day by a city building inspector who would duly find several violations, perhaps even condemning the building. These actions would soon increase the battle of words, with Hague upping his anticommunist rhetoric and the CIO and its supporters beginning to use terms such as "fascist" and "dictator" when describing Hague.[287]

As the war of words began to heat up, so did the headlines. The *New York Post* began a series about Hague, most of it not very complimentary. A February 7, 1938 article described Hague thusly:

> *Hague rules Jersey City by the old time boss methods of fear, force and favor. His is the most powerful local political machine left in the U.S. He differs from the conventional boss in only two ways: 1) He has chosen to hold office, though putting his puppets in the Governor's chair, in Congress and on the bench. 2) As the long-secure ruler of a city composed of humble working folk, he is more blatant and brazen than most in asserting his dominance, in defying his critics, in smashing his enemies and in enjoying the financial rewards of power. But he lacks the imagination, the ambition and the rabble-rousing eloquence of a Hitler or a Huey Long. Hague's real peers—Tweed, Croker, Vare, Sullivan, Ruef—are dead. The day of his kind is almost done. He is not a portent but a relic, not the First of the Dictators but the Last of the Bosses.*[288]

Hague's actions began to garner national attention. The term "dictator" was beginning to be utilized with greater frequency by newspapers when describing the mayor. The February 7, 1938 issue of *Life* magazine showed a photograph of Hague with a small mustache above the upper lip, which gave him an almost eerie similarity to Adolph Hitler.[289] The October 8, 1940 *New York Times* featured a cartoon drawn by political cartoonist Clifford Berryman showing Republican presidential candidate Wendell Willkie pointing to three song and dance men (labeled Hague, Kelly and Flynn) standing on a

platform, labeled "Little Hitlers, Third Term Trio," all giving the Nazi salute. Another little man, labeled "Crump" says, "Gosh, he overlooked me!"[290] In a campaign speech in October 1940, Willkie charged that President Roosevelt was trying to perpetuate his power and win an unprecedented third term "through petty Hitlers" who controlled the Democratic machines in the large cities, specifically alluding to Edward J. Kelly of Chicago, Edward J. Flynn of the Bronx and Frank Hague of Jersey City.[291] Another drawing appearing in the *Daily Worker*, on December 1, 1937, showed Hague lighting a cigar with the Constitution and the Bill of Rights.[292]

To the outside world, Hague's actions may have seemed extreme, but to the Jersey City locals, he was their protector, and his methods were standard operating procedure. As such, their support for their mayor was unwavering. To prove to the nation that his city's population was behind him, Hague planned a rally to support his position, and when Frank Hague planned a rally, it was not like your typical rally. *Time* magazine described the rally this way:

> *In a cold drizzle, on a blocked-off avenue near the big armory in Jersey City one evening last week John Serpico, president of International Fireworks Co., started setting off bombs as fast as he could light them. Slowly a crowd gathered, staring at the huge street banners proclaiming:* Time to Strike Against the Red Menace. *Children thought it was the Fourth. Around the armory a regiment of Jersey City policemen barked: "Right inside, folks, right inside."*[293]

Once inside the Jersey City Armory, the attendees were greeted with a banner as big as a barn that was hung over the speakers' platform; in typical Hague rally fashion, it read, "Jersey City 100% American. Reds Keep Out."

The irony here was that Frank Hague, the man who was so anticommunist, was certainly a man whose ideas verged very close to that of a socialist.[294] Hague's socialist leanings would be seen again with his building of the third-largest hospital in the world in Jersey City (using New Deal funds) and then giving away free medical care to the residents of Jersey City—what we would today call socialized medicine.[295] Given Hague's limited educational background, as well as his misguided yet genuine belief in his patriotism, it is unlikely that he realized that his actions in both the post office as well as the hospital were much closer to communism than that of a labor union's.

What Hague probably didn't realize was that his actions against the CIO would forever secure and enhance the First and Fourteenth Amendments. While Hague started the battle, in the end he would be the loser, not from a

political standpoint, as his support among the faithful never wavered, but from a legal one. Following is a short summary of how this case came to be heard by the high court and the violations of the First and Fourteenth Amendments.

In 1937, the Jersey City ordinance requiring groups advocating civil disobedience or overthrow of the government to obtain a permit from the chief of police before they could publicly meet or distribute literature in public places was tested by representatives from the CIO.

The CIO arrived in Jersey City to urge workers to exercise their right to organize, which had recently been granted as a result of the National Labor Relations Act passed in 1935. It was not the ordinance in and of itself that was the violation of the First Amendment but the fact that no permits had been issued to these groups. Various groups representing organized labor were repeatedly denied permits to hold meetings or hand out printed information on grounds that their members were communists, which by itself was not a violation of the ordinance and thus they should not have been denied a permit.

The next incident took place a year later. When socialist presidential candidate Norman Thomas announced that he was coming to Jersey City to speak and campaign, the Jersey City police were waiting for him. On April 30, 1938, Thomas was physically placed in a patrol car and driven to the ferry station, where he was escorted onto the boat and sent back to New York. No arrest took place. When asked about the incident, Hague responded that Thomas had been "deported," as though Jersey City were an independent republic.[296] After this incident, as well as others, the ACLU and its lead attorney, Morris Ernst, became involved. Ernst, who wanted to avoid arrests, which would have involved a long trial filled with appeals, instead sought an immediate injunction against Hague's "systematic violation of first amendment rights," and the strategy worked. In late 1938, Federal District Court judge William Clark ruled that the CIO was a legal organization and that its meetings would not produce a breach of the peace and issued an order forbidding the city from evicting union organizers, ending all illegal search and seizures as well as ordering the cessation of interference of the distribution of literature. But it would not end here. Hague's attorneys appealed to the Third Circuit Court of Appeals, which agreed with the district court that an appeal would be made to the United States Supreme Court.[297]

By the time the Supreme Court heard the case, public attitude toward freedom of speech had begun to change. Civil libertarians had convinced a puritanical public that censorship in academic freedom, sex education and literature was more damaging than edifying. The one area in which they had not been very

successful was in the political realm; it was an era when the public trusted its government and believed that any governmental action was done with the goal of protecting its safety, thus the outcome of the court case was not a given. In summary, the CIO's argument as noted by the court was as follows:

> *It further alleges that acting under an ordinance which forbids any person to "distribute or cause to be distributed or strewn about any street or public place any newspapers, paper, periodical, book, magazine, circular, card or pamphlet," the petitioners have discriminated against the respondents by prohibiting and interfering with distribution of leaflets and pamphlets by the respondents while permitting others to distribute similar printed matter; that pursuant to a plan and conspiracy to deny the respondents their Constitutional rights as citizens of the United States, the petitioners have caused respondents, and those acting with them, to be arrested for distributing printed matter in the streets, and have caused them, and their associates, to be carried beyond the limits of the city or to remote places therein, and have compelled them to board ferry boats destined for New York; have, with violence and force, interfered with the distribution of pamphlets discussing the rights of citizens under the National Labor Relations Act; have unlawfully searched persons coming into the city and seized printed matter in their possession; have arrested and prosecuted respondents, and those acting with them, for attempting to distribute such printed matter; and have threatened that if respondents attempt to hold public meetings in the city to discuss rights afforded by the National Labor Relations Act, they would be arrested; and unless restrained, the petitioners will continue in their unlawful conduct. The bill further alleges that respondents have repeatedly applied for permits to hold public meetings in the city for the stated purpose, as required by ordinance, although they do not admit the validity of the ordinance; but in execution of a common plan and purpose, the petitioners have consistently refused to issue any permits for meetings to be held by, or sponsored by, respondents, and have thus prevented the holding of such meetings; that the respondents did not, and do not, propose to advocate the destruction or overthrow of the Government of the United States, or that of New Jersey, but that their sole purpose is to explain to workingmen the purposes of the National Labor Relations Act, the benefits to be derived from it, and the aid which the Committee for Industrial Organization would furnish workingmen to that end; and all the activities in which they seek to engage in Jersey City were, and are, to be performed peacefully, without intimidation, fraud, violence, or other unlawful methods.*[298]

Hague and his attorneys unsuccessfully argued that in the 1897 Supreme Court ruling in *Davis v. Massachusetts*, the Boston Common gave the city absolute discretion over the use of public places.

In summary, the court agreed with the CIO, noting:

> *The bill alleges, and the findings sustain the allegation, that the respondents had no other purpose than to inform citizens of Jersey City by speech, and by the written word, respecting matters growing out of national legislation, the constitutionality of which this court has sustained.*
>
> *Although it has been held that the Fourteenth Amendment created no rights in citizens of the United States, but merely secured existing rights against state abridgment, it is clear that the right peaceably to assemble and to discuss these topics, and to communicate respecting them, whether orally or in writing, is a privilege inherent in citizenship of the United States which the Amendment protects.*[299]

This decision was not unanimous. Justice McReynolds, in his very strongly worded dissenting opinion, felt that this was not a constitutional matter and that the federal judiciary should not have even taken the case. He also felt that, as presented, municipalities should have the right to "control its own parks and streets."

> *I am of opinion that the decree of the Circuit Court of Appeals should be reversed and the cause remanded to the District Court with instructions to dismiss the bill. In the circumstances disclosed, I conclude that the District Court should have refused to interfere by injunction with the essential rights of the municipality to control its own parks and streets. Wise management of such intimate local affairs, generally at least, is beyond the competency of federal courts, and essays in that direction should be avoided.*
>
> *There was ample opportunity for respondents to assert their claims through an orderly proceeding in courts of the state empowered authoritatively to interpret her laws with final review here in respect of federal questions.*[300]

The significance of this case in constitutional law, as well as in group and individual freedoms, is unquestionable. *Hague v. CIO* was the first time the First Amendment was used to prevent the government from suppressing an expressive activity and opening public areas like parks and streets to free discussion.

What the court had to decide was whether freedom to disseminate information concerning the provisions of the National Labor Relations Act,

and to assemble peaceably for discussion of the act and of the opportunities and advantages offered by it, was a privilege or an inalienable right secured against state abridgment by the Fourteenth Amendment.

Hague was also found to have violated the Fourteenth Amendment: "No State shall make or enforce any law which shall abridge the privileges or immunities of citizens of the United States."

Viewed today, there can be no defense of some of the actions taken by Hague; however, in order to be fair to Hague, his statements and actions need to be viewed through a contemporary lens. Frank Hague lived in an era when civil liberties were constantly being threatened, usually under the guise of protection for the country and its citizens. This can be seen in the actions of President Woodrow Wilson (who today is viewed by most historians as an above-average chief executive), who presided over an administration that committed some of the most egregious violations of civil liberties ever seen in this country. Among the acts that he supported was the Espionage Act, which made dissident opinion punishable with jail. He refused to curb the actions of his postmaster, who refused to allow the U.S. mail to be used to send dissenting publications, and although Wilson did not order the crackdown on labor unions by his attorney general, he was keenly aware of such actions, choosing to turn a blind eye.[301] Following the war, it was Wilson and his attorney general, with their anti-Bolshevism stand, who were responsible for the start of the Red Scare.[302] And while Hague has been portrayed as the author of the anti-Red, communist-union connection, he had been well schooled in the theory by others before his actions in 1937.

In recent years, following the 9/11 attacks, the population of this country willingly accepted the actions of leaders who, in an effort to protect its citizens, rightly or wrongly hampered civil liberties. Two weeks after the attacks, Supreme Court justice Sandra Day O'Connor was quoted in the *New York Times* as saying, "We're likely to experience more restrictions on our personal freedom than has ever been the case in our country...It will cause us to re-examine some of our laws pertaining to criminal surveillance, wiretapping, immigration and so on."[303]

A retrospective look at Hague's actions against the CIO should include the fact that there *was* a communist element within the CIO, and as recent unclassified documents from the former Soviet Union reveal, a number of these elements were, in fact, anti-American and were actually spying for the Soviets. While this may not excuse Hague's abuse of the Constitution, to some degree it mitigates it.

FRIENDS IN HIGH PLACES

In his book *Plunkitt of Tammany Hall: A Series of Very Plain Talks on Very Practical Politics*, William Riordan wrote of the many discourses on politics delivered by Tammany Hall politico George Washington Plunkitt. Plunkitt was not shy about admitting his use of position in politics to get rich (which fits the term "graft") but that the trick was to do it legally, what he called "honest graft." He clearly distinguished this from "dishonest graft," which occurred if the task was accomplished by breaking the law.

Through his various connections, both political and not, Plunkitt would get word of a potential public works project and then purchase all of the property at the proposed site. He would then resell the property to the municipality at a hefty profit when the projects were publicly announced. In defending his actions, Plunkitt said, "I seen my opportunities and I took 'em." This, too, was the case with Frank Hague, who also saw his opportunities and "took 'em."[304]

Political ethics laws in the 1920s and 1930s hovered between lax and nonexistent, allowing politicians the privilege of essentially legally trading on inside information.[305] The ability to know about a proposed building project before it was publicly announced became the source of riches for many a politician, including Frank Hague. However, unlike others, Hague had a problem. The salary of Jersey City's mayor was in the range of $8,000 annually, so while other politicians who were lawyers, bank executives or other professionals had no problem explaining where they received the funds to make a purchase of property, red flags would certainly be raised if a mayor making $8,000 annually were to purchase a $100,000 piece of property for cash, and in 1929 the flag did go up.

Although firmly in control of the office of the state attorney general (appointed by the governor), as well as that of the county prosecutor, the one thing that Hague had failed to control was the state legislature, where both the assembly and the senate consistently remained in Republican hands. Hague's lavish lifestyle was becoming obvious, and the boy born on a kitchen table in the city's poorest area was now residing in a fourteen-room duplex apartment on Hudson Boulevard, in what was known as the Bergen Hill section, far from the downtown district from which he had come. To top matters off, Hague paid no rent, which gave rise to the speculation that Hague was a behind-the-scenes owner of the building. In addition, there were two maids and a full-time cook, as well as a handyman who doubled as a chauffeur for Mrs. Hague.

In May of every year, the Hague family would pick up and relocate to their home near the ocean in Deal, New Jersey, which after a few weeks of Jersey Shore sun they would usually abandon for a European getaway aboard one of the newer luxury liners. Upon their return, there would be time spent in Jersey City until the winter months rolled in, at which point Hague and his family would take refuge in their oceanfront villa in Biscayne Bay, Florida. While in Florida, Hague would be a regular in the owners boxes at Hialeah, were he was known as a heavy better. All of this caused the Republican-controlled legislature to demand an investigation of Hague's private and public life. State senator Clarence Case would head up the investigative committee. Case represented Somerset County, where he was a well-respected criminal defense attorney.[306] During the course of the investigation, the committee subpoenaed 335 witnesses, which generated an astounding 8,200 pages of testimony.[307]

Among the information yielded by the testimony was that Hague had substantial deposits in the National City Bank located in New York, as well as significant stockholdings in the First National Bank in Jersey City, owned by his friend, Edward I. Edwards, as well as in a second bank, the Trust Company of New Jersey. One of the most damning pieces of evidence was a pocket diary owned by Hague's good friend, contactor John Ferris. Ferris had been given a $1.5 million contract to improve the area around Journal Square in the heart of Jersey City, and in the diary was a notation that read: "Hague and freeholders…200,000." Although no dollar sign was used, the implication was clear, at least to the committee investigators. However, John Ferris died before his appearance before the committee to substantiate the entry.[308]

While the issue of whether Ferris paid kickback money to Hague for the Journal Square project will forever remain a mystery, the benefit of

the development of Journal Square to the citizens of Jersey City is often understated. Credit to Hague is stingy for his role in the development of the region, which effectively served its intended function, namely as the city's transportation center. It was a regional crossroads with a stop on the "Hudson Tubes" subway line that ran between New York and Newark, as well as scores of regional bus and trolley lines that all came together at Journal Square. In a 2004 report prepared for the Jersey City Economic Development Agency by Princeton University, the following statement was made: "A defining political phase of Jersey City was the Mayoralty of Frank Hague (1917–1947), who was not only influential in politics but in achieving landmark public buildings and infrastructure. The world-renowned Medical Center was built under his mandate, as were the Stanley and Loews Theaters and the Journal Square."[309]

Hague's purchase of land, including the Journal Square area, remained an area of questioning for the committee; however, like the other questions asked of him, Hague refused to answer.

Journalist John Farmer believes that during the more than thirty years of his leadership of Jersey City, Frank Hague probably owned some 20 percent of Jersey City and Hudson County land, using dummy corporations to buy parcels of land shortly before they were needed for industrial and residential development and selling such land at a huge profit. Farmer also noted, however, that although there were ethical issues involved, Hague's actions were not illegal. He went on to say that Hague made a great deal of money in the bull run of the stock market of the 1920s.[310] This was a major issue in the Case committee's investigation.

In one scenario presented by the committee, a parcel of land was purchased for $60,000 by Mr. H.S. Kerbaugh of New York City; shortly thereafter the county, which purchased it from Kerbaugh for $386,215, condemned the property. In another transaction, Kerbaugh purchased a tract of land in Journal Square for $218,000; shortly thereafter the county condemned the property, paying Kerbaugh $320,000 for only one-twelfth of the parcel.[311] It was suspected that Kerbaugh was a front for Hague, and although he was subpoenaed, he could never be located. Nonetheless, the committee believed that it had enough evidence to ruin Hague's political career and even perhaps land him behind bars. Case believed that the most vital testimony required in order to press criminal charges against Hague would come from Hudson County prosecutor and Hague's personal attorney, John Milton, but when he appeared, he stated that he had destroyed his checkbooks and all his records as he was no longer practicing private law.[312]

Mainly out of a sense of frustration, Hague was called to appear before the committee. Hague's reply to every question asked by the committee was the same: "I decline to answer." The committee now sought to have Hague appear before the entire legislature, one that had only two Democrats in the twenty-one-member state senate and a dozen more members in the sixty-member assembly. Although members of both houses screamed at him for his continuous refusal to answer questions, Hague remained calm, saying that his finances were his personal business and that the legislature lacked jurisdiction. The response to this was for the Republican majority to take the dramatic step of voting to have Hague immediately arrested.[313]

In his continuous Teflon manner, Hague avoided jail when John J. Fallon, a former Hague assemblyman and now serving as a judge on the New Jersey Chancery Court, ordered Hague released on a writ of *habeas corpus*, citing the unconstitutional use of judicial power by the legislature. The case subsequently was appealed to the Court of Errors and Appeals, which at the time was New Jersey's highest court. Here the justices voted six to six, with four abstentions. This was a victory for Hague, who later told reporters, "It is exactly what I expected."[314] There was a very good chance that there was a deeper meaning to the statement than the press realized.

What Frank Hague didn't know, although surely suspected, was that the investigation committee chairman, Senator Case, was in contact with U.S. Attorney General John Sargent. In his letter to the attorney general, Case confirmed the power of Hague: "There is a very general disgust with the Hudson County administration, which means practically the (entire) Jersey City administration inasmuch as the city of Jersey City dominates the entire County of Hudson." Case continued by specifically mentioning Hague by name: "The dominating figure in Hudson County politics is Mr. Frank Hague, Mayor of Jersey City."[315]

Case went on to describe in some detail the book-making operation taking place in Jersey City—his concern was not so much on the bookies as the fact that he believed that they could not operate without political protection and thus payment of graft money, ostensibly either directly or indirectly to Frank Hague. So fearful of internal leaks was Case that he closed his letter by saying, "I am taking the liberty to write you this letter without the knowledge of my associates on the commission, thinking that for the time being this might be a wiser course."[316]

Declassified FBI documents indicate that the attorney general forwarded the Case information to its director, J. Edgar Hoover. Hoover was not keen on getting the bureau involved, and on June 28, 1928, he wrote back

asking for written instructions as to what role, specifically, the office of the attorney general wished the FBI to play in the investigation. Hoover also raised a jurisdictional question: "It is not clear to my mind exactly what federal statute is being violated and it would appear to be largely a question of policy as to whether the federal authorities should inject themselves into what is apparently a local situation." A memorandum from Assistant Attorney General O.R. Luhring to Hoover dated August 22, 1928, indicates that the office of the attorney general (like Hoover) determined that there had been no violation of federal criminal statute, and thus it did not require the bureau's investigation.

Not satisfied with this response, on August 15, 1928, Senator Case and the commission's counsel, R.E. Watson, sent correspondence to the attorney general's office asking staff to enlist the aid of the Internal Revenue Service, alleging that Hague had violated federal tax law and had not fully reported his income. Watson wrote, "Frank Hague is mayor of Jersey City and has been a commissioner of the city for the past fourteen or fifteen years. His salary in that office has never exceeded $8,500.00 per year." Watson then went on to describe Hague's lavish lifestyle and said that "[i]t is impossible to believe that Mayor Hague could have ever have come into possession of such large blocks of property, or could have maintained himself in the way in which he does, without ever having received taxable income."[317]

This information, unlike that previously supplied, apparently raised the interest of the U.S. attorney's office. Assistant U.S. Attorney Mabel Walker Hillebrandt responded to Watson on August 22, 1928: "I have today personally sent a copy of your letter to Mr. Blair, Commissioner of Internal Revenue, with the request that an officer of the intelligence service be assigned immediately to investigate the suspicious transactions which you brought to my attention."[318] No criminal charges were ever brought against Hague. Speculation as to why has ranged from Hague calling on some of his Republican friends (although this was unlikely) to a manpower shortage causing the government to focus its attention on trying to obtain indictments and convictions against various organized crime figures such as Al Capone.[319]

While his Teflon-like magic would again allow Hague to escape with both his freedom and power intact, it would not end the efforts of his political enemies, not only from outside his party but also from within his own Democratic Party. In 1937 and 1938, Hague, because of his anti-union activities, had attracted a great deal of adverse publicity. Fearing that such publicity would have a negative effect on all Democratic candidates, FDR decided that Hague needed to be knocked down a notch, and in 1940 he got

his opportunity. Through what historian Thomas Fleming described as "a combination of cajolery and political arm twisting, the president persuaded Hague to accept Charles Edison, son of the inventor Thomas Edison, as the Democratic nominee for governor in 1940."[320] Edison had been appointed assistant secretary of the navy by FDR in 1937. With the death of Secretary of the Navy Calude Swanson in early 1939, Edison was elevated to fill the position on December 30, 1939.

By the first part of 1940, FDR was looking for a way to remove Edison and told chief aide James Farley that it was because Edison was hard of hearing, making it difficult to work with him; the real reason was so he could fill the post with a Republican. Roosevelt felt that a bipartisan cabinet would be beneficial to passing his legislative agenda. There has also been speculation that FDR felt that an independent Democrat might slow the tide of Republicanism that was occurring in New Jersey, in part due to the rising reform movement, a movement that was strongly anti-Hague.[321] FDR instructed Farley to call Hague and ask him to run Edison for governor; Hague reluctantly agreed to FDR's request, albeit with caveats. It was this part of the deal that worried Farley, who reported back to FDR, saying, "Hague is a hard taskmaster and he might want Charley to keep certain obligations that Charley wouldn't want to fulfill, I don't think it would be fair to Charley to get him involved."[322] FDR knew that Edison was intransigent and had no intention of becoming a Hague puppet like A. Harry Moore. To convince him to run, Roosevelt promised Edison that Hague would confine himself to Jersey City; this promise by FDR was totally disingenuous, as he continued to funnel federal patronage through Hague.[323]

Edison, who had been a Republican in the 1930s, switched parties with Roosevelt's election and was a big supporter of the New Deal. Now he was an independent Democrat who owed nothing to Hague, and he tried to distance himself from Hague every chance he got. In a campaign speech given in Sea Girt in Hague's presence, Edison said, "If you elect me governor, you will have elected a governor who has made no promises to any man," a statement clearly aimed at Hague.[324] While Edison won the election by more than 64,000 votes, he carried only seven of the state's twenty-one counties and was even defeated in his home county of Essex. Nevertheless, the boss came through, supplying Edison with more than 108,000 votes from Hudson, enough to make up the shortfalls from the counties that Edison did not win. Edison owed his victory to Frank Hague; however, he would quickly forget this. One of the first things the newly elected governor did upon entering his office in Trenton was to have the direct phone line from

Jersey City to the governor's office disconnected.[325] But it was Edison's next move that infuriated Hague the most.

Edison told a newspaper that in naming a judge to the Courts of Errors and Appeals, he would appoint a judge, not a political stooge, a direct attack on Hague. Hague responded, "I'm gonna break you Charley, if it's the last thing I do, because you're a damned ingrate."[326] When Edison called on his friend FDR for help in controlling the "ruthless boss," there was silence from the White House.[327] There has been much speculation as to why Roosevelt remained silent instead of coming to Edison's aid. While it may have been his refusal to get involved in state and local issues, or perhaps he was too overwhelmed with the war to get involved with such petty matters, the most reasonable explanation was that FDR was a politician first and foremost. FDR was well aware of the fact that Frank Hague would be around long after Charles Edison left the governorship and that in order to be reelected in 1944, he would need to carry the increasingly Republican state of New Jersey—and in order to do this, he would require a large plurality from Hudson County. There was no way that he was going to choose Edison over Hague, and he would later prove this when Hague wanted one of his loyal supporters, Thomas F. Meaney, appointed to fill a seat on the federal bench. Despite objections from Edison, not only did the president comply with the request, he also did so without even the courtesy of informing Edison.

Tensions between Hague and Edison began almost immediately following the latter's election. Insisting on a reformation of "Jersey justice" and opposed to political clubhouse judges on the bench, Governor Edison refused to appoint a Hudson County Hague selection to the state Supreme Court; instead, he chose Frederic R. Colie, a bar association–endorsed Republican from Newark.[328] Not only was Colie a Republican, but he was also the man who led the opposition to Governor Moore naming Hague's son, Frank Jr.—a law school dropout who miraculously passed the New Jersey bar examination (when more than 50 percent failed)—to the bench of New Jersey's highest court, the Court of Errors and Appeals.[329] Hearing the news, Hague called Edison and roared over the telephone: "Charley, you've turned out to be just the kind of governor I thought you'd be, you…Benedict Arnold!"[330]

The Hague-Edison war increased in intensity over railroad taxes. Two of the New Jersey lines had filed for bankruptcy, and two others were on the verge of doing the same. The railroads, in part, blamed the high taxes levied on them by municipalities such as Jersey City, as well as counties and the state, a state that they perceived (and in most cases they were correct) was run by Frank Hague.[331] In its 1940 report, the Interstate Commerce Commission

noted that the average tax accrual per mile of track in the United States was $1,809, while in New Jersey this amount exceed $10,000; even New York had a per-mile rail tax of only $3,200. Nonetheless, Hague argued that now that prosperity had returned to the country, the railroads should not only ante up the $34 million in back taxes, but they should also do so with interest, amounting to almost $81 million, of which half belonged to Jersey City.[332]

Edison believed that his role in the state government was to revise the antiquated New Jersey state constitution. The current constitution limited a sitting governor to three years and forbade a governor from succeeding himself; it also allowed the legislature to override a veto by a simple majority. Although most agreed that an update of the document was necessary, there was opposition from rural republicans when Edison suggested that the state senate be restructured to more accurately reflect the state population. However, his biggest mistake in his attempt for change was describing the changes as a way of "curbing Hague's power." With that statement, any hopes of Edison holding a state constitutional convention were over.

With the 1943 election looming, Edison continued to try to dismantle Hague's grip on the state, and in 1942 he found a way. The Hague patronage machine was fed by taxes, especially those imposed on big businesses and utilities and by the Hague-appointed Hudson County Tax Board. Edison realized that if he could cut off the head, the body would die, and through the exercising of various powers given him as governor, he replaced the entire five-man tax board with his own people. Hague's response was swift and decisive—he immediately blocked any appointments made by Edison to any position or state board in New Jersey.[333] As if this were not enough, the battle was now out in the open, complete with name-calling. On a radio program, Edison lashed out at Hague, calling him "corrupt and dictatorial," and formed a statewide anti-Hague organization, United Democracy.[334] Despite his best efforts and absent the support promised from FDR, Edison went into the state Democratic Convention already a defeated man. Frank Hague had again used his still strong but diminishing power to have his candidate for governor, Newark mayor Vincent Murphy, nominated. Come election day, although Hague used every card in the deck, Murphy lost the contest by 130,000 votes. Even more disturbing to state Democrats was Edison's failure to endorse his party's candidate (he had instead remained neutral).[335]

Although he lost the statehouse, Hague was far from being politically impotent, and the newly elected Republican administration—with the new powers granted by the passage of the new state constitution, which ironically had finally passed with the support of Hague—sought to end the

reign of Frank Hague once and for all. The new constitution compelled elected officials to testify in state investigations, and now Walter van Riper, the newly appointed state attorney general and Republican heir apparent for the governor's seat in the next election, would set his sights on the mayor. The target was the well-known but illegal betting hall in Jersey City known as the "Horse Bourse," which was commonly believed to be under the protection of Hague, who was receiving substantial sums of money from the operation. One of Van Riper's first moves was the removal of all Hudson County detectives under Hague's control.[336]

Van Riper had in his possession details of where wire rooms were located and the phone numbers attached to them and thus the owners of these phone numbers, many of whom, like John Quinn, were ward leaders in the Hague organization.[337] But the investigation never really got off the ground. Within months, new attorney general Walter van Riper was indicted by a federal jury for kiting checks and for selling black-market gasoline through a service station that he partially owned.[338]

While Hague historian Thomas Fleming, among others, speculated that some grand jury witnesses had committed perjury and that the charges against Van Riper were, in fact, trumped up, until now no proof has been offered up to confirm this. There has also been much speculation as to the Hague-Roosevelt relationship, as well as the role that the president played in rescuing Hague. Although not a blanket confirmation, files indicate that Roosevelt, as well as FBI director Hoover, did play a role in the charges brought against Van Riper, which in turn saved Hague from prosecution.

While attending a seminar at the Columbia University School of Journalism, former New Jersey governor Charles Edison was holding an off-the-record conversation with other attendees at the seminar. One of those listening was a gentleman described in FBI documents as Judge E.A. Tamm. Tamm felt that the off-the-record comments by Edison would be of interest to the FBI director and sent Hoover a memo dated September 15, 1948. In it, he detailed that Edison "spoke at considerable length in a completely off the record statement relative to his experiences as Under-Secretary and Acting secretary of the Navy and as Governor of New Jersey. Edison's talk was particularly vitriolic in reference to the late President Franklin Delano Roosevelt and very critical of Mayor Hague of New Jersey and the collaboration between Roosevelt and Hague."[339]

The memo continued: "Edison stated in the course of his discussion that the only person who ever succeeded in 'getting something' on Hague was the former attorney general of New Jersey, Van Riper."

Edison went on to say that "as soon as Hague realized that Van Riper was really going to 'get' him, Hague proceeded to Washington and talked with Mr. Roosevelt." Edison indicated that as a result of the conference between Roosevelt and Hague, Roosevelt sent for J. Edgar Hoover and instructed him to conduct an investigation of Van Riper's activities. As a result of this phony FBI investigation of Van Riper, he was indicted on fictitious charges of OPA and bank violations. Edison indicated that this investigation was so harassing to Van Riper that he was unable to proceed with his own investigation and prosecution of Hague. Edison said that he personally expressed his displeasure about this situation, as well as the continuing use of the Hague machine to pressure the president, to which FDR responded that "when it was necessary to accomplish your objective to cross a river you should not hesitate to ride on the shoulders of the devil himself if that was the most expedient way to get across the river."[340]

The following day, Special Agent Clegg, who was also attending the seminar, was scheduled to speak. Apparently intrigued by Edison's off-the-record comments, reporters questioned Clegg in detail about the FBI and its investigatory tactics. When word about Edison's comments and reporters' questions to Clegg reached Hoover, he immediately asked for Clegg to prepare a memorandum outlining what he remembered about the event.

In a memorandum titled "APPEARANCE BEFORE AMERICAN PRESS INSTITUTE, COLUMBIA UNIVERSITY, MARCH 18TH, 1947—WALTER D. VAN RIPER, FEDERAL RESERVE ACT, MAIL FRAUD, CONSPIRACY," Assistant Director Clegg outlined his recollection of events for Hoover. Among the questions he remembers being asked was: "Was the FBI ordered to discontinue the investigation of the Hague Machine at the request of Attorney General Biddle?" Clegg told Hoover in the memo that he informed the questioner "that the FBI did not make political investigations." Clegg went on to state that he was "not aware of any investigation which the Bureau had conducted of a political machine, as such." (One cannot really believe that Clegg was so naïve as to think that the FBI had no role in investigating political corruption; instead, he no doubt was telling Hoover how he responded to the question.)[341]

Edison's semi-public insinuation of a "fix" involving Roosevelt, Hoover and the FBI sent Hoover into a rage, and he sent a memo to have Agent Clegg go make a personal visit to Edison's New York City home to speak with him. Ostensibly the visit was to make further inquiry into the matter, as well as to let Edison know of Director Hoover's displeasure with his statements and to "put him straight" as to the role of the FBI.[342]

The visit apparently had an effect on Edison because on September 23, 1948, Edison sent a letter to Hoover addressing the director as "Dear Edgar,"

possibly in an attempt to remind Hoover of their friendship; Edison reiterated what he had told Clegg. Far from an outright denial, Edison stated that he had "no recollection of ever having made such a statement anywhere or any time." This attempt at plausible deniability continued: "There was a period of questions and answers in which I quite naturally was speaking off the cuff."[343]

It is, of course, impossible to know whether Edison had inside knowledge of a Hague-Roosevelt-Hoover deal to save Hague from prosecution or if he was simply speculating. However, given the details of the statements that Edison attributed to Roosevelt, as well as his inside Washington connections, coupled with Hoover's apparent concern about Edison's alleged statements and the flimsy evidence against Van Riper (who was ultimately acquitted on all counts), it would seem reasonable to speculate that FDR's interference on behalf of Hague occurred.

Further confirmation that these events likely happened is the now well-known fact that one of the most egregious offenders of using federal agencies such as the IRS as a political weapon was FDR himself. In Roosevelt's first term as president, he attacked Andrew Mellon, former secretary of the treasury under Presidents Coolidge, Harding and Hoover, a man whose economic philosophy was the complete antithesis of Roosevelt's.[344] Mellon had no hesitation of expressing his dismay with the president's policies on how to end the country's economic depression, especially the policy of expansive government and increased spending programs.

Through his current secretary of the treasury and longtime friend Henry Morgenthau and his attorney general Homer Cummings, Roosevelt set out to get Mellon. Author John Morton Blum detailed how the wheels of the investigation were set in motion when Morgenthau ordered Elmer Irey, head of the intelligence unit at the Bureau of Internal Revenue (later renamed the Internal Revenue Service), to conduct an audit of Mellon. When Irey hesitated, Morgenthau called him personally and demanded that Irey conduct the audit. Morgenthau told the prosecutor that in this particular case, "You can't be too tough in this trial to suit me."[345]

It is known that FDR used government agencies against political rivals—among the most often employed was the IRS. It was the IRS that conducted a lengthy investigation of Huey Long, the flamboyant Louisiana governor and senator. Long, who had originally support FDR, now ridiculed his New Deal administrators as charlatans and incompetents.[346] Roosevelt responded by calling Long one of the two most dangerous men in the country and tried to control Long by denying him federal patronage, even going so far as to send federal funds to

Long's political enemies. The order from the White House was, "Don't put anybody in and don't help anybody that is working for Huey Long or his crowd. That is 100 percent."[347]

The Long case demonstrates that to FDR, loyalty was paramount, and he would not hesitate to use the agencies at his disposal to crush a political enemy. Long, like Hague, was not independently wealthy, and like Hague he had somehow found enough money to hold the loyalty of his state. Unlike in the case of the staunchly loyal Hague, Long's federal funding was cut in the hopes that it would essentially starve Long out, leaving him with no money for patronage. Yet he remained as popular as ever, causing the government to wonder how this could be. The conclusion was that graft and kickbacks from state contracts were enough to keep Long in power. Following an IRS investigation, a number of state contractors who built state highways began to cooperate with the government.[348] Although there were a number of prosecutions of Long associates, and while some convictions were obtained, other trials ended with acquittals. After Long's assassination, his organization was taken over by his brother, Earl, who decided to make peace with an administration that demanded loyalty and would not hesitate to use the agencies available to it to obtain what it wanted. In exchange for promised support, the IRS investigation ended. Roosevelt won almost 90 percent of Louisiana's vote in 1936.[349]

FDR could put a halt on an investigation just as quickly as he could start one. In 1942, the IRS had begun an investigation of a junior congressman from Texas named Lyndon Johnson. It was discovered that Brown and Root Inc., a very large Texas contracting firm that had constructed dams and built other projects with federal dollars, had donated heavily to Johnson's two senate campaigns in the 1940s.

Although campaign contributions were not tax deductible, the contracting firm did so anyway, thus triggering an IRS audit. The audit determined that they owed the government more than $1.5 million in back taxes and penalties and were also exposed to possible jail time.[350] The audit trail of Brown and Root eventually led to Johnson himself, who became an IRS target for failing to properly report income from his campaigns.

On January 13, 1944, following an eighteen-month investigation of Johnson by no fewer than six IRS agents, President Roosevelt held a meeting with Johnson. What transpired in the meeting is not known; what is known is that later that day, the president contacted Elmer Irey and began the process of halting the investigation of Johnson. Brown and Root was allowed to settle its back tax matter for $372,000. Johnson, like Hague, was too valuable to the president to lose.[351]

GENTLEMEN, HATS OFF

B y the 1940s, the demographics of Jersey City had changed considerably. An examination of the 1930 census shows a population of 316,715, and there would be a continued drop in population over the next decade, especially in the downtown wards.[352] The cause of this decline included urban flight to suburbia and a decline in the birth rate, no doubt tied to the Depression, when having children and thus more mouths to feed was not a good idea. However, it would be the adoption of a stricter immigration policy by the United States, which caused a decline in foreign-born whites from 29.0 percent in 1910 to 13.7 percent in 1950, that would have the greatest effect on Frank Hague's political future. This decline in the number of foreign-born persons and the absence of suitable replacements was the beginning of the end for most big city bosses, including Hague.[353]

The changing demographics, with Italians and Slavs now dominating the immigrant population in a city where the Irish and Germans had made up the majority during most of his reign, didn't seem to register with Hague. He had always tried to give representation to the minority groups in the city by allowing them to have spots on his ticket for seats in the State Assembly and board of education (even giving the positions of police captain and police court judgeships). However, his continuing policy of giving major patronage positions such as county and state bench appointments—as well as state senator, U.S. representative, city commissioner, county freeholder and sheriff—to only Irish Catholics, with an occasional very friendly Protestant thrown in, would turn out to be a mistake.[354]

It is hard to believe that Hague, who, despite his lack of formal education, could tell you off the top of his head the exact number of votes from a voting

district in the last election, did not recognize both the increasing animosity among the newer majority groups and the fact that his failure to institute a policy of a balanced ticket, especially in city commission elections, was hurting him and his organization. Instead, it is more likely that Hague's reluctance to establish the "balanced ticket" policy stemmed from his "Us Against the World" loyalty ethos from his Horseshoe days.

As late as 1948, there was a vociferous outcry from the increasing Polish population when instead of appointing Poles to fill two upcoming vacancies (one on the board of freeholders, the other on the city commission), Hague instead had the Irish freeholder and an Irish city commissioner simply switch positions. However, because he still controlled city and county patronage, coupled with the social services that his organization supplied, Hague was able to maintain control and loyalty to some degree. This, however, was about to change.

The New Deal, while being the most significant factor in helping Hague to remain in power, would simultaneously result in a decrease in the reliance on his organization by the city's citizens. The beginning of 1940 saw the start of monthly payment to seniors via the newly instituted Social Security System, and by 1943, ward leaders were reporting decreases in requests for the organization-supplied Christmas dinners. The number of dinners requested in 1942 was fifteen thousand; by 1943, this had decreased to seven thousand, a relatively small amount when compared to the twenty-five thousand requests received during the Depression era.[355] This postwar economic good fortune that was visiting the citizens of Jersey City did not hold the same good fortune for Hague. The success of the Hague organization, like most big city political organizations, actually depended on the misfortune of its constituents, which in turn created a need for the organization's services. The instituting of the Federal Employment Act of 1946, coupled with other government changes and an overall improvement in the economy, created an environment requiring little dependence on organizations such as Hague's. No longer was there the need for food or jobs; this increase in prosperity was a deathblow to any organization that relied on patronage for loyalty.

While Hague came through for FDR in 1944, it was the beginning of the end of his ability to win statewide elections for the Democratic Party. The decline had already begun in 1943, when the Democrats lost the statehouse, and although Hague wasn't sorry to see Edison leave, his replacement, Republican Walter Edge (who had been cooperative with Hague in his first term as governor and as a U.S. senator in the 1920s), had become annoyed and angry with Hague for the mudslinging that was coming out of Hudson County. Edge, unlike the earlier years, was now a determined opponent.

Among the first order of business for Edge was a change in the state constitution. A draft of the new constitution was clearly anti-Hague, as it included language such as allowing the legislature to investigate the conduct of local officials, thus overruling the court's 1929 decision in the case in which Hague had refused to testify during a legislative investigation of his finances. Hague, although weakened, still had enough steam left to defeat the first draft of the new constitution. However, the battle was far from over, and a determined Edge and the Republican legislature began to turn up the heat. The first move was to appoint a new attorney general and install him as acting prosecutor in Hudson County, where daily raids of gambling houses had begun. In addition, there were new judges appointed in Hudson County, along with gubernatorial appointed jury commissioners. Other changes instituted included the mandated use of voting machines for all elections in Hudson. All of this, of course, was aimed at cutting off Hague's economic and judicial power. In the 1945 municipal elections in Jersey City, a confident GOP endorsed the anti-Hague ticket that doubled its votes from the 1940 municipal election yet still went down to defeat by more than fifty thousand votes.[356]

The GOP had better luck in the gubernatorial election of 1946, where it was once again victorious, with Alfred Driscoll winning the governorship. Unlike his predecessor, Driscoll believed that you catch more flies with honey than vinegar, and instead of utilizing the GOP majority against Hague and Hudson County, he practiced a policy of inclusion. Driscoll believed that this was the only way that a new state constitution would ever become a reality. He began with two large carrots: the appointment of a new jury commissioner and the filling of a vacancy on the bench in Hudson, both by men who had been endorsed by Hague. This attempt at bipartisanship worked. Hague abandoned his opposition to the new constitution, and in the summer of 1947, at a meeting at Rutgers University, a new draft charter for the state was completed.[357] The change in the new constitution that would have the biggest effect on Hague's future was the abolition of the Court of Chancery—it was this court's injunctive power that often had come to Hague's rescue. Nonetheless, Hague gave his full support to the new laws by which the State of New Jersey would operate.

Governor Driscoll was criticized for kowtowing to Hague; however, in his defense, Driscoll realized that if the GOP were to continue to ignore or discriminate against Hudson County, the chances for success in obtaining a new constitution were close to zero. Now, with Hague's support, the new constitution won an easy victory in the election of 1947.

Perhaps Hague's acquiescence to the change in the constitution was a result of his having reached a period in life when the grief-to-profit ratio of being a larger-than-life political icon no longer tilted to the profit side. The continued criticism of his not being in the city and spending more time in Florida became a constant complaint by many people of all socioeconomic backgrounds. The local paper, the *Jersey Journal*, attacked Hague's continued absence from Jersey City in scathing editorials with comments such as, "[B]ut he can't hide from the facts that there's more garbage spilled on Jersey City's streets than he can find in Miami, more offensive odors in one night from unsanitary sewage disposal then he can sniff in one month at Miami Beach."[358] All of this was true, but it was not the result of corruption; rather, it was from a tired and aging mayor who found it difficult to give up the only job he had had for his entire adult life. Gone were the surprise midnight inspections of the Jersey City Medical Center and the testing of the promptness of the responses from fire and police; these were tasks that only he could perform, or so he believed, and his failure to delegate these (although it is doubtful that these could have been delegated, since they required a man with extraordinary personal devotion to these institutions) resulted in a city that was now in crisis. It was Hague's failure to realize that he could not, no matter how much he enjoyed Florida, run Jersey City as an absentee business.

Hague's failure to see the earlier signs of voter disenchantment may be excusable. However, his failure to act following the 1947 municipal election in the adjoining town of Hoboken was a clear sign that Frank Hague was losing his political edge. The Hoboken organization run by Mayor Bernard McFeely was a carbon copy of its Jersey City counterpart, the exception being that the level of nepotism in the Hoboken organization was so overt, such as when McFeely had named his brother as chief of police and his nephew as deputy chief of police, as to cause a backlash.[359] In the 1947 election, a slate of three Italians and two Irishmen defeated McFeely in a sure sign of the increased lack of tolerance for both nepotism and for a city that was controlled solely by the Irish.[360] Frank Hague was either unable to hear this signal or chose to ignore it. Regardless, his next move would be fatal.

On June 4, 1947, Frank Hague abruptly announced his retirement as mayor. The office was to be assumed by his nephew, Frank Hague Eggers. While Eggers was taking over the front office, Hague would continue as party leader from his home in Florida, remarking to a reporter, "Don't worry. I'll be around for a long time."[361]

The appointing of Eggers, especially the fact that he was a relative, did not go over well with a lot of Hague supporters, especially second ward leader

John V. Kenny. Kenny believed that he and Hague had an understanding that he would be the successor to the post of Jersey City mayor. Now, if Frank Hague would not put him there, he would get there himself.[362]

With election day in 1949 quickly approaching, Eggers, who had already served as mayor of Jersey City for two years, and three other Hague city commissioners were fighting for political survival. Also in the fight was a name that was not on the ballot. Frank Hague, who had come to Jersey City from his Florida home, began campaigning with his nephew, Frank Hague Eggers. Standing before the crowd of five thousand in the auditorium of Dickinson High School, he challenged the crowd, reminding them that he had given them the great Jersey City Medical Center and the Margaret Hague Maternity Hospital. "Will we turn over these buildings and desert motherhood?" he demanded while his fist pounded the lectern. The five thousand responded in unison, "No!" On and on he went, asking for consideration in return for favors he had delivered to them.[363]

Hague's reception at other rallies would not be so welcoming. On May 3, 1949, Hague entered Jersey City's second ward, the very ward in which he was born. But the second ward was no longer Frank Hague's home; it now belonged to the man who had served as the ward leader for twenty years under Hague, John V. Kenny. While standing in a reviewing stand watching a parade, a crowd of Kenny supporters began waving placards with anti-Hague slogans and started booing and throwing wads of paper at the former mayor and his nephew.

The once powerful Frank Hague had not elected a Democratic U.S. senator in New Jersey since 1936; he had not elected a governor since 1941, and although he was still a vice-chairman of the Democratic National Committee, his once influential voice in national politics had faded long ago. In the past, Hague could be relied on to deliver the whole of New Jersey. Now, only Hudson County remained in his clutch, and even this geography was rapidly slipping from his grip. If he were now able to rescue his nephew's fledgling campaign, the title of boss would remain his.

John V. Kenny, a onetime Hague lieutenant, whose own father, Ned, had taught Frank Hague the political ropes and helped him win his first political election as a constable more than forty years earlier, had been removed as the leader of the second ward.[364] The excuse given for the dismissal by city hall was that Kenny had cooperated with New Jersey attorney general Walter van Riper, Hague's archenemy, in an investigation into conditions at the Hudson County Penitentiary that led to the indictment of Hague ally Joseph Buckley. Kenny denied the accusation.[365]

On February 5, 1949, John V. Kenny announced that he would run his own slate of candidates against Eggers.[366] Kenny's election strategy relied heavily on returning war veterans. Kenny believed that once out of Jersey City and exposed to people from other parts of the country, they realized that not all cities were run like Jersey City and that these returning vets "were not about to take marching orders from some old Irishman sitting in a mansion in Key Biscayne, Florida."[367]

The most significant campaign strategy by Kenny was that he, unlike Hague, realized the importance of the increasing Italian and Polish immigrant population in Jersey City and took advantage of this by running what was known as a balanced ticket. Kenny added an Italian and a Pole to his slate and called it the "Freedom Ticket." Sensing a Kenny victory, organized labor, including Teamsters czar David Beck, as well as civic groups and most county and city employees, began to flock to the Kenny team.[368]

In addition to a balanced ticket, the Kenny campaign was very well funded and had no hesitation about outspending its opponent. The majority of the funding came directly from Kenny, who had become a wealthy man as owner of a trucking business. Historian Thomas Fleming believed that money was the crucial element in the election of 1949, and he pinned responsibility for the outcome on Hague's right-hand man, John Malone:

> *The Kenny organization had unprecedented amounts of money to spend. The going rate in Jersey City had long been five dollars a vote. This was always dispensed freely, especially in the poorest sections of the city. Hague's ward leaders were soon deluged with frantic pleas for help from their district leaders. They simply could not match the Kenny prices, and the sums dispensed by City Hall to each ward for this purpose were soon exhausted. At 1 P.M., the leader of the sixth ward phoned Malone at City Hall. "Johnny," he said, "I've got to have ten thousand dollars right away. They're paying fifteen dollars a vote and they're murdering us." "The hell with them," Malone rasped. "We're not goin' over five dollars a vote and that's final. It'll give them bad habits." With a curse the ward leader slammed down the phone. Then he called the ward's chief bookmaker (and his best friend), George Ormsby. "Can you get me ten grand right away?" "Come down and pick it up," Ormsby said.[369]*

Long before the polls closed, the $10,000 was gone, as were an additional several thousand dollars of the ward leader's (Fleming's father's) own money, which he always kept in reserve on election day. He should have saved it. At

nine o'clock that night, the stunning news came over the radio. Kenny had won by twenty-two thousand votes. He had carried every ward but one: the sixth.

It is this result from which Fleming derived his conclusion that had the decision been made earlier to spend the money, many believe that Eggers would have won the election. Instead, on election day, Hagueism became a memory, and with it the legacy and lore of his Rice Pudding Day, the fixed ballot boxes, the voting of the dead, the bullyboys beating up poll watchers, the cops swinging nightsticks on labor organizers—all of that, whether fact or fiction, became history and Frank Hague's legacy. Left to Mayor Kenny was a city fairly free of crime and vice, a city with a first-class medical center and maternity hospital. It was also a city in flux—struggling, like most other American cities of the time, to stay afloat required higher taxes. Jersey City already had one of the highest tax rates in the nation. There were already a number of vacant factories deserted by fleeing industry, with no new businesses coming into the city, thus creating the circuitous problem of high unemployment, which would put additional burdens on the municipality.

With returning veterans easily able to obtain low-interest mortgages, Jersey City turned into a huge patchwork of slums caused by a mass exodus from the inner cities to the suburbs. Although it was not a city in the best of shape, it was no worse than other cities going through similar changes in the era. Certainly the changes had nothing to do with Hague or his abilities as mayor. By the 1950s, the automobile had changed American society by significantly improving urban mobility, thus facilitating white flight. Howard Preston illustrated how the automobile became a social symbol of wealth and combined with federal subsidies to lead to the development of new suburbs.[370]

By early 1950, the pundits had all but written off a Hague comeback. However, the county board of freeholders was still in the hands of members friendly to Hague, albeit by a slim five-to-four majority. In a move aimed at showing Jersey City and Hudson County that Frank Hague was not a political has-been, the freeholders fired the sitting director of the Hudson County Board of Public Works, Union City mayor Harry G. Thourot. Thourot's replacement was Frank Radigan, who earlier in the year had been fired by the Kenny organization as a county engineer, a job that he had held for twenty-eight years. Additionally, the freeholders reappointed Frank Schlosser as county counsel, a post that Kenny had relieved him of the previous year. Another Hague supporter, Daniel O'Reagan, was also given a position as a county attorney, while Hague's former third ward leader, J. Leo O'Neill, was placed in the position of superintendent of the county's almshouse. In an effort to show who was in control of county patronage, the

freeholders doubled the salary of Harrison mayor Frederick Gassert, who was also a county attorney, from $5,000 annually to $10,000.[371]

Hague's comeback attempt included having his nephew challenge Kenny in his reelection bid for mayor in 1953. But the handwriting was on the wall: at a rally on May 1, 1953, in the same second ward where he had been booed four years earlier, a crowd of eight hundred people had gathered to hear Hague and his nephew Eggers speak when a gang of fifty youths began pelting them with eggs. In addition to the eggs, there was a strategically placed bass drum that was pounded every time Hague or his nephew went to speak. The sabotage continued, and just as Eggers was about to challenge Kenny to a debate, the wires to the portable floodlight were cut, and permission to tap into the streetlight was denied by city officials, which required the remainder of the rally to be conducted by flashlight.[372]

This comeback attempt was temporary, and Kenny was reelected. Kenny solidified his power following the 1953 contest for New Jersey governor when, in an incredibly close primary election, Hague's choice, Elmer Wene, lost to Kenny's pick, Robert B. Meyner, by only 1,585 votes statewide, a 50.4 percent to 49.6 percent margin.[373] Meyner would go on to win in the general election in November of that year, and it was at this point that a multitude of former Hague supporters switched their allegiance to John V. Kenny.[374] However, even with this victory, Kenny never acquired Hague's broad influence in the state—a declining Jersey City no longer produced the millions for the organization that it had in Hague's day.

Frank Hague once said that he would live and die in the Horseshoe, but, "Jersey City is where I was born and Jersey City is where I'll die,"[375] but this would not be the case. On January 1, 1956, he quietly passed away in his New York City apartment at 480 Park Avenue. Frank was going out the way he lived—in style.

When his estate was probated, it was valued at more than $2 million (about $16 million in today's money). The entire estate was left to his wife, Jennie Warner Hague. In 1962, when Mrs. Hague died at the age of eighty-eight, her estate would become tied up in a legal battle. Her will specified that her son receive her entire estate, with the exception of $1, which was left to her adopted daughter, Ann Margaret. *Time* magazine reported, "When she died last December at 88, Jennie Warner Hague, widow of Jersey City's boisterous Boss Hague, left an estate now appraised at $5,000,000 [about $30 million in today's money] as her share of the family fortunes." Jennie left the money to her son, Frank Hague Jr., and cut off her adopted daughter, Ann Margaret Loughran, with only $1. "I don't want to shout and rave,"

said Ann Margaret, who brought suit in a Manhattan court. "I just feel quite coolly that it's unjust."[376] The case was eventually settled with Margaret receiving an estimated $1 million.

The biggest irony is that most successful New Jersey politicians, especially from the 1930s through the 1940s, owe their success to Frank Hague, and yet there is an ongoing attempt even today, either directly or via proxy, to remain distant from the man. Apologists for many of New Jersey's early twentieth-century politicians sing their praises but continue to criticize Hague's moral compass while neglecting the fact that those they are praising sought and accepted his help.

In a recent biography of former New Jersey governor and chief justice of the state's Supreme Court, Richard Hughes, constitutional law professor John Wefing wrote how "Hughes never really liked Hague himself, but he recognized that Hague had been a dominant political force in the state for many years, able to turn out huge numbers of voters in his Democratic stronghold, Hudson County"[377]—the implication being that it was okay to associate with Frank Hague if you needed him, as if just the fact that Hughes disliked Hague in some absurd way cleansed him and that it was just that unfortunate circumstances forced him to deal with a dirty man. In this biography, the author quoted Hughes, who, when speaking about his father (a staunch New Jersey Democrat who held numerous patronage positions and served as the Democratic leader of Burlington County and as mayor of Burlington in 1950), would say that he "was loyal to Hague, as every Democrat had to be."[378] The implication here, which would be a real stretch, was that his father had no choice, though of course he did. His father chose to do business with Frank Hague. Hughes's father, like others, had a choice of being either with Frank Hague or against him, and from the moment he made that decision, any attempt at weaving a story that allowed for plausible deniability would be nothing short of disingenuous. The one notable exception was A. Harry Moore. In an interview many years ago, the wife of Governor Moore stated that the two people who had the most influence in a positive way on her husband were Otto Wittpenn and Frank Hague.[379]

This case of criticism through one side of the mouth while complimenting through the other side can be seen with FDR. As seen earlier, Roosevelt, who had been upset with Hague for his support of Alfred Smith at the Democratic convention in 1932, would eventually come to embrace Hague. This love affair began following the rally held for FDR and organized by Hague in Sea Girt, New Jersey, where more than 100,000 people had arrived to cheer

Roosevelt on. In later years, FDR would continue to rely on Hague to win reelection, to the point of allowing Hague to violate federal mail fraud rules and protecting him from a state investigation.[380]

Governor Hughes and FDR were not the only ones to take advantage of Hague and then attempt to distance themselves from the man. Harry Truman, FDR's successor to the White House, was no fan of Frank Hague.[381] This dislike of Hague did not, as some believe, stem from aloofness but instead from a genuine dislike due to Hague's actions in attempting to deny Truman's nomination. Truman was no stranger to boss politics, was himself the product of the Pendergast machine and would later issue a full pardon

Hague with President Truman. *Courtesy of Jersey City Public Library.*

to Boston city boss James Curley.[382]

In 1972, John V. Kenny pled guilty to six counts of income tax evasion, and although originally sentenced to eighteen years, this sentence was reduced on appeal, and Kenny was sent to a federal prison hospital for an eighteen-month term; he was released in March 1973.[383] The irony here is that much of the one-sided negative view of Frank Hague, who was never convicted of any crime, is due to the concentrated efforts of convicted felon John V. Kenny.

One of the very few authors to address what the citizens of Jersey City felt about Hague is Reinhard H. Luthin. Following numerous interviews with citizens who lived and worked in Jersey City during Hague's rule, his assessment as to why people approved of Frank Hague for so many years despite allegations of fraud and corruption is telling:

> *Numerous Jersey City citizens saw something wholesome in Hague's rule…as to the reasons for their approval, they pointed to the city's "family life." They cited the mayor's edict against women drinking at bars and his elimination of professional prostitution; they told of efficient police and fire departments and of good schools, and above all they lauded the Medical Center as "the best in the world." Some consider the Boss a "square shooter"—his word was good, as politicians' words went.*[384]

Luthin did express his disdain for those who defend Hague's "protection" of the racetrack bookmakers "who took dollars from the breadwinners of families." But as Karcher pointed out, here again we have the issue of the double standard. Karcher said, "How different philosophically is that [racetrack bookmakers] from what the State of New Jersey does in extracting revenues from lotteries and casino gambling?"[385]

Karcher's example of how gambling, when sanctioned by the government, no longer wears its scarlet letter is a perfect example of the double standard used by historians when evaluating the legacy of Frank Hague. Where is the outrage that White House aide Michael K. Deaver became a millionaire in less than a year by selling his access to power? In a blatant example of a double standard, one need only read the textbooks of schoolchildren. In these texts, FDR is hailed as the deliverer from the Great Depression when, in fact, many of his actions during that period in all probability extended the suffering of Americans. Powell specifically cited how the actions of FDR were especially onerous on African Americans, as well as white southerners.[386] And as mentioned earlier, FDR's actions in removing U.S. citizens from their homes and placing them in internment camps will forever live as a major

stain on this country.[387]

There is no question that by the late 1930s and early 1940s, Jersey City was not the city that had previously been attributed to Frank Hague. Where there were spotless streets, there was now garbage and a sanitation department that was woefully ill-equipped to handle the situation. The city's sewer system was totally antiquated and on the verge of collapse, and there had been no new schools built since 1931.[388] But to lay all of this at the feet of Frank Hague is unfair. While the Jersey City Sanitation Department was still using horse-drawn wagons to pick up its garbage, other cities had modernized; however, the use of old wagons required a large team of men to pick up garbage, sweep the streets and tend the horses. This required a lot of manpower, which kept men occupied and place food on the tables of many Jersey City residents. However, with the start of World War II and the call up of able-bodied males, a shortage of manpower, and thus a shortage of personnel to handle the antiquated garbage carriages, ensued.[389]

History, legend and lore has firmly planted Frank Hague's career in the spectrum of morally gray, and there is no doubt that the placement is an accurate one. But if one is to delve further into this often-used analogy, one must first concede that gray is not a true color but rather a blend of black and white. The reviewers of Hague's clearly ambiguous legacy have chosen to separate out the two elements and concentrate exclusively on the black. As was stated in the introduction, the goal of this study was not exoneration but rather the adjustment of that overused, one-sided prism.

People knew and spoke highly of Hague when they needed him to advance their own careers, but once their goals were accomplished, Frank Hague once again became the villain that McKean and chroniclers have made him out to be. Instead of recognition for the positive changes he made, Frank Hague's legacy languishes in a fairy tale world of gangsters and bootleggers. The persistent lack of acknowledgement of the positive changes that Frank Hague brought to Jersey City continues to be a major oversight for trained historians and deserves a second look.

FBI DOCUMENTS

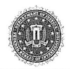

U.S. Department of Justice

Federal Bureau of Investigation

Washington, D.C. 20535

August 30, 2010

MR. LEONARD F. VERNON
SUITE C
813 EAST GATE DRIVE
MOUNT LAUREL, NJ 08054

FOIPA Request No.: 1150007- 000
Subject: HAGUE, FRANK

Dear Mr. Vernon:

Enclosed is a copy of responsive material consisting of 46 pages released in its entirety concerning the subject of your request, Frank Hague.

Should you desire to appeal this release of information, you should direct your appeal, in writing to the Director, Office of Information Policy, U.S. Department of Justice,1425 New York Ave., NW, Suite 11050, Washington, D.C. 20530-0001. Your appeal must be received by OIP within sixty (60) days from the date of this letter in order to be considered timely. The envelope and the letter should be clearly marked "Freedom of Information Appeal." Please cite the FOIPA Number assigned to your request so that it may be easily identified.

Very truly yours,

David M. Hardy
Section Chief
Record/Information
 Dissemination Section
Records Management Division

MEMORANDUM FOR MR. SUISING.

The attached communication addressed to the Attorney
General by State Senator Clarence E. Case, of New Jersey, was
forwarded to this Bureau without any notation as to the action
desired by the Department. Therefore, I am returning it with
the request that written instructions be issued to the Bureau as
to what action the Department desires the Bureau to take in con-
nection with this matter.

It is not clear to my mind exactly what Federal Statute
is being violated and it would appear to be largely a question
of policy as to whether the Federal authorities should inject
themselves into what is apparently a local situation. However,
I will be very glad to abide by any instructions which you desire
to issue concerning the handling of this matter.

Very truly yours,

McL. Director.

Hon. John G. Sargent,
Attorney General,
Washington, D. C.

My dear Attorney General:

 By way of self-identification may I say that I met you at the Rugers University Commencement where, at the time you received your degree, I introduced Mr. William J. Ellis, Commissioner of Institutions and Agencies of the State of New Jersey, for a similar honor.

 I am writing to ask whether the Department of Justice is able and willing to cooperate with a legislative investigating commission, of which I am the chairman, at present engaged in an inquiry into the affairs of Hudson County. There is a very general disgust with the Hudson County administration, which means practically the Jersey City administration inasmuch as the City of Jersey City dominates the entire county of Hudson.

 The dominating figure in Hudson County politics is Mr. Frank Hague, Mayor of Jersey City, who also is the controlling personality in Democratic politics in the State of New Jersey and a very considerable factor in National Democratic politics.

 There has long been a popular distrust and suspicion of the affairs in Hudson County and there have been one or two abortive investigations. Much against my inclination, but because it was represented a public duty, I accepted membership in and the chairmanship of the present commission authorized by the last Legislature and now, a bi-partisan body, in active operation.

 Last Thursday, Mr. John Warren, a former judge and himself a prominent Democrat of Hudson County, voluntarily took the witness stand and testified in general terms to a situation that is quite revolting, and amongst other subjects adverted to the fact that there is a gamblers' clearing house in Jersey City thzat could not exist without the knowledge of the local authorities. From other sources it has been suggested to me that there is a method of graft in existence whereby the betting rooms pay on a sliding scale based on the number of telephone installations, and that there is a cooperation between the houses of this character in Hudson County and those in the City of New York. If such a situation exists, I have reason to believe that a trail actively picked up in New Jersey would quickly lead to New York and there be lost, for the reason that

JUN 2 · 1928

 D & INDEXED

the authority of this commission would cease at the Jersey line; and of course we could get no help from New York. The success of an investigation of this particular character very frequently depends on the secrecy with which the leads are obtained. I am wondering, therefore, whether the Department of Justice has or can secure and will produce for our use any evidence of this alleged book-making conspiracy, particularly in any graft paying enterprise.

If by this or some other means the true Hudson County situation can be disclosed, a service of incalculable value will have been rendered to the State of New Jersey and to good Government in general. It will be very difficult to get tangible evidence, inasmuch as a part of the system seems to be to tie up in varying degrees everybody who has or would be likely to have any evidence of guilt so that he also is party to the transaction and will keep his mouth shut.

I am taking the liberty to write you this letter without the knowledge of my associates on the commission, thinking that for the time-being this might be the wiser course.

Is it possible for you to come over to Macedonia and help us? If you deem it advisable, I shall be very glad to come to Washington to discuss the matter with your representatives.

With personal regards, I am

Respectfully yours,

(S) C. E. Case

August 20, 1928.

RECORDED

AUG 21 1928

MEMORANDUM FOR MR. LUHRING.

I am transmitting, attached hereto, copy of
a communication received from Mr. R. E. Watson, Attorney
of New Jersey, and Counsel to the New Jersey Joint Legisla-
tive Commission.

It will be noted that he refers therein to the
alleged existence in Jewsey City of a clearing house
for baseball lotteries and pool room and race track betting.

Will you please advise me whether, in your opinion,
this is a matter which should call for investigative action
by this Bureau.

Very truly yours,

Director. E

Encl. 100763.

R. F. & A. D. WATSON
COUNSELORS AT LAW
46 BAYARD STREET
NEW BRUNSWICK, N. J.

RUSSELL E. WATSON
A. DUDLEY WATSON

August,
Fifteenth,
1 9 2 8.

62 - 20079

John E. Hoover, Esq.,
Director, Bureau of Investigation,
Department of Justice,
Washington, D. C.

Dear Sir:- Personal and ~~confidential.~~

 As counsel to the New Jersey Joint Legislative Commission created under Joint Resolution No. 13, which is now engaged in the investigation of governmental affairs and matters of public interest in Hudson County, New Jersey, I have learned that Jersey City is the clearing house of Eastern pool room and race track betting. Enclosed herewith, for your personal and confidential use, find a statement showing the nature of the system and its operations.

 There is ground to believe that this system is likewise availed of for the operation of baseball lotteries, which I am informed are a proper subject of investigation by your Bureau. I am sending you this memorandum for such use, if any, as it might be to you.

 If I can be of any aid or assistance to you, or if an interview is desirable or necessary, I am at your service.

 It is unnecessary for me to request that you restrict as much as possible the number of those to whose attention the enclosed memorandum will come.

Yours truly,

REW.T.
enc.

RECORDED & INDEXED

62-20079-2
BUREAU OF INVESTIGATION

AUG 17 '28 A. M.
DEPARTMENT OF JUSTICE

AUG 21 1928

139

COPY GAJ

R.E. & A.D.Watson
Counselors at Law
46 Bayard St.
New Brunswick, N.J.

August Fifteenth 1928

John E. Hoover, Esq.,
Director, Bureau of Investigation,
Department of Justice,
Washington, D.C.

Dear Sir:- Personal and confidential

 As counsel to the New Jersey Joint Legislative Commission
created under Joint Resolution No. 13, which is now engaged in the
investigation of governmental affairs and matters of public interest
in Hudson County, New Jersey, I have learned that Jersey City is the
clearing house of Eastern pool room and race track betting. Enclosed
herewith, for your personal and confidential use, find a statement show-
ing the nature of the system and its operations.

 There is ground to believe that this system is likewise availed
of for the operation of baseball lotteries, which I am informed are a
proper subject of investigation by your Bureau. I am sending you this
memorandum for such use, if any, as it might be to you.

 If I can be of any aid or assistance to you, or if an inter-
view is desirable or necessary, I am at your service.

 It is unnecessary for me to request that you restrict as much
as possible the number of those to whose attention the enclosed memo-
randum will come.

 Yours truly,

 (S) R E Watson

ADDRESS REPLY TO
"THE ATTORNEY GENERAL"
AND REFER TO
INITIALS AND NUMBER

ORL

DEPARTMENT OF JUSTICE

WASHINGTON, D. C.

FMP-ZOB

August 22, 1928.

62-20079-4

MEMORANDUM FOR THE DIRECTOR OF
THE BUREAU OF INVESTIGATION.

I have your memorandum of the 20th instant, inclosing a copy of a letter which you received from Mr. R. E. Watson, an attorney of New Brunswick, New Jersey, and counsel to the New Jersey Joint Legislative Commission, relative to the existence in Jersey City of a clearing house for baseball lotteries and pool room and race track betting.

The facts as set forth in the memorandum of Mr. Watson do not seem to constitute a violation of any Federal criminal statute. This seems to be the familiar example of state authorities attempting to get the Federal Government to remedy conditions which should be cleared up through state action. I do not believe the matter cause for any investigation by your Bureau.

Respectfully,

O. R. LUHRING,
Assistant Attorney General.

RECORDED

62-20079-4
BUREAU OF INVESTIGATION

AUG 29 1928 M.
DEPARTMENT OF JUSTICE

FILE

DECLASSIFICATION AUTHORITY DERIVED FROM:
FBI AUTOMATIC DECLASSIFICATION GUIDE
DATE 07-26-2010

62-20079-4\

HN:FR>

RECORD

AUG 29 1928

August 28, 1928.

Mr. R. E. Watson,
46 Bayard Street,
New Brunswick, New Jersey.

62-20079-48

Dear Sir:

 I beg to acknowledge at this time receipt of your
communication of August 15, 1928, transmitting statement
showing the system and operations of a clearing house for
baseball lotteries and pool room and race track betting.

 In accordance with required procedure, this matter,
in its entirety, was submitted to Assistant Attorney General
Luhring of this Department for decision and instructions as
to investigative jurisdiction of this Bureau. I am now in
receipt of a communication from Assistant Attorney General
Luhring, reading as follows:

 "The facts as set forth in the memorandum of Mr.
Watson do not seem to constitute a violation of any Federal
criminal statute. I do not believe the matter calls for any
investigation by your Bureau."

 In view of the foregoing, I regret that I am unable
to institute any investigative action on the part of this
Bureau in the matter in which you are interested.

 Very truly yours,

 Director.

OFFICE OF THE DIRECTOR, BUREAU OF INVESTIGATION

From

To

OFFICIAL INDICATED BELOW BY CHECK MARK

Attorney General ☐

General Donovan ☐

General Luhring ☐

General Willebrandt ☐

General Marshall........................ ☐ *Please try & get prompt answer from Luhring on this.*

Mr. Chase ☐

Mr. Carusi.................................. ☐

Mr. Baldwin ☐

Mr. Stewart ☐

Assistant Director....................... ☐

Inspector ☐

Chief, Division 3 ☐ *8/22/26 J – E . N .*

Chief, Division 5 ☐

Chief, Division 6 ☐

Chief, Division 7 ☐ *Hr. file*

Miss Gandy................................. ☐

Personnel Filing Section ☐

--------------------------------------- ☐

--------------------------------------- ☐

--------------------------------------- ☐

7—1554 U. S. GOVERNMENT PRINTING OFFICE: 1927

There are large nests of phone rooms and telephones used
for gambling purposes in violation of local and federal law. The
placing of bets and soliciting of business for the different pool
rooms is done openly and unmolested by the police of the several
cities of New Jersey. The District Attorney's office ignore
the activity of the gamblers. No prosecution could be success
fully procured in this locality or the City Courts because of
the political affiliations of the gamblers.

It is alleged that approximately $50,000 per month is
paid to men who are in official positions or closelny linked
with the political organization that dominate the affairs of
this State. Investigations to date disclose the following
facts:

A private circuit or wire is used for the purpose of
receiving and transmitting race track odds, winners, prices,
scratches and jockeys. A separate sheet is used to eliminate
the necessity of naming horses in betting in the races. They
are announced over the private circuit or wire system in Jersey
City. This wire runs from 289½ Eighth Street or head
quarters, from there to Charles Goode's, 369½ Ninth Street,
Broadcasting headquarters are at 389½ Eighth Street.

Telephone numbers attached are in active service daily and
bets are placed on horses running at the different tracks through
out the country. Betters congregate at the places listed and
bet on the horses, write out tickets, initial the tickets and the
amount paid on the result of the race and pay to the managers
of these gambling rooms cash withbthe slip. If the better wins,
the manager pays the better the next day. The pay off is govern-
ed by the odds published from the track in the New York Telegraph.

New York book makers and gamblers do their betting on a
large scale. Substantial sums are paid on the races and a
good portion underwritten by Charles Goode or Gene Sullivan.
The pay off, in the event of winning, where the wager is a large
one, is done direct by a representative of Goode's and one of
the banks of New York City. Applicants from out of town
apply for the privilege of doing business in Hudson County,
must be O.K'd. by Bob Kennedy, a Mateer man, before they are
permitted to run in Jersey.

Bookmakers in New York doing business with Jewsey City or
Hoboken:

Names	Addresses	Tel. nos.
William and John Cook	Claridge Hotel, Broadway & 44th. St.	
John Hogan	68 Greenwich St.	Bowling Green 7759
Edward Dunne	Avonia Club, 261 W. 14th. St.	Chelsea 5961
John Bambrick (cafe)	Charles and 4th. St.	" 1269
August Groll	18 Maiden Lane	John 1163
Harry Norton	1st. ward, c/o Thomas McClachey, Liberty and West Street	

This wire runs from 289½ Eighth Street or headquarters,
from there to Charles Goode's, 269½ Ninth Street on public
service poles down Ninth Street to East Hamilton Place, up
Eighth Street to Jersey Avenue to Grand Street on purlic service
poles, up Eighth Street to Varick Street, deadening at Grand
Avenue, down Grand Street to Van Vorst and York Street to the
river front on public service poles. Montgomery and Gregory
on public service poles, from Gregory Street on telephone poles
to Henderson Street along Henderson Street to Newark Avenue,
up Newark Avenue to Summit Avenue, dead ending at Cottage Street

on Public Service ploes. Pick up at Monmouth Street and
Newark Avenue to an alley between Fourth and Fifth Street, the
line runs along this alley from a dead end at Brunswick Street
to the main trunk at Jewsey Avenue and this alley. Branch from
 the main trunk on Jersey Avenue dead ends at Erie and Third
Street, cutting in No. 230 Third Street on telephone poles, up
Third Street to Coles Street to Eighth Street, cutting 229$\frac{1}{2}$
Seventh Street, over housetops, (Broadcasting headquarters are
at 289$\frac{1}{2}$ Eight Street. From here around East Hamilton Place,
down Pavonia Avenue to Erie Ferry on Public Service poles from
Grove and Newark Avenue along Grove Street to Ninth Street
Jersey City, from Gorve Street and 20th. street under public
service elevated road Hoboken to Newark Street, down Newark
Street to Willow Avenue, over Willow Avenue to a spot between
Second and Third Street on public service poles, from this
spot over housetops to River Street along Hudson Street to
Eleventh Street on public service poles, dead ending at Eleventh
Street along Park Avenue to Fourth Street to Bloomfield Street
dead ending at Fourteenth Street on public service poles.

Levy	143 Montgomery St. J.C.	Montgomery	2267
			2266
			2798
Quinn	200 Pavonia Ave. J.C.	"	4423
			4427
Fisher	179 8th St. J.C.	"	5710-12-3
Hynes	200 Pavonia Ave. J.C.	"	1613
			1616
Regan	81 Bright St. J.C.	"	1049
			2322
Lessex	514 Grove St. J.C.	"	2115 & 6
Al Fredericks	75 Montgomery St. J.C. Room 216	"	4273
Barney Eckstein	200 Pavonia Ave. J.C.	"	783
Billy Kay	198 York St. J. C.	"	1689
Matty Frank	229½ 7th St. J. C.	"	1317
			1804
Benny Gorson	200 Pavonia Ave. J.C.	"	4362
			4366
			4132-3
Gene Sullivan	421 Grove St. J.C.	"	2394
			3089
	66 Pavonia Ave. J.C.	"	3961
			1184
Lewis	223 Pavonia Ave. J.C.	"	3558
Temporarily closed-18 Cottage St. J.C.			616
Sam Mateer	200 Pavonia Ave. J.C.	"	1692
			1680
			2626
Sam A. Mateer	58 Pleasant Ave. Montclair, N.J.	Montclair	4112

Hoboken.

	604 Washington St.	Hoboken	992
	905 Hudson St.	"	3745
			6939
			3745
			2477
			2724
	161 12th St.	"	2841
	51 Park Ave.	"	2660

Appendix

Operator's Name.	ADDRESS.	Telephone No.
Goode	269½ Ninth St. J.C.	Montgomery 4047
Crampton	360 Grove St. J.C.	" 723
		" 903
		" 890
		" 809
		" 3294
Gerdes	665 Newark Ave. J.C.	" 229
		" 230
		" 231
Tony	240 4th St. J.C.	" 1107
		" 1396
		" 2482
	1230 Garden St. Hoboken,	2398
	911 Park Ave. "	2389 2964-5
	706 Bloomfield St. "	1954
	205 Garden St. "	1454
	131 Washington St. "	1108
	1222 Washington St. "	1231
	356 Ferry St. "	2316
	72 Hudson St. "	2441
Marrone	244½ 1st St. J.C.	Montgomery 3822
		" 3930
		" 2675
		" 2678
Einkenspiel,	98 Newark Ave. N.J.	" 3211 -2-3-4
Mrs. Kelly & Wolf	374 Henderson St. J.C.	" 5750 -1-2-3
Gross	143 Montgomery St. J.C.	" 2860 3445 3755

159 - 9 St.	Hoboken	2336
621 Bloomfield St.	"	2738
207 - 10th St.	"	364
709 Garden St.	"	2661
421 Newark St.	"	2360
73 Washington St.	"	2587
209 Bloomfield St.	"	926
1128 " "	"	1706
582 Garden St.	"	2713
1230 Garden St.	"	2399
728 Park Ave.	"	2485
209 6th St.	"	2336
800 Garden St.	"	881
623 Bloomfield St.		
1219 Park Ave.		2808
76 River St.		1878

In addition to the Hoboken and Jersey City numbers and
addresses enumerated, the system extends to Bayonne, Harrison, Union
City and the Fort Lee Ferry. Information is relayed to the Jersey
System from the track via #223 West 34th Street, under the management
of Thomas Powell. This information, in turn, is relayed to $289\frac{1}{2}$
Eighth Street, Jersey City, which in turn distributes it through the
phone service to the numerous pool rooms and gambling rooms listed
here.

Sam Mateer, wire man for Charles Goode, (Mayor Hague's agent),
has his headquarters in the rear of the real estate office conducted
by Armstrong and Gallagher, 200 Pavonia Avenue, Phone 7777 Montgomery.
Mateer resides in Montclair, New Jersey and has three to five wire men
working under his direction. He drives a Haines open car.

The men employed under Mateer repair and install all wires for
Charles Goode. Application for new rooms and phone service for

gambling are passed upon by Mateer, who makes the arrangements and either approves or disapproves the applicant.

Mateer collects from the phone room pperators each month on the 27th and 28th the assessment for service being approximately $300.00 per month, and an additional charge of $30. per month is added for phone service for each phone.

The Jersey City and Hoboken contracts are procured by the betting ring through Mateer from the Telephone Company, in every incident are engaged throhgh Mateer's connections and the contracts are signed with fictitious names, in other words, the telephone contracts are signed by a myth. The Empire News, whose office is at No. 223 West 34th Street, controls the extension line running from their switch board, Lackawanna 9400 to 298 - 8th Street, Jersey City. This is where the headquarters was originally installed and afterwards moved to 289½ 8th Street by private wire man employed by the fraternity. This is a private extension and runs through the tunnel under the river.

A telephone employee of Hoboken, known as "Telephone Red" repairs private wires for gamblers and acts as informer for police inspector Dan Kiely of Hoboken. It is alleged, and enough evidence has been procured to substantiate this statement, that several politicians in Jersey City and Hoboken, whose names appear in this report, are paid off by Inspector Kiely of the Hoboken Police collecting protection money from the various pool rooms in Hoboken.

A Republican leader of more or less importance by the name of William P. Verdon, has a man by the name of Jack, about 5 ft. 4 in. about 45 years old, that collects on the 3rd, 7th, 12th and 25th of each month, both in cash and checks from the different pool rooms in Jersey City and Hoboken. The assumption being that

this money finds its way into Verdon's hands.

Bets are made over the phones at City Hall, on Grove Street, by City officials and City employees, acting as betting brokers for the various pool rooms also by employees of city and county that congregate in pool rooms during the hours of racing. Well known officials place bets openly at the several pool rooms in the downtown districts of Jersey City.

INFORMATION BUREAU IN WOODLAWN.

Name	Address	Telephone.
Edward King.	61 Kimbles Ave.	Fairbanks 2100 1650
Manetesta	" " "	" 2475
Northern News	110 Hyatt Ave.	" 1244

POOL ROOMS IN YONKERS.

Donahue		" 2215 1915
J. Ston		Yonkers 6245 8829
Joe Boss		" 228 8988
William Cook and Murray 39 Dock Street		2277 " 4783

The Yonkers rooms do a daily business with Jersey City Rooms. Of the betting receipts a large percentage is sent to Charles Goode or Gene Sullivan. The telephone between Yonkers and Jersey City Telephones are used in transmitting of bets. In Yonkers the pool rooms are run on a very large scale and almost anyone can enter and place bets.

Jersey City, N. J.
February 1, 1935.

Hon. Lester H. Clee, Speaker, House of Assembly
Hon. Sidney Goldberg, Chairman, House Committee on Elections.

Gentlemen:

Have read with considerable interest the weeping open letter of Mayor Frank Hague about your Supervisor election bill wherein this notorious ballot-box stuffer with a court record a mile long piously states he desires honest elections. Here is Hague's court record in brief and I leave it to your own good wisdom to decide whether such a gangster should be entitled to any consideration in any legislation concerning elections in New Jersey.

1. Jersey City, 1891. As Frank Hague, member of notorious Red Tiger Gang. Criminal activities of gang listed in "History of Jersey City Police Department."

2. Jersey City, Nov. 10, 1904. As Deputy Sheriff Frank Hague. Charge, contempt in Red Dugan case. Sentence, $100 fine by Common Pleas Judge Blair and dismissal from office.

3. Jersey City, March 17, 1909. As City Hall Custodian Frank Hague. Charged in Hudson County criminal court with obtaining $750.00 from "Nigger Mike" to obtain release of a pickpocket a few years previous when Hague was a deputy sheriff. The pickpocket jumped bail and was not apprehended until 1909.

4. Jersey City, 1914. As Director of Public Safety Frank Hague. Charged in Hudson County criminal court with giving $500.00 of police emergency funds to Samuel LePosen, alias "Cockeyed" Webber of New York, to stage fake robbery for Hague's glory.

5. Trenton, 1928. As Mayor Frank Hague. Arrested on warrant of Legislature. Charge, contempt. Released in $1,000 bail. Charge dismissed by Vice Chancellor John J. Fallon, a political aide.

6. Trenton, 1929. As Mayor Frank Hague. Arrested on warrant of Legislature. Charge, contempt. Tried and found guilty by Legislature. Sentence, six months in Mercer County jail. Discharged by Vice Chancellor Fallon.

7. Washington, D. C., 1930. As Mayor Frank Hague. Investigated by Department of Justice. Charge, Income Tax evasion. Avoided prosecution by having Theodore M. Brandle pay $60,000 to Government by check. Hague later drove Brandle out of county as a "vicious labor racketeer" when Brandle demanded repayment of money.

Hague says he wants the so-called "bi-partisan" county boards of elections retained in the new election act for Hudson and Essex counties to "protect" the voters. Senator Joseph G. Wolber, it seems, has fallen for Hague's tripe and onions.

All voters can be adequately protected if the Goldberg bill is amended to include my recent suggestion for appointment of *election officers by the new Supervisor of Elections on recommendation of the county chairmen of the political parties.*

Hague doesn't want the county boards of elections retained to protect the voters——he wants them retained so that he can continue to control and steal elections in Hudson and other counties and profit in the huge graft which the board can dispense. Following is a sample of a small portion of this graft;

RECORDED FEB 9 1935
INDEXED
FEB 8 1935

R. E. & A. D. WATSON
COUNSELORS AT LAW
43 PATERSON STREET
NEW BRUNSWICK, N. J.

COPY

August,
Fifteenth,
1 9 2 8.

Left
5-48-60-1

Mrs. Mabel Walker Willebrandt,
Assistant Attorney General,
Department of Justice,
Washington, D. C.

Dear Madam:- Personal and confidential.

 As Counsel to the New Jersey Joint Legislative Commission created by Joint Resolution No. 13, which is now engaged in an investigation into governmental affairs and matters of public interest in Hudson County, New Jersey, I desire to bring to your attention certain information, some of which has been adduced in evidence before the Committee and some of which will be adduced in evidence in September, which seems to point to violations of the Income Tax Law.

MONTCLAIR SERVICE CORPORATION.

 For many years prior to 1922, the Montclair Water Company had been offering for sale a body of water in Morris County, near Boonton, New Jersey, known as Split Rock Pond, for the sum of $150,000.00. The property had been offered to the City of Jersey City as being a suitable source of potable water supply and was known to responsible officials of Jersey City to be in the market. In 1922 a man of no personal responsibility named Joseph G. Hoffman entered into a contract to buy the property from the Montclair Water Company for $125,000.00, payable $15,000.00 in cash and $110,000.00 by a long term purchase money mortgage. Immediately thereafter, the Montclair Service Corporation was incorporated under the laws of the State of Delaware. Its officers were residents of the State of New York. The Company did not register in New Jersey. Mr. Hoffman assigned his contract to the Montclair Service Corporation, which took title to the Split Rock Pond property. Within a few weeks, the City of Jersey City began condemnation proceedings, which resulted in the acquisition of the property by Jersey City at a price of $325,000.00. The Montclair Service Corporation realized a profit of approximately $200,000.00.

153

In 19⬛ and 1931 I published an ⬛ependent weekly paper which had a State-wide as well as a large Hudson County circulation. Paul Seglie, a Republican member of the Hudson County Board of Elections then and now, insisted that the annual election advertising notice be given to my paper and the only way he had it awarded was by threatening not to vote to award the same notice to Democratic Hudson County weekly papers.

Upon obtaining the $880.00 check from the county after the election I saw the list of weekly papers in addition to the four dailies to which the advertisement was given. To my amazement I discovered that thirty-two (32) alleged weekly papers were on this list of which only one or two are printed and published regularly. The other 30 are all adjuncts of Hague political clubs or organizations and are only published around election time to get the $880.00 which multiplied by 30 means that $26,400.00 of the taxpayers' money is thrown away as political graft by the man who wants "honest" elections.

Just what other graft there is in the purchase of supplies, printing, the hiring of polling places, purchase of ballot boxes, and other functions of the county boards of elections is unknown to me but can be imagined if the award of election advertising is any criterion. Under a "bi-partisan" arrangement this graft originates because the members of one party will refuse to "go along" with the graft of the members of the other party unless a reciprocal arrangement is entered into.

The following is an idea of graft in the purchase of binders by the "bi-partisan" county boards of elections for the permanent registration forms following adoption of the permanent registration act in 1926 or 1927.

In Essex County the "bi-partisan" board purchased 2,000 Kalamazoo canvas-bound binders at $24.00 each and disregarded lower priced offers by Irving-Pitt and other companies manufacturing better or equally as good binders at lower prices at retail.

In Bergen County, where the then county purchasing agent chased the Kalamazoo representative out of his office, he purchased 200 (all that was needed there) Irving-Pitt leather-bound binders at $21 each. When the Kalamazoo representative discovered that the Bergen purchasing agent was more interested in saving money for the taxpayers than he was in having a certain election official of Essex County explain the "merit" of the Kalamazoo binder the salesman offered to sell 200 Kalamazoo canvas-bound binders to Bergen County at $17 each.

In spite of this, the Essex "bi-partisan" board, which would-not permit the Essex County Purchasing Agent to buy its supplies turned right around and purchased 2,000 of the very same $17 Kalamazoo canvas-bound binders at $24 each, a waste or graft of $14,000.00.

In Middlesex County Kalamazoo binders were purchased by the "bi-partisan" county board of elections at an excessive price after the Essex election official mentioned the "merit" of the Kalamazoo binder in a speech at a luncheon to the "bi-partisan" board.

In Passaic County, John McCutcheon was then county clerk. He had previously discarded Kalamazoo binders from his office because they were higher-priced and not as good for the work of the office as other well-known makes. At that time the Passaic "bi-partisan" county board of elections consisted of two Hague Democrats, one Edge Republican, and one McCutcheon Republican.

When the purchase of the binders was made, the McCutcheon Republican member, a woman, voted against purchasing Kalamazoos and voted for the purchase of cheaper and better binders. The two Hague Democrats and the one Edge Republican voted for and purchased the higher-priced Kalamazoos at taxpayers' expense.

Before amending the Golberg election act to retain county boards of elections, an investigation should be conducted by the House election committee to ascertain the truth of my charges and dig into other "bi-partisan" graft. One man, selected by the Legislature, can handle all the election machinery and stop graft, and any Republican selected by the Legislature can do the work more honestly and more efficiently than any Democrat or set of Democrats selected and dictated to by Frank Hague, the ballot box stuffer.

The Goldberg committee could also ascertain what has happened to Superintendent of Elections John Ferguson's "investigation" of the fraud committed by Hague on Governor Hoffman's vote in Hudson County last November, whereby Hague stole at least 20,000 votes from our Governor and Ferguson stopped his investigation at the request of Hague's Senator, Edward P. Stout, of Hudson, and Assistant Corporation Counsel Charles A. Rooney who read Hague's weeping letter to you. Ferguson states he stopped the investigation as an act of "senatorial courtesy."

The same committee could also reveal how Hague stole the 1933 Jersey City municipal election which investigation Ferguson also fell down on. Start your investigation and proof of the ballot box stuffing by Hague will be furnished you to present to the public. Abolition of the "bi-partisan" boards will result in honest elections.
Sincerely,
(Signed) George Biehl.

DECLASSIFICATION AUTHORITY DERIVED FROM:
FBI AUTOMATIC DECLASSIFICATION GUIDE
DATE 07-26-2010

Federal Bureau of Investigation
United States Department of Justice
936 Raymond-Commerce Building
NEWARK, NEW JERSEY

Mr. Nathan
Mr. Tolson
Mr. Baughman
Mr. Clegg
Mr. Coffey
Mr. Crowl
Mr. Egan
Mr. Foxworth
Mr. Clavin
Mr. Barbo
Mr. Hottel
Mr. Loster
Mr. McIntire
Mr. Naughton
Mr. Nichols
Mr. Pennington
Mr. Schilder
Mr. Tamm
Mr. Tracy
Miss Gandy

October 2, 1937

PERSONAL AND ~~CONFIDENTIAL~~

Director
Federal Bureau of Investigation
Washington, D. C.

Dear Sir:

I had lunch today with Sam Flex of the Identification Division, Essex County Sheriff's Office, and Mr. Miles W. Beemer, who is now connected with the WPA in New Jersey. Mr. Beemer was a former Commissioner of Tenement Houses in New Jersey, and he has also, in the past, been connected with the Atlantic City Chamber of Commerce. I was told he was the person who originated the idea of having a "Miss America" contest.

During the conversation, Mr. Beemer told me something about Mayor Hague's organization in Jersey City which I thought might be of interest to you. Mr. Beemer stated that approximately twenty-six or twenty-seven years ago Hague began forming his organization. He first, according to Beemer, was connected with a gang of boys who were engaged in petty thieving. During the course of one of their thefts at a mercantile establishment, the proprietor of the establishment was shot and killed. Mr. Beemer gave the impression that he believed that all of the boys were involved; however, he stated that one of them was induced to "take the rap," and that through political influence the others were not prosecuted.

Mr. Beemer stated that After this happened Hague, realizing what the petty thievery operations might lead to, quit the gang. Hague was a very affable person, well liked, and soon became the ward leader of his district. He was then given a position on the Water Board by the then mayor of Jersey City, who held the control. Beemer stated that there is no question but what Hague undermined the leader and soon built up a powerful organization for himself.

The particular thing that I was interested in in Mr. Beemer's story is the fact that Mayor Hague is alleged to have today, directly and indirectly, on his payroll, about 40,000 persons and that each of these persons is supposed to account for four votes. Beemer stated that Hague's organization was one of the best; that it is required that each district leader know every person who resides in his district; that card indexes are kept on these persons

RECORDED
&
INDEXED

62-26679-6

NOV 1937

and a complete record is maintained on such card indexes as to the individual, his likes and dislikes, his occupation, his family; and Beemer stated that they even went further and kept up with the movements of each individual, stating that if, for instance, some married man was running around with some woman, a notation of this was made on the card index, and, as a result, if one of the members should attempt to "kick over the traces" he was called in and his record was related to him, after which he usually changed his mind."

(Mr. Beemer went on to state that)"Any time one of the residents started to move out of a district, it was the duty of the district leader to ascertain why, and if it was found that the person was moving due to the high rents, for instance, the district leader then arranged to have the taxes reduced on the property and the landlord lowered his rent in order that the tenant would not move. If a person was offered a higher salary in some other place, the district leader would arrange to see that his salary was increased, all of which was done through making allowances to the business man and compensating him to some extent for the increase which he granted. Beemer went on to tell about how closely the district leaders stayed in touch with the residents of their wards, stating that they even knew when a man was discharged from a position, and they would investigate such discharge and if it was found that it was not actually the fault of the worker, the employer would be induced to rehire him."

I indicated nothing more than a passing interest in Hague's organization to Mr. Beemer as it was the first time that I had met him. Consequently, I secured no information other than that concerning the method of operation of Hague's machine. However, I thought that you might find this of interest.

Respectfully yours,

P. E. FOXWORTH,
Special Agent in Charge

PEF mcc

1836 Raymond-Commerce Building
Newark, 2, New Jersey

March 15, 1947

PERSONAL AND CONFIDENTIAL

Director, FBI

RE: FEDERAL JUDGE THOMAS F. MEANEY
AND MAYOR FRANK HAGUE;
INFORMATION CONCERNING

Dear Sir:

The following is submitted for your information.

On the evening of February 25, 1947, Special Agent JESSE L. ORR contacted Mrs. GRACE BRANDENBERG of 2402 Hudson Boulevard, Union City, New Jersey, who is the wife of Dr. LEOPOLD BRANDENBERG. Mrs. BRANDENBERG has been contacted on numerous occasions in the past at which time she has repeatedly stated that she is a close friend of one JAMES O'LEARY of Union City, who is an active racketeer and gambler in Hudson County and who furnishes Mrs. BRANDENBERG with reliable information concerning the criminal element in Hudson County.

According to Mrs. BRANDENBERG, O'LEARY at the present time is driving an automobile for a Mr. STAREY, who is a politician and editor of a small political newspaper in Bayonne, New Jersey. O'LEARY advised Mrs. BRANDENBERG on Sunday, February 23, 1947, that some time ago Mr. STAREY was in Mayor HAGUE's Office in Jersey City when Mayor HAGUE was talking with Federal Judge MEANEY on the telephone. Among other things Mayor HAGUE said to Judge MEANEY was "I want to see Joseph Fay on the streets."

Mrs. BRANDENBERG furnished no other information in this regard and she was not specifically questioned further nor was any mention made of the JOSEPH S. FAY case.

Very truly yours,

S. C. McKee,
SAC

67-58-586
WMP:PJS

RECORDED
62-20099-8
F B I
42 APR 1 1947

COPY:AJH .

OFFICE OF DIRECTOR

FEDERAL BUREAU OF INVESTIGATION

UNITED STATES DEPARTMENT OF JUSTICE

62-20079-9

September 15, 1948

10:37

Judge E. A. Tamm called and
inquired as to how you were
feeling this morning.

He stated that he had
dictated a memorandum to his
secretary regarding former
Governor Edison of New Jersey
and he was sending it over.
It should be here within the next hour
or so.

Memorandum attached.

eh

Director's Notation:
"1. Does Clegg recall this?
2. I think we should have
Clegg go & see Edison &
put him straight as to facts
as they pertain to FBI.

H."

INDEXED - 125 62-20079-9

COPY:AJH.

62-20079-1

September 15, 1948

MEMORANDUM

A source of information, whose identity has been furnished, advised that he recently attended a seminar at the School of Journalism at Columbia University. A number of distinguished and prominent persons appeared before the seminar. Among these persons was former Governor of New Jersey, Edison, who spoke at considerable length in a completely off-the-record statement relative to his experiences as Under-Secretary and Acting Secretary of the Navy and as Governor of New Jersey. Edison's talk was particularly vitriolic in references to the late President Franklin Delano Roosevelt and very critical of Mayor Hague of New Jersey and of the collaboration between Roosevelt and Hague. Edison stated in the course of his discussion that the only person who had ever succeeded in "getting something" on Hague was the former Attorney General of New Jersey, Van Riper, who, Edison indicated, was a protege of his, Edison's. Edison stated that as soon as Hague realized that Van Ripper was really going to "get" him, Hague proceeded to Washington and talked to Mr. Roosevelt.

As a result of the conference between Roosevelt and Hague, Edison stated that Roosevelt sent for J. Edgar Hoover and instructed him to conduct an investigation of Van Riper's activities as a result of which "the FBI conducted a phony investigation of Van Riper upon fictitious charges of OPA and bank violations". Edison stated that despite the fact that the OPA violation was non-existent and the bank case was, in addition to being a highly technical one barred by the statute of limitations, the FBI succeeded in so harassing Van Riper that he was unable to proceed in carrying out his investigation and prosecution of Hague.

Edison cited this situation apparently in much greater detail than above to indicate that the tentacles of contamination of the Hague Machine were so powerful and all embracive as to even permit him to reach in and "fix" J. Edgar Hoover and the FBI. Edison indicated that he personally protested to FDR about this situation and that of FDR's utilization of the Hague Machine, at which time Roosevelt indicated that when it was necessary to accomplish your objective to cross a river you should not hesitate to ride on the shoulders of the devil himself if that was the most expedient way to get across the river.

The day after Mr. Edison's appearance before the seminar, an FBI official identified as Assistant Director Clegg appeared before the seminar group. Several members of the seminar had talked over the possibility of "baiting" the FBI speaker on the basis of the Van Riper case but the FBI official indicated that he had absolutely no knowledge of the facts in the Van Riper case.

END

COPY:AJH

62-20079-1

FROM

OFFICE OF DIRECTOR, FEDERAL BUREAU OF INVESTIGATION

TO

OFFICIAL INDICATED BELOW BY CHECK MARK

Mr. Tolson.........()

Mr. Clegg.........()

Mr. Glavin.........()

Director's Notation:
"Cordially acknowledge.

H."

MR. TOLSON September 16, 1948

H. H. CLEGG

APPEARANCE BEFORE AMERICAN PRESS INSTITUTE, COLUMBIA
UNIVERSITY
MARCH 18, 1947 –

WALTER D. VAN RIPER, FEDERAL RESERVE ACT; MAIL FRAUD;
CONSPIRACY

Concerning the Director's inquiry as to whether I remember when I
appeared before the Columbia University's American Press Institute I recalled
any questions concerning the investigation of the Van Riper case in New Jersey,
see my attached memorandum (94-1-2846-105) covering this meeting.

Of course, as was to be expected, when a bunch of police reporters
are going to ask questions, many of their questions had the nature and
the tone of "baiting", but always good-naturedly, but the majority of their
questions were of a serious type. Of the "baiting" type, however, were such
questions as the one concerning Walter Winchell's alleged access to the FBI
files and his friendship with Mr. Hoover, questions as to the Washington, D. C.
Police Department, the overlapping of police agencies in the District of
Columbia and similar questions.

You will notice in the list of typical questions asked in the
attached memorandum are the following:

"13. Does the FBI make political investigations?"

"14. Was the FBI ordered to discontinue the investigation of the Hague
Machine at the request of Attorney General Biddle?"

I remember these questions specifically. I answered that the FBI did not make
political investigations and elaborated further by stating that in the event
there was a violation of a Federal law under our jurisdiction involved, the
FBI would then make an investigation regardless of the political affiliation
of any of the accused persons but that the FBI made no investigations for
political purposes nor would it do so under the administration of Mr. Hoover.
As to the question as to whether the Bureau would discontinue the investigation
of the Hague Machine at the request of Attorney General Biddle, I had never
heard of any investigation of the Hague Machine, as such, and the immediately
preceding question was obviously a lead to this question since it referred to
political investigations. I explained that I was not aware of any investigation
which the Bureau had conducted of a political machine, as such.

RECORDED - 125

There were no references to the Van Riper case or any specific case but the question by tone and nature seemed to imply that the FBI may have been ordered to discontinue a political investigation of the Hague Machine and I had never heard of any such request being made or cancelled and so told them. There were no follow-ups to this question. The case was not specifically identified in any other way. Governor Edison was not referred to in any way and no other purpose was indicated for the question other than the implied indication that the FBI may have started or discontinued an investigation for political purposes. I explained thoroughly that the FBI did not do such things.

HHC:hd

CHARLES EDISON
West Orange
New Jersey

September 23, 1948

Dear Edgar:

Earlier this week Mr. Clegg of your office
called upon me in New York City to discuss a
report that I had made certain allegations con-
cerning your department while appearing before a
Journalism Seminar at Columbia University on
March 14, 1947. The remarks attributed to me
were that former Attorney General Biddle had been
instrumental in calling off a Federal Bureau of
Investigation probe of Frank Hague and the Hague
Organization.

Your Mr. Clegg was most cooperative and
understanding. I assured him that I had no recol-
lection whatsoever of having made any statement
such as the one attributed to me at this Columbia
Seminar. Furthermore, I stated that I had no
recollection of ever having made such a statement
anywhere or at any time.

Subsequently, I have looked up the records
of my appearance at Columbia University and, since
I spoke from a prepared manuscript, I could easily
ascertain that I had made no such statement in the
portion of my talk made from a prepared manuscript.
However, I do recall that there was a period of
questions and answers in which I quite naturally
was speaking off the cuff.

To further check my own memory, I contacted
Superior Judge C. Thomas Schettino of New Jersey,
who was present at the Columbia University Seminar,
and he stated that I positively made no such
reference as ascribed to me. Judge Schettino
would have been unusually attentive to my remarks
inasmuch as he was there in his former capacity as
my assistant in the Edison Industries.

RECORDED - 125

- 2 -

In all sincerity, Ed. I honestly believe that nothing that I said in March of 1947 at Columbia University could possibly have been construed as a criticism of your department. I have had a great deal of admiration first, for you as an individual and for your direction of the Bureau, and secondly, for the overall calibre of the work of the Bureau as a whole.

As you know, there were newspaper comments and comments by others, at the period of two or more years ago, which reflected upon the FBI's work in the investigation, indictment, and prosecution of New Jersey's Attorney General, Walter Van Riper. If memory serves me correctly, I have on at least one occasion spoken to you personally about these reports. This is the nearest thing to a criticism of your department that comes to my mind, but I am quick to add that I am positive that I made no allusions to the Van Riper case during my appearance at the Columbia Seminar.

Enough of this serious talk. I merely want to add that it is my sincere hope that you believe, as I believe, that there is no truth in the allegations relayed to me by Mr. Clegg. I do want to wish you a speedy recovery from your illness, and to relay the hope that this letter find you fully returned to good health and good spirits.

Sincerely yours,

Voicewritten /s/ Charles Edison
by Ediphone-A

Mr. J. Edgar Hoover, Director
Federal Bureau of Investigation
9th & Pennsylvania Avenues
Washington, D. C.

NOTES

INTRODUCTION

1. *Time*, "When the Big Boy Goes," January 16, 1956, http://www.time.com/time/magazine/article/0,9171,861807,00.html.
2. Gerald Leinwand, *Mackerels in the Moonlight: Four Corrupt American Mayors* (Jefferson, NC: McFarland & Company, 2004), 71.
3. *New York Times*, "Austere Funeral Is Held for Hague," January 6, 1956.
4. *Tonawanda News*, January 5, 1956, North Tonawanda, New York, Evening News.
5. Leinwand, *Mackerels in the Moonlight*, 6.
6. Mark Foster, "The Early Career of Mayor Frank Hague," master's thesis, University of Southern California, 1968, 19.
7. Helene Stapinski, *Five Finger Discount: A Crooked Family History*, 1st ed. (New York: Random House, 2001), 24; *Equal Justice* 10–12 (1935–39).
8. *Boardwalk Empire*, HBO Series, Season 1, Episode 4.
9. Leinwand, *Mackerels in the Moonlight*, 77.
10. De Witt Wallace, Lila Acheson Wallace and Lila Bell Wallace, *Readers Digest* (N.p.: Reader's Digest Association, 1938), 73. Reprint of Marquis W. Childs, "Dictator—American Style," *St. Luis Post-Dispatch*, February 20, 1938.
11. Steven P. Erie, *Rainbow's End: Irish-Americans and the Dilemmas of Urban Machine Politics, 1840–1985*, California Series on Social Choice and Political Economy (Berkeley: University of California Press, 1990), 132.
12. Matthew Raffety, "Political Ethics and Public Style in the Early Career of Jersey City's Frank Hague," *New Jersey History* 124, no. 1 (2009): 38.
13. Jack Beatty, *The Rascal King: The Life and Times of James Michael Curley* (New York: DaCapo Press, 2000), 190.
14. William Bulger, *James Michael Curley: A Short Biography with Personal Reminiscences* (Beverly, MA: Commonwealth Editions, 2009), 57.

15. *Time*, "When the Big Boy Goes."

16. Todd Michael Schaefer, *Thomas A. Birkland Encyclopedia of Media and Politics*, 1st ed. (Washington, D.C.: CQ Press, 2006), 119.

17. Melvin G. Holli, *The American Mayor: The Best and Worst Big City Leaders* (University Park: Pennsylvania State University Press 1999), 13.

18. Mike Royko, *Boss: Richard J. Daley of Chicago* (New York: Plume, 1988), 30.

19. Ibid., 124.

20. Robert Singh, *American Government and Politics: A Concise Introduction* Thousand Oaks, CA: Sage Publications, 2003), 106. "Chicago police assaulted anti-war protesters, while inside turmoil engulfed proceedings and Chicago boss Richard Daley hurled anti-Semitic abuse at Senator Abraham Ribicoff (Democratic, Connecticut)."

21. Ibid., 190.

22. Holli, *American Mayor*, 13.

23. Dayton David McKean, *The Boss: The Hague Machine in Action* (Boston: Houghton Mifflin, 1940).

24. Steven Hart, *The Last Three Miles: Politics, Murder, and the Construction of America's First Superhighway* (New York: New Press, 2007), 83.

25. Martin Paullson, *The Social Anxieties of Progressive Reform—Atlantic City, 1854–1920* (New York: New York University Press, 1994), 224.

26. My Bankruptcy Help, "Walter Evans Edge," http://my-bankruptcy-help.com/?b=Walter_Evans_Edge.

27. McKean, *The Boss*, 68.

28. Ibid., 68–69.

29. Monica Prasad, Andrew J. Perrin, Kieran Bezila, et al., "'There Must Be a Reason': Osama, Saddam, and Inferred Justification," *Sociological Inquiry* 79 (May 2009): 142–62.

30. *Knuller (Publishing, Printing and Promotions) Ltd v. Director of Public Prosecutions, All England Law Reports: The All England Law Reports 1936–to date, All ER 1972*, vol. 2, All ER 898 at 932, 1972. This element of the judgment was obiter. http://uce2003els.studio400.me.uk/R-v-Knuller_1972.pdf.

31. Joel B. Pollak, "The Blagojevich Trial: Honest Graft and Dishonest Graft," Big Government, http://biggovernment.com/jpollak/2010/06/03/the-blagojevich-trial-honest-graft-and-dishonest-graft.

32. Bruce M. Stave, John M. Allswang, Terrence J. McDonald and Jon C. Teaford, "A Reassessment of the Urban Political Boss: An Exchange of Views," *History Teacher* 21, no. 3 (May 1988): 293–312.

33. Jim Murray, *Tunnels* (Bloomington, IN: AuthorHouse, 2007), 8.

34. Jules Witcover, *Sabotage at Black Tom: Imperial Germany's Secret in America, 1914–1917* (Chapel Hill, NC: Algonquin Books, 1989), 22–24.

35. Women's History, "Women's Suffrage Victory: Nineteenth Amendment Becomes Law," http://womenshistory.about.com/od/suffrage1900/a/august_26_wed.htm.

36. William Safire, *Safire's Political Dictionary* (New York: Oxford University Press, 2008), 335.

37. Stave et al., "Reassessment of the Urban Political Boss."

The Horseshoe

38. U.S. Election Atlas, "1856 Presidential General Election Results," http://www.uselectionatlas.org/RESULTS/national.php?year=1856&f=0.

39. Douglas Shaw, "The Making of an Immigrant City: Ethnic and Cultural Conflict in Jersey City, New Jersey, 1850–1877," PhD dissertation, University of Rochester, 1976, 62.

40. *(Jersey City) Evening Journal*, June 13, 1870.

41. *(Jersey City) Daily Sentinel and Advertiser*, April 4, 1854.

42. Richard J. Connors, *A Cycle of Power: The Career of Jersey City Mayor Frank Hague* (Metuchen, NJ: Scarecrow Press, Inc., 1971), 152–54.

43. *(New York) Irish World*, February 10, 1872.

44 *(Jersey City) Daily Sentinel and Advertiser*, August 22, 1854

45. Hugh D. Spitzer, "Those Dirty (Fill in the Blanks) Turn into Americans," *Seattle Times*, May 24, 2006, http://seattletimes.nwsource.com/html/opinion/2003014307_spitzer24.html.

46. *New York Sun*, October 29, 1870.

47. *(Jersey City) Evening Journal*, October 13, 1870.

48. *(Jersey City) American Standard*, November 8, 1870. O'Bierne quoted at a meeting of the Irish Emigrant Aid and Land Colonization Society. Similar statement made on June 4, 1870, *(Jersey City) Evening Journal*.

49. John A. Martins, "Ethnic Neighborhoods, a Series—Downtown Continues to Be Home for Various Groups but It Wasn't Always that Way," *Hudson Reporter*, August 9, 2003, http://www.hudsonreporter.com/view/full_stories_home/2392699/article-Ethnic-neighborhoods-a-series-Downtown-continues-to-be-home-for-various-groups-but-it-wasn-t-always-that-way.

50. Jeff Greenfield, "Payoffs Still Define Politics in Some Cities," *Los Angeles Times*, April 13, 1986, http://articles.latimes.com/1986-04-13/opinion/op-4641_1_political-machine.

51. Reinhard H. Luthin, *American Demagogues* (Boston: Beacon Press, 1954), 129.

52. James T. Fisher, *On the Irish Waterfront: The Crusader, the Movie, and the Soul of the Port of New York*, 1st ed. (Ithaca, NY: Cornell University Press, 2010), 28.

53. William H. Shaw, *A History of Essex and Hudson Counties, New Jersey*, vol. 2 (Philadelphia, PA: Everts & Peck, 1884), 1,150–61.

54. *New York Times*, "Steers on the Rampage: Tossing People Right and Left in Jersey City," October 7, 1884.

55. McKean, *The Boss*, 19, 28; Ralph G. Martin, *The Bosses* (New York: G.P. Putnam's Sons, 1964), 169. Martin puts the specific number at

forty saloons in the Horseshoe. The *New York Times* noted gang violence, including murder, in four published stories from October 6, 1884, to May 9, 1887. *New York Times*, "The Victim of Gang Rule: Murder of a Ship Carpenter in Jersey City. He Refuses Beer Money to Some Ruffians and Is Attacked," October 6, 1884; *New York Times*, "Brutal Assault on a Women: Five Members of a Jersey City Gang of Ruffians Arrested," October 14, 1884; *New York Times*, "Murdered in Jersey City," April 5, 1887; and *New York Times*, "Murdered by Jersey City Roughs," May 9, 1887.

56. *New York Times*, August 21, 1870.

57. Henry Barnard, "Special Report of the Commissioner of Education on the Condition and Improvement of Public Schools in the District of Columbia: Submitted to the Senate June 1868, and to the House, with additions, June 13, 1870" (Washington, D.C.: Government Publishing Office, Department of Education), 96.

58. Chapter 64, Sec. 1 of the New Jersey Child Labor Law did not go into effect until 1904, and even then was rarely if ever enforced. Hague, through his handpicked Congressional representative Mary T. Norton, was indirectly responsible for the passage of the Fair Labor Standards Act, which affected child labor.

59. Thomas Fleming, *"Mysteries of My Father": An Irish American Memoir* (Hoboken, NJ: Wiley, 2005), 34. Historian Matthew Raffety raised some doubt as to whether Hague was a member of the Red Tiger gang, noting his ability to locate only one source linking Hague with a specific gang; there were, however, documents introduced during the 1929 investigation of Hague indicating that he was a member of the gang. Hugh Hague would eventually straighten out, becoming a Jersey City firefighter with the help of Democratic leader Dennis McLaughlin, who got him the job.

60. *New York Times*, "Deaths from Cholera Murbus, Two Residents of Jersey City Who Ate Fruit Freely and Drank Beer," August 30, 1893; *New York Times*, "Thousands Are in Danger, Jersey City Water Condemned in Vain by Doctors" July 31, 1894; *New York Times*, "Typhoid in Jersey City; Thirty-seven Hospital Cases May Be Due to Bad Water," August 22, 1894.

61. Hart, *Last Three Miles*, 31.

62. William V. Shannon, "The Political Machine I: Rise and Fall, The Age of the Bosses," *American Heritage Magazine* 20, no. 4 (1969).

63. Raymond E. Wolfinger, "Why Political Machines Have Not Withered Away and Other Revisionist Thoughts," *Journal of Politics* 34 (1972): 374. Southern Political Science Association.

64. James C. Scott, "Corruption, Machine Politics, and Political Change," *American Political Science Review* 63, no. 4 (December 1969): 1,142–58.

65. Harold F. Gosnell, "The Political Party Versus the Political Machine," *Annals of American Academy of Political and Social Science* 169 (September 1933): 21–28. American Academy of Political and Social Science.

66. Rebecca Menes, "Corruption in Cities: Graft and Politics in American Cities at the Turn of the Twentieth Century," National Bureau of Economic Research (NBER) Working Paper No. 9990, issued in September 2003.

67. Lincoln Steffens, *The Autobiography of Lincoln Steffens* (Berkeley, CA: Heyday Books, 2005), 651.

68. George C.S. Benson, *Political Corruption in America* (Lexington, MA: D.C. Heath and Company, 1978), xiv.

69. David R. Colburn and George E. Pozzeta, "Bosses and Machines: Changing Interpretations in American History," *History Teacher* 9, no. 3 (1976): 445–63.

70. Ibid.

71. John S. Matlin, "Political Party Machines of the 1920s and 1930s: Tom Pendergast and the Kansas City Democratic Machine." PhD diss., Department of American and Canadian Studies, School of Historical Studies, University of Birmingham, September 2009, 131.

72. U.S. Bureau of the Census, "Historical Statistics of the United States, Colonial Times to 1957" (Washington, D.C.: Government Printing Office, 1960), 70; Linda Levine, "The Labor Market During the Great Depression and the Current Recession," Congressional Research Service, June 19, 2009, 13. http://digital.library.unt.edu/ark:/67531/metadc26169/m1/1/high_res_d/R40655_2009Jun19.pdf.

73. Bruce M. Stave, ed., *Urban Bosses, Machines and Progressive Reformers* (Lexington, MA: D.C. Heath and Company, 1972), 297.

74. Adam Cohen and Elizabeth Taylor, *American Pharaoh: Mayor Richard J. Daley—His Battle for Chicago and the Nation* (New York: Back Bay Books, 2001), 161.

75. Letter from Special Agent in Charge, Newark, New Jersey FBI Office, to Hoover, FBI File on Frank Hague, document #62-20079-6, October 2, 1937, FBI File on Frank Hague, document, obtained under FOI Act. The letter indicates a lunch meeting that he had with Mr. Sam Flex of the Essex County Sheriff's Office, as well as Mr. Miles Beemer, who was connected in some capacity with the WPA. It also talks about Hague. The agent indicated that Beemer believed that *all* of the boys were involved; however, one was convinced to take the rap. The letter goes on to say how Hague had forty thousand people on the payroll and that each of these was expected to deliver four votes.

76. P.J. Madgwick, *American City Politics* (London: Routledge and Kegan Paul, 1970), x.

77. Jay M. Shafritz, Norma M. Riccucci, David H. Rosenbloom and Katherine C. Naff, *Personnel Management in Government: Politics and Process*, 5th ed. (New York: CRC Press, 2001), 93–101.

78. Thomas G. Dagger, "Political Patronage in Public Contracting," *University of Chicago Law Review* 51, no. 2 (Spring 1984): 518–58.

79. Lester G. Seligman, "The Presidential Office and the President as Party Leader," *Law and Contemporary Problems* 21, no. 4 (Autumn 1956), 724–34.

FACT FROM FICTION

80. McKean, *The Boss*, 20.

81. Alfred Steinberg, *The Bosses*, 1st ed. (New York: MacMillan Company, 1972), 12.

82. McKean, *The Boss*, 20; Joseph Hayes III, *Domestic Threats* (Bloomington, IN: IUniverse, 2002), 27.

83. Steinberg, *The Bosses*, 27.

84. Susanna Barrows, *Robin Room Drinking: Behavior and Belief in Modern History* (Berkeley: University of California Press, 1991), 112.

85. Jules Zanger, "Food and Beer in an Immigrant Society," *Society* 33, no. 5 (July/August 1996): 61.

86. Connors, *Cycle of Power*, 60.

87. *Jersey Journal*, "Davis Funeral Pageant to Be a Mile Long," January 11, 1911.

88. Perry Duis, *The Saloon: Public Drinking in Chicago and Boston, 1880–1920* (Champaign: University of Illinois Press, 1998), 15.

89. *New York Times*, "Hudson County's Degradation: Where Official Corruption Runs Riot and Is Not Concealed," October 22, 1893. Davis's ownership of a horse racing track in Guttenberg, New Jersey, was the major source of McLaughlin's income.

90. Thayer Watkins, "The Political Machine of Frank Hague of Jersey City, New Jersey," San Jose State University, http://www.applet-magic.com/hague.htm; Steinberg, *The Bosses*, 40, specifically mentions the stealing of a ballot box by Kenny. Luthin indicated that the ballot box may have been at a different location than the saloon but was taken there and opened and ballots counted in a back room of Kenny's saloon; Luthin, *American Demagogues*, 129.

91. Duis, *The Saloon*, 131.

92. Steinberg, *The Bosses*, 14.

93. Raffety, "Political Ethics and Public Style," 38; Steinberg, *The Bosses*, 15.

94. *Time*, "New Jersey: Frank Hague's Pawns," November 9, 1942, http://www.time.com/time/magazine/article/0,9171,884609,00.html.

95. *Hudson Dispatch*, "Hague Did Not Obey Grand Jury Subpoena," October 10, 1904.

96. Raffety, "Political Ethics and Public Style," 38, 42.

97. Ibid., 38.

98. *Jersey Journal*, "Wittpenn Admits Hague Went to Boston on Behalf of 'Red' Dugan," October 21 1911.

99. Raffety, "Political Ethics and Public Style," 38. Similar reference to how a neighborhood viewed someone who was willing to take personal risk to help another member of the neighborhood can be seen when Michael Curley took a civil service examination for a neighborhood friend who could not pass it but needed to in order to get a job. Curley's eventual arrest and jailing for the incident made him a hero, not a villain.

100. *Jersey Journal,* "Hague Guilty of Contempt of Court," November 10, 1904; Fred J. Cook, *American Political Bosses and Machines* (New York: Franklin Watts, Inc., 1973), 110.

101. George Rapport, *The Statesman and the Boss* (New York: Vantage Press, 1961), 19.

102. Connors, *Cycle of Power,* 8; Rapport, *Statesman and the Boss,* 17, stated that the county board of assessors granted a tax rate of $5 on every $1,000 of real estate owned. If taxed at the rate of other industries, the city could have collected an additional $500,000 to $600,000 annually.

103. Steinberg, *The Bosses,* 16.

104. Foster, "Early Career of Mayor Frank Hague," 19.

105. See Eugene M. Tobin, "Mark Fagan and the Politics of Urban Reform: Jersey City, 1900–1917," PhD dissertation, Brandeis University, 1972.

106. Rapport, *Statesman and the Boss,* 19.

107. Ibid., 18.

108. Eugene M. Tobin, "'Engines of Salvation' or 'Smoking Black Devils': Jersey City Reformers and the Railroads, 1902–1908," Michael H. Ebner and Eugene M. Tobin, eds., *The Age of Urban Reform: New Perspective on the Progressive Era* (Port Washington, NY: Kennikat Press, 1977), 150.

109. Eugene M. Tobin, "The Progressive as Single Taxer: Mark Fagan and the Jersey City Experience, 1900–1917," *American Journal of Economics and Sociology* 33, no. 3 (1974): 287–97.

110. Leinwand, *Mackerels in the Moonlight,* 71

111. Raffety, "Political Ethics and Public Style," 39, estimated that there were one hundred patronage jobs available for Hague to distribute. Leinwand, *Mackerels in the Moonlight,* 71, indicated that there were no more than twenty-four such jobs available to Hague.

112. Raffety, "Political Ethics and Public Style."

113. Steinberg, *The Bosses,* 18.

114. Connolly's trial ended in a hung jury. *Washington Times,* "Connolly Murder Jury Disagrees: No Verdict in Case of Man Who Killed Another During Primary Election," April, 21, 1909, 1.

115. Thomas F.X. Smith, *The Powerticians* (Secaucus, NJ: Lyle Stuart, 1982), 41.

116. William E. Sackett Scannell, *New Jersey First Citizens: Biographies and Portraits of the Notable Living Men and Women* (N.p.: BiblioBazaar, 2009), 299; Rapport, *Statesman and the Boss,* 50.

117. Ibid., 15.

118. Ibid.

119. Ibid., 51.

120. *New York Times,* "Wilson Named for Governor in Jersey: Democrats Choose President of Princeton to Lead Their Fight on First Ballot," September 16, 1910.

121. Foster, "Early Career of Mayor Frank Hague," 23.

122. Rapport, *Statesman and the Boss*, 65; *New York Times*, "Wilson Tells Smith He Will Fight Him: New Jersey's Governor-Elect Threatens to Stump the State Against the Ex-Senator," November 29, 1910, 18.

123. Thomas Fleming, *New Jersey: A History* (New York: W.W. Norton & Company, 1985), 159.

124. Connors, *Cycle of Power*, 17.

125. Ibid., 16.

126. *New York Times*, "Rule by Commission Loses in Jersey City: Machines of Both Parties Help Roll Up Majority of 1,483 Against Gov. Wilson's Plan," July 19, 1911; *New York Times*, "Gov. Wilson Urges Jersey City to Arise: Cheered by 4000 as He Urges the People to Rule by Adopting Commission Plan," July 15, 1911.

127. Watkins, "Political Machine of Frank Hague."

The Director of Public Safety

128. *New York Times*, "Jersey Towns to Vote Today: Jersey City Expected to Adopt Commission Form of Government," April 15, 1913.

129. Connors, *Cycle of Power*, 29.

130. Ibid., 28.

131. *New York Times*, "Wittpenn Wins a County Committee," March 23, 1913, 14; *New York Times*, "Wittpenn Turned Down: Hudson County Committee Comes Out for Fielder for Governor," July 19, 1913.

132. *New York Times*, "Commission Rule for Jersey City," April 16, 1913.

133. *New York Times*, "Count Confirms Wittpenn Victory: All of Mayor's Supporters Returned in Elimination Election for City Commissioners," May 15, 1913.

134. Fisher, *On the Irish Waterfront*, 31.

135. *New York Times*, "Wittpenn Men Lose in Jersey City Vote: Opposition Elect All but One of Five Members of the Commission," June 11, 191.

136. Eric H. Monokkonen, *Police in Urban America, 1860–1920*, Interdisciplinary Perspectives on Modern History (New York: Cambridge University Press, 2004), 1.

137. Ibid., 547–80.

138. *New York Times*, "Package Contained Bread, Homeless Man Carried It in Jersey City at Night and Was Shot," August 28, 1899.

139. Mark H. Haller, "Historical Roots of Police Behavior: Chicago, 1890–1925," Essays in Honor of J. Willard Hurst, part 2, *Law & Society Review* 10, no. 2 (Winter 1976): 303–23.

140. Connors, *Cycle of Power*, 16.

141. Randall G. Shelden, *Controlling the Dangerous Classes: A Critical Introduction to the History of Justice* (Boston: Allyn and Bacon, 2001).

142. Rapport, *Statesman and the Boss*, 188–90.

143. Hart, *Last Three Miles*, 73.

144. Leinwand, *Mackerels in the Moonlight*, 73.

145. McKean, *The Boss*, 39.

146. Ibid.

147. *New York Times*, "In New Jersey," February 27, 1916.

148. Thomas Fleming, "The Political Machine II: A Case History 'I Am the Law,'" *American Heritage Magazine* 20, no. 4 (June 1969): 33–48. Cook put the number of officers put on trial at 225, *American Political Bosses and Machines*, 112.

149. Leinwand, *Mackerels in the Moonlight*, 74.

150. Fleming, "Political Machine II."

151. Smith, *The Powerticians*, 60.

152. George Creel, "The Complete Boss," *Collier's* 98 (October 10, 1936): 58.

153. Jack Alexander, "King Hanky-Panky of Jersey City," *Saturday Evening Post*, October 26, 1940, 121–24; Luthin, *American Demagogues*, 143.

154. *New York Times*, "Fireman Sadly Hampered: Jersey City's need of Reform Made Very Evident," February 26, 1887.

155. Foster, "Early Career of Mayor Frank Hague," 120.

156. Ibid., 189.

157. Henry Landau, *The Enemy Within: The Inside Story of German Sabotage in America* (New York: Putnam's Sons, 1937), 8.

158. Smith, *The Powerticians*, 55.

159. *New York Times*, "Millions of Persons Heard and Felt Shock," July 31, 1916; *Portsmouth Daily Times*, "Ammunition Explosion Shells New York and Jersey City," noon extra edition, July 31, 1916, 1.

160. Witcover, *Sabotage at Black Tom*, 13.

161. *Jersey Journal*, "Big Munitions Explosion at Black Tom; 50 Believed Dead; 21 Hurt in City Hospital; Damage $75,000,000," July 30, 1916, 1.

162. *New York Times*, "Railroad Heads to Be Arrested for Explosion," August 1, 1916, 1.

163. Leinwand, *Mackerels in the Moonlight*, 74.

164. McKean, *The Boss*, 41–43; *New York Times*, "Jersey City's New Heads: Mayor Fagan Apparently Defeated by Democrats at Second Election," May 9, 1917.

165. Luthin, *American Demagogues*, 133.

166. *New York Times*, "Refuse to Take Baby; Say Theirs Is a Boy: Couple May Be Held on Abandonment," October 5, 1922; *New York Times*, "Mrs. Rich, Who Thought Her Baby a Boy, Accepts Mayor's Decree that It Is a Girl," October 10, 1922.

167. Russel B. Porter, "Portrait of a 'Dictator,' Jersey City Style," *New York Times*, February 13, 1938.

168. Thomas W. Hopkins, "Bureau of Special Service, Jersey City Public Schools," in Sheldon Glueck and Eleanor Touroff Glueck, *Preventing Crime: A Symposium* (New York: McGraw-Hill, 1936), 115; Edwin McCarthy Lemert, "Instead of Court: Diversion in Juvenile Justice," *Crime and Delinquency*, vol.

2, National Institute of Mental Health, Center for Studies of Crime and Delinquency, Supt. of Docs. (Washington, D.C.: U.S. Government Printing Office, 1971), 31; Arthur W. Pease, "History of Jersey City and Its Police, Part VII," *Jersey City Watch* 5, no. 5 (May 1, 2010); Virginia Barckley, "They Go to School in the Hospital," *American Journal of Nursing* 54, no. 3 (March 1954): 328–30; Benedict S. Alper, "Progress in Prevention of Juvenile Delinquency: Children in a Depression Decade," *Annals of the American Academy of Political and Social Science* 212 (November 1940): 202–8.

169. K.L. Thompson, "Jersey City's School Community Program: Schools that Serve the Community," *Journal of Educational Sociology* 9, no. 6 (February 1936): 364–69.

170. Joan N. Burstyn, *Past and Promise: Lives of New Jersey Women* (Syracuse, NY: Syracuse University Press, 1997), 318–19.

171. Carmela Karnoutsos, "A. Harry Moore School," Jersey City Past and Present, New Jersey City University, http://www.njcu.edu/programs/jchistory/pages/a_pages/a_harry_moore_school.htm.

172. *New York Times*, "$50,000 Therapeutic Pool Approved for Jersey City," April 27, 1938.

173. Jersey City Redevelopment Agency, "Margaret S. Herbermann Manor," http://www.thejcra.org/index.php?p=project-details&pid=85.

The Organization

174. *New York Times*, "The Ballot-Box Frauds—The Inquiry into the Hudson County Crime: How the Jersey City Election Officials Manipulated the Ballot Boxes," February 13, 1890.

175. Summer Dawn Hortillosa, "Hudson County Personalities Headed to New Jersey Hall of Fame," *Jersey Journal*, June 3, 2011, http://www.nj.com/jjournal-news/index.ssf/2011/06/hudson_county_personalities_am.html.

176. *New York Times*, "Find 27 Dead Men 'Voters' in Jersey: Hudson County Board Strikes Their Names from List on Proof of Demise," May 6, 1927.

177. Connors, *Cycle of Power*, 45.

178. McKean, *The Boss*, 122.

179. Shannon, "Political Machine I."

180. Hart, *Last Three Miles*, 158–59.

181. FBI File on Frank Hague.

182. Fleming, *"Mysteries of My Father,"* 193.

183. Fleming, "Political Machine II," 33–48.

184. Ibid.

185. FBI File on Frank Hague.

186. Fleming, *"Mysteries of My Father,"* 195.

187. Raymond F. Gregory, *Norman Thomas: The Great Dissenter* (New York: Algora Publishing, 2008), 162.

188. McKean stated that when Hague became mayor of Jersey City in 1917 and his organization took over the city government, the tax rate was $21.00 per $1,000.00 of assessed valuation. The total cost of the city government, including schools, was $3,994,502.00, or $14.79 per capita. No one today would think this excessive. In addition to the city taxes, the municipality collected $2,859,908.00 for state and county purposes, so that the total of all taxes collected was $6,854,410.00, or $29.09 per capita. Ten years later, the tax rate had risen from $21.00 to $35.75, an increase of 41 percent. Beginning in 1927, the costs of schools and city government are separated, so we find that schools cost $4,429,574.00 and the city government $10,107,085.00, a total of $14,536,659.00, or $47.35 per capita. The per capita cost had increased in the first ten years by more than 300 percent.

189. Alan Karcher, *Municipal Madness* (New Brunswick, NJ: Rutgers University Press, 1998), 184. The number cited by Karcher excluded school personnel.

190. Steinberg, *The Bosses*, 42.

191. Ibid., 43.

192. Connors, *Cycle of Power*, 68–69.

193. McKean, *The Boss*, 44.

194. Rapport, *Statesman and the Boss*, 149.

195. Steinberg, *The Bosses*, 31.

196. Connors, *Cycle of Power*, 49.

197. Leinwand, *Mackerels in the Moonlight*, 83.

198. Luthin, *American Demagogues*, 134.

199. Connors, *Cycle of Power*, 49.

200. Fleming, "Political Machine II," 33–48.

201. Connors, *Cycle of Power*, 49–51.

202. McKean, *The Boss*, 92.

203 *New York Times*, "Fraud and Graft Charged in Jersey," May 8, 1921, 1.

204. McKean, *The Boss*, 50.

Mrs. Norton Goes to Washington

205. Women's History, http://womenshistory.about.com/od/suffrage1900/a/august_26_wed.htm.

206. William L. Chenery, "One in Three Women Vote," *New York Times*, December 19, 1920.

207. Richard P. McCormick and Katheryne McCormick, "Equality Deferred: Women Candidates for the New Jersey Assembly, 1920–1993," Center for the American Women and Politics, Eagleton Institute of Politics, Rutgers, 1994, 11–13.

208. Sara Alpern and Dale Baum, "Female Ballots: The Impact of the Nineteenth Amendment," *Journal of Interdisciplinary History* 16, no. 1 (1985): 43–67.

209. Grace Abbott, "What Have They Done," *The Independent*, October 24, 1925, 475–76.

210. *New York Times*, "Harding Wins; Million Lead Here; Big Republican Gains in Congress; Miller Leads Smith for Governor," November 3, 1920, 1.

211. *Journal of Illinois State Historical Quarterly* 13 (1920): 414.

212. Ann Martin, "Feminists and Future Political Action," *The Nation* 120 (February 3, 1925): 185–86; Robert I. Rotberg, *Politics and Political Change* (Boston: MIT Press, 2001), 285–90.

213. Frank R. Kent, "Women's Faults in Politics," *Women Citizen* 11 (March 1927): 23, 46–47.

214. Malcolm M. Willey and Stuart A. Rice, "A Sex Cleavage in the Presidential Election of 1920," *Journal of the American Statistical Association* 19 (1924): 519–20.

215. Maxine N. Lurie, Marc Mappen and Michael Siegel, *Encyclopedia of New Jersey* (New Brunswick, NJ: Rutgers University Press, 2004), 882.

216. *Daily Northwestern*, "Only Woman in New Congress Is Fifth to Sit in Lower House," November 15, 1924; *Current Biography Yearbook, 1945*, "Mary T. Norton" (N.p.: H.W. Wilson Company, 1945), 501.

217. Matthew Andrew Wasniewski, *Women in Congress 1917–2006* (N.p.: Joint Committee on Printing, April 10, 2007), 61.

218. *New York Times*, "Calls Tariff Bill Unfair to Women; Mrs. Norton Says It Will Increase Cost of Nearly Every Article They Wear," August 28, 1929, 14.

219. *New York Times*, "Birth Control War Hit as Commercial Representative Mary Norton Pleads Against Carrying of 'Filth' in the Mails," January 20, 1934, 17.

220. *New York Times*, "W.P. Connery Jr. Dead in Capital; Chairman of Labor Committee of House Joint Author of Wages and Hours Bill," June 16, 1937, 23.

221. Luis Stark, "Wages and Hours Bill Now Headed for a Vote," *New York Times*, May 8, 1938.

222. Marcy Kaptur, *Women of Congress: A Twentieth-Century Odyssey* (Washington, D.C.: Congressional Quarterly Press, 1996), 46.

223. Thomas Fleming, *The New Dealers' War: FDR and the War Within World War II* (N.p.: Basic Books, 2002), 152.

224. Politicker, New Jersey, http://www.politickernj.com/campaign-remember.

225. *New York Times*, "Edward I. Edwards Ends Life by Bullet," January 27, 1931.

226. Luthin, *American Demagogues*, 137.

227. *Newark Evening News*, November 4, 1925.

228. Luthin, *American Demagogues*, 138.

229. Arthur M. Schlesinger, *History of American Presidential Elections, 1789–1984*, vol. 4 (N.p.: Chelsea House Publishers, 1985), 2,830; *New York Times*, "Mayor Hague Holds Roosevelt 'Weak,'" June 24, 1932.

230. Jean Edward Smith, *FDR* (N.p.: Random House Trade Paperbacks, 2008), 280; Cook, *American Political Bosses and Machines*, 122. Hague estimated the crowd at 250,000.

231. *New York Times*, "Huge Jersey Crowd to Hail Roosevelt Special Trains Ordered," August 27, 1932.

232. Luthin, *American Demagogues*, 122.

HAPPY DAYS ARE HERE AGAIN

233. Harjit K. Arora and Michael P. Buza, "United States Economy and the Stock Market," *Journal of Business and Economics Research* 1, no.1 (2003): 107–116; George Athanassakos, *Globe Investor Magazine*, October 20, 2008, http://v1.theglobeandmail.com/partners/free/globeinvestor/international/sept08/online/depression.html.

234. Arnold Richard Hirsch and Raymond A. Mohl, *Urban Policy in Twentieth Century America* (New Brunswick, NJ: Rutgers University Press, 1992), 10.

235. Michael Lewis, "No Relief from Politics Machine Bosses and Civil Works," *Urban Affairs Review* 30, no. 2 (December 1994): 210–26. See also Jim Powell, *FDR's Folly: How Roosevelt and His New Deal Prolonged the Great Depression* (N.p.: Three Rivers Press, 2004).

236. Charles F. Searle, *Minister of Relief: Harry Hopkins and the Depression* (Syracuse, NY: Syracuse University Press, 1969), 162.

237. Powell, *FDR's Folly*, 97.

238. Randall M. Miller and William Pencak, *Pennsylvania: A History of the Commonwealth* (University Park: Pennsylvania State University Press, 2002), 298.

239. John T. Flynn, *The Roosevelt Myth* (Garden City, NY: Garden City Books, 1948), 65, 127.

240. Lyle W. Dorsett, *Franklin D. Roosevelt and the City Bosses* (N.p.: Kennikat Press, 1977), 102.

241. Burton W. Folsom, *New Deal or Raw Deal?: How FDR's Economic Legacy Has Damaged America* (N.p.: Threshold Editions, 2009), 154.

242. Leonard F. Vernon, *Jersey City Medical Center* (Charleston, SC: Arcadia Press, 2004), 11.

243. Ibid., 13.

244. Ibid., 11.

245. Ibid., 14.

246. Margarete Arndt and Barbara Bigelow, "Hospital Administration in the Early 1900s: Visions for the Future and the Reality of Daily Practice," *Journal of Healthcare Management* (January–February, 2007), http://www.entrepreneur.com/tradejournals/article/158907311_1.html.

247. Vernon, *Jersey City Medical Center*, 18.

248. Ibid., 83.

249. McKean, *The Boss*, 166.

250. Lurie, Mappen and Siegel, *Encyclopedia of New Jersey*, 423.

251. Leinwand, *Mackerels in the Moonlight*, 88.

252. Vernon, *Jersey City Medical Center*, 29.

253. Ian R. McDonald and Hector R. Maclennen, "A Consideration of the Treatment of Elderly Priagravida," *British Journal of Obstretrics and Gynecology* 67, no. 3 (June 1960): 443–50; Vernon, *Jersey City Medical Center*, 53.

254. Marquis W. Child, *I Write From Washington* (New York: Harper Brothers, 1942), 113–14.

255. Vernon, *Jersey City Medical Center*, 69.

256. Personal communication with Hague's daughter.

257. Simon Louis Katzoff, *Timely Truths on Human Health*, reprint edition (N.p.: Co-operative Publishing Company, 1921), 196.

258. *New York Times*, "Hague Fights Back at Inquiry Charges: Defends Hospital Outlay," March 27, 1929.

259. Frank R. Dufay, *Simpler Times* (N.p.: Trafford Publishing, 2003), 45–46.

260. Folsom, *New Deal or Raw Deal?*, 156.

261. Mary Kay Linge, *Jackie Robinson: A Biography*, annotated edition (N.p.: Greenwood, 2007), 110.

262. McKean, *The Boss*, 9.

263. New Jersey State Library, http://www.njstatelib.org/NJ_Information/Digital_Collections/Governors_of_New_Jersey/GMOOR.pdf.

THAT MAN IS A RED

264. Ross Petras and Kathryn Petras, *The Stupidest Things Ever Said by Politicians* (N.p.: Pocket, 1999), 155.

265. On February 19, 1942, Roosevelt signed Executive Order 9066. Under the terms of the order, some 120,000 people of Japanese descent living in the United States were removed from their homes and placed in internment camps. The government justified its action by claiming that there was a danger of those of Japanese descent spying for the Japanese. However, more than two-thirds of those interned were American citizens, and half of them were children. None had ever shown disloyalty to the nation. In some cases, family members were separated and put in different camps. During the entire war, only ten people were convicted of spying for Japan, and they were all white.

266. Lurie, Mappen and Siegel, *Encyclopedia of New Jersey*.

267. *New York Times*, "Gompers Assails Boston: Asks Jersey City Mayor to Delay Police Union Action," September 23, 1919.

268. Hart, *Last Three Miles*, 88.

269. Ibid., 94.

270. Ibid., 153.

271. Ibid., 144.

272. Ibid., 145.

273. Russell B. Porter, "Portrait of a 'Dictator,' Jersey City Style: Mayor Hague Controls Not Only His Home Town but Pulls the Strings of the State Government," *New York Times Magazine*, February 13, 1938, 5.

274. Robert H. Zieger, *The CIO, 1935–1955* (Chapel Hill: University of North Carolina Press, 1997), 30.

275. Andrew Edmund Kersten, *Labor's Home Front: The American Federation of Labor During World War II* (New York: New York University Press, 2009), 144; Zieger, *The CIO*, 76.

276. Zieger, *The CIO*, 80–81.

277. Ibid., 15.

278. Harvey Klehr, Harvey Klehr, Kyrill M. Anderson and John Earl Haynes, *The Soviet World of American Communism* (New Haven, CT: Yale University Press, 1998), 54–56.

279. Michael Barson and Steven Heller, *Red Scared!: The Commie Menace in Propaganda and Popular Culture* (San Francisco: Chronicle Books, 2001), 16.

280. Murray B. Levin, *Political Hysteria in America: The Democratic Capacity for Repression* (N.p.: Basic Books, 1971), 29.

281. David M Kennedy, Elizabeth Cohen and Thomas A. Bailey, *The American Pageant* (Boston: Houghton Mifflin Company, 2001), A33.

282. City of Jersey City, http://www.cityofjerseycity.org/hague/life/life020738.shtml.

283. *Life*, "The Last of the Bosses: Mayor Frank Hague and His Jersey City," February 7, 1938, 49.

284. Hart, *Last Three Miles*, 171.

285. McKean, *The Boss*, 195–96.

286. David G. Wittels, "Mayor Hague," *New York Post*, February 3, 1938, 1.

287. *Life*, "The Last of the Bosses," 44.

288. David G. Wittels, "Mayor Hague," *New York Post*, February 7, 1938, 1, column 2.

289. *Life*, "The Last of the Bosses," 46.

290. *New York Times*, October 8, 1940.

291. Pop Art Machinie, http://popartmachine.com/item/pop_art/LOC+1000307/I-DON.

292. *Daily Worker*, December 1, 1937.

293. *Time*, "Labor: Greatest Show in Jersey," January 17, 1938, www.time.com/time/magazine/article/0,9171,758857,00.html.

294. David Witwer, "Westbrook Pegler and the Anti-Union Movement," *Journal of American History* 92, no. 2, http://www.historycooperative.org/journals/jah/ 92.2/witwer.html.

295. Vernon, *Jersey City Medical Center*, back matter.

296. *New York Times*, "Federal Grand Jury Will Hear Thomas 'Kidnapping' in Jersey City, to Be Sifted This Week," October 16, 1938, 40.

297. *The Hague Injunction Proceedings* (N.p.: Yale Law Journal Company, Inc.), 1938.

298. Boston College, "Hague v. Committee for Industrial Organization," http://www.bc.edu/bc_org/avp/cas/comm/free_speech/hague.html.

299. Ibid.

300. Ibid.

301. John Milton Cooper Jr., *Woodrow Wilson: A Biography*, 1st ed. (New York: Knopf, 2009), 11.

302. Ibid., 523.

303. Linda Greenhouse, "A Nation Challenged: The Supreme Court; In New York Visit, O'Connor Foresees Limits on Freedom," *New York Times*, September 29, 2001.

FRIENDS IN HIGH PLACES

304. William L. Riordan, *Plunkitt of Tammany Hall: A Series of Very Plain Talks on Very Practical Politics* (N.p.: Signet Classics, 1995), 3.

305. Insider trading was neither illegal nor unlawful in New Jersey in the 1920s and 1930s.

306. Case would later be named to the bench of the New Jersey Supreme Court and would serve as chief justice from 1946 to 1948.

307. Steinberg, *The Bosses*, 37.

308. McKean, *The Boss*, 111.

309. "A Vision for Revitalizing Journal Square Jersey City, NJ, Prepared For: The Jersey City Economic Development Corporation Urban and Regional Planning Workshop," Woodrow Wilson School of Public and International Affairs, Princeton University, January 2004, 32.

310. John S. Matlin, "Political Party Machines of the 1920s and 1930s: Tom Pendergast and the Kansas City Democratic Machine," PhD diss., Department of American and Canadian Studies, School of Historical Studies, University of Birmingham. September 2009, 104. Farmer cited no evidence to back up this claim.

311. *New York Times*, "Hague Bars Inquiry Into His Bank Funds; Jersey City Mayor Refuses to Tell Lawmakers Whether He Had Account Here. Land Deals Under Fire but Witness Asserts He Had No Connection with Man Who Got Big Profits from City. Kerbaugh Deal Is Described," March 26, 1929.

312. I have been unable to find information as to why Milton was allowed to testify since he was Hague's personal attorney. I was under the assumption that any information would be protected under attorney-client privilege.

313. *New York Times*, "Hague Is Arrested; Quickly Free in Bail," November 23, 1928.

314. *New York Times*, "Hague Wins Again; Freed From Arrest," August 28, 1929, 1.

315. Letter from New Jersey state senator Clarence Case to U.S. Attorney General John Sargent, June 25, 1928, FBI File on Frank Hague, document #62-20079-01. The letter explains that he is head of a legislative committee that is investigating corruption in Hudson County especially Jersey City. It goes on to ask if the DOJ would share any information that it had on file and if it would share it with the committee.

316. Letter from Hoover to AUSA O.R. Luhring, acknowledging letter from Case to U.S. Attorney General John Sargent, June 28, 1928, FBI File on Frank Hague, document #62-20079-01. It is Hoover's opinion that no federal law was violated and that this was a state issue; however, he was willning to defer and proceed if instructed to do so.

317. Letter from R.E. Watson, Esq., to Mable Walker Willebrandt, AUSA, August, 15, 1928, FBI File on Frank Hague, document #5-48-60-1. This details the cover-up of Booton, New Jersey property and the evasion of taxes. As far as Hague, the focus was on his $500,000 investment in an "enterprise," as well as his $100,000 cash purchase of a shore home. The letter goes on to state that it was the belief of committee members that Hague had not filed tax returns or had underrepresented his income if he did file. It states that the committee would look into Hague's finances to see if he had been the beneficiary of corrupt governmental activities. The letter goes on to urge the DOJ to investigate.

318. Letter to R.E. Watson, Esq., from AUSA Mable Walker Hildebrandt, August 22, 1928, FBI File on Frank Hague, document #62-20079. Letter indicates that she had reviewed the information that he (Watson) supplied as discovered by the Joint Legislative Committee investigating Hague. Watson had indicated that the committee could prove income evasion by Hague, and Hildebrandt indicated that she would forward info to the IRS and ask that it start an investigation. Made in response to Watson's letter.

319. Jonathan Eig, *Get Capone: The Secret Plot that Captured America's Most Wanted Gangster*, 1st ed. (New York: Simon & Schuster, 2010), 72.

320. Fleming, "Political Machine II."

321. James A. Farley, *Jim Farley's Story: The Roosevelt Years* (N.p.: Wylie Press, 2007), 212.

322. Martin, *The Bosses*, 202.

323. Herbert D. Rosenbaum and Elizabeth Bartelme, eds., *Franklin D. Roosevelt: The Man, the Myth, the Era, 1882–1945* (Westport, CT: Greenwood Press, 1987), 28.

324. Fleming, *New Jersey: A History*, 187.

325. Barbara G. Salmore and Stephen A. Salmore, *New Jersey Politics and Government: Suburban Politics Comes of Age* (Lincoln: University of Nebraska Press, 1993), 41.

326. Rosenbaum and Bartelme, *Franklin D. Roosevelt*, 34.

327. Ibid., 35.

328. New Jersey State Library. http://www.njstatelib.org/NJ_Information/ Digital_Collections/Governors_of_New_Jersey/GEDIS.pdf, Charles Edison on 212.

329. Hague Jr. continued his legal education under the then permitted method of clerkship with Hague family attorney John Milton.

330. Leinwand, *Mackerels in the Moonlight*, 100.

331. In fact, the Great Depression had affected the railroads as much if not more than the tax rates.

332. The Constitution of 1844 New Jersey State Library, http://www. njstatelib.org/NJ_Information/Digital_Collections/Governors_of_ New_Jersey/GEDIS.pdf.

333. Via a method practiced in the New Jersey legislature known as "senatorial courtesy," any senator could oppose the appointment of a nominee without cause. The practice continues to this day.

334. Frank McGady, "Dead Governor of New Jersey," http://mcgady.net/ ms/dgov/deadgovernorsnj_pt3.html#edison.

335. *New York Times*, "Gov. Edison Ignores Murphy in Address; Constitution Referendum More Important than Electing Governor, He Asserts," November 2, 1943, 18.

336. *New York Times*, "Dismisses 14 Hague Men; Van Ripper Drops Detectives on Hudson Prosecutors Staff," April 20, 1944, 36.

337. FBI File on Frank Hague, document #62-2009-[last digit illegible]. This is a description of how horse race betting is operated via numerous telephones, with a detailed description of how payoffs are made. There is a list of all parties involved, along with their addresses and telephone numbers.

338. *New York Times*, "Van Riper Indicted as OPA Violator," February 16, 1945, 25.

339. FBI File on Frank Hague, #62-20079-9,10,11, September 15, 1948. The memorandum referred to contains statements allegedly made by Edison about Frank Hague and FDR. The memorandum states that Edison said that as soon as Hague realized that New Jersey attorney general Van Ripper was "about to get him," Hague went to Washington to speak with FDR. Judge Tamm makes a comment about Edison's insinuation that Hague was so powerful he could "fix" Hover and the FBI.

340. FBI File on Frank Hague, document #62-2009-10.

341. FBI File on Frank Hague, document #62-20079-10. It is difficult to believe that Clegg was so naïve as to think that the FBI had no role in investigating political corruption; instead, he no doubt was telling Hoover how he responded to the question.

342. FBI File on Frank Hague, document #62-20079-9. This is the Hoover memorandum instructing Agent Clegg to "visit" Edison and "put him straight."

343. Letter to J. Edgar Hoover from Charles Edison, September 23, 1948, FBI File on Frank Hague, document #62-20079-11.

344. Powell, *FDR's Folly*, 83.

345. John Morton Blum, *The Morgenthau Diaries: Years of Crisis, 1928–1938* (Boston: Houghton Mifflin, 1959), 324–25.

346. T. Harry Williams, *Huey Long* (New York: Alfred A. Knopf, 1969), 635.

347. Ibid., 795.

348. Harnett T. Kane, *Louisiana Hayride* (Gretna, LA: Pelican Publishing Company, 1941, 1998), 164–87. See also Elmer Irey, *The Tax Dodgers: The Inside Story of the T-men's War with America's Political and Underworld Hoodlums* (Garden City, NY: Garden City Publishing, 1949), 88–117, and Williams, *Huey Long*, 794.

349. Edgar Eugene Robinson, *They Voted for Roosevelt: The Presidential Vote, 1932–1944* (Palo Alto, CA: Stanford University Press, 1947).

350. Robert A. Caro, *The Years of Lyndon Johnson: The Path to Power* (New York: Alfred A. Knopf, 1982), 501, 742–53; Robert A. Caro, *The Years of Lyndon Johnson: Means of Ascent* (New York: Alfred A. Knopf, 1990), 15, 16, 74, 272–75, 285–86.

351. Caro, *Path to Power*, 742–53.

GENTLEMEN, HATS OFF

352. Skyscraper City, http://www.skyscrapercity.com/showthread.php?t=602174&page=6.

353. Daniel R. Grant, "Trends in Urban Government and Administration," *Law and Contemporary Problems* 30, no. 1 (Winter 1965): 38–56; Connors, *Cycle of Power*, 202.

354. Connors, *Cycle of Power*, 142–43.

355. Ibid., 148.

356. Ibid., 154.

357. Ibid., 155.

358. Ibid., 168.

359. Ibid., 150–51.

360. *New York Times*, "M'feely Defeated, Fusion Ticket Wins in Hoboken Voting; 22-Year Rule of Democratic Mayor Ends," April 3, 1946.

361. Connors, *Cycle of Power*, 169.

362. *New York Times*, "Kenny Will Be Candidate: Heads Jersey City Slate in Move to Unseat Hague Forces," February 5, 1949.

363. Martin, *The Bosses*, 39.

364. Connors, *Cycle of Power*, 173–74.

365. *New York Times*, "Hague Machine Ousts Ward Leader," June 16, 1948.

366. *New York Times*, "Kenny Will Be Candidate," February 5, 1949.

367. Fleming, *"Mysteries of My Father,"* 97; both Hart, *Last Three Miles*, 176–77, and Fleming use Key Biscayne; however, the house was on Biscayne Bay in Miami, not in Key Biscayne.

368. *Time*, "New Jersey: Hague's End," May 23, 1949, http://www.time.com/time/magazine/article/0,9171,794736,00.html.

369. Fleming, *"Mysteries of My Father,"* 305.

370. Howard L. Preston, *Automobile Age Atlanta: The Making of a Southern Metropolis* (Athens: University of Georgia Press, 1979).

371. *New York Times*, "Hague Group Puts 3 in Hudson Jobs," January 12, 1951. Frederick Gassert served as the mayor of Harrison, New Jersey, as well as the leader of the Hague forces in the western end of Hudson County, where the city of Harrison is located.

372. *New York Times*, "Jersey City Mayoral Candidate Greeted by a Barrage of Eggs in Kenny's Bailiwick," May 2, 1953.

373. John Farmer, "Mayor Frank Hague: When Jersey City Ruled Politics," http://blog.nj.com/njv_john_farmer/2009/05/frank_hague_when_jersey_city_r.html.

374. *New York Times*, "Hague Followers Shift Allegiance: Hudson Officials Flock to Shake Hands With Kenny, New County Leader," November 11, 1949.

375. Hart, *Last Three Miles*, 181.

376. *Time*, March 1, 1963, People Section.

377. John B. Wefing, *The Life and Times of Richard J. Hughes: The Politics of Civility* (New Brunswick, NJ: Rutgers University Press, 2009), 22.

378. Wolfinger, "Why Political Machines Have Not Withered Away," 8.

379. J. Owen Grundy, *Moore, Wittpenn and Hague: Mrs. A. Harry Moore's Death Recalls Her Husband's Early Political Career and the Two Jersey City Mayors Who Most Influenced It* (Jersey City, NJ: Jersey City Public Library, 1975).

380. Foster, "Early Career of Mayor Frank Hague"; see also the FBI file documents.

381. David McCullough, *Truman* (New York: Simon & Schuster, 1993), 773.

382. Beatty, *Rascal King*, 507.

383. *New York Times*, "John V. Kenny Leaves Prison," March 2, 1973.

384. Luthin, *American Demagogues*, 143.

385. Karcher, *Municipal Madness*, 184.

386. Powell, *FDR's Folly*, 135, 229.

387. Witwer, "Westbrook Pegler and the Anti-Union Movement."

388. Connors, *Cycle of Power*, 165.

389. Ibid., 166.

INDEX

ABOUT THE AUTHOR

Dr. Leonard Vernon, of Laurel, New Jersey, is a recognized expert on Frank Hague. He is a well-known local author, and his works include *Jewish South Jersey* and *Jersey City Medical Center*, as well as *A Profession Persecuted: The History of the Chiropractic Profession in New Jersey*.

Visit us at
www.historypress.net